DRAWING AND PAINTING WITH
Colored Pencil

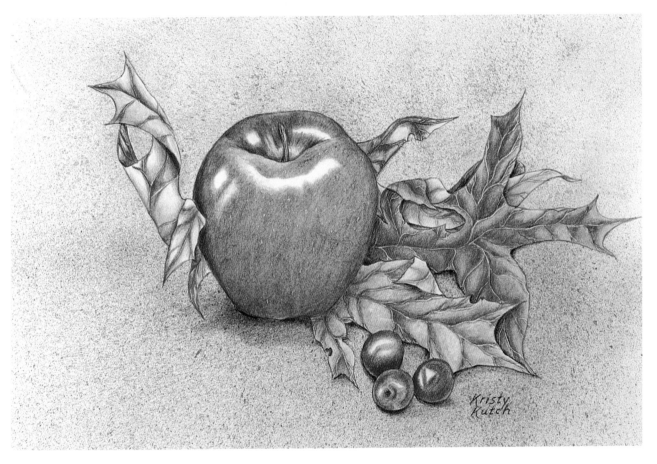

Kristy
Kutch

Dear Rita,
 Thank you so much for co-ordinating my L.O.L.A.A.
workshops!

Gratefully,
Kristy

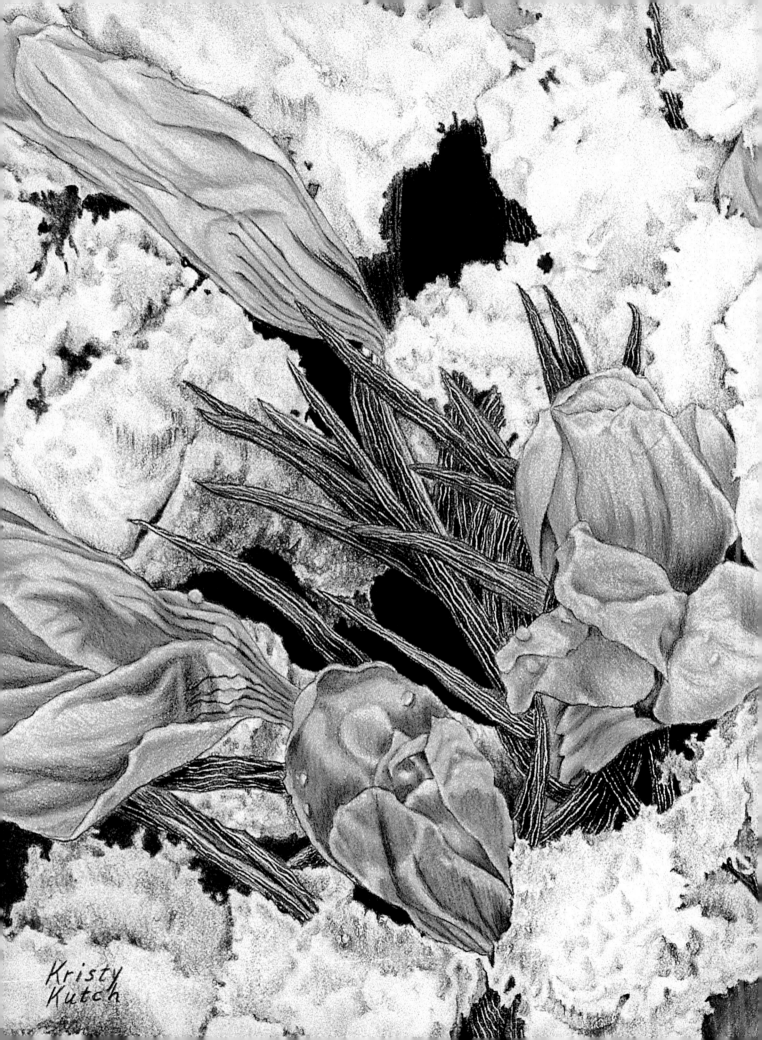
Kristy
Kutch

DRAWING AND PAINTING WITH
Colored Pencil

BASIC TECHNIQUES FOR MASTERING TRADITIONAL AND WATERSOLUBLE COLORED PENCILS

KRISTY ANN KUTCH

WATSON-GUPTILL PUBLICATIONS/NEW YORK

HALF-TITLE PAGE: *Adrienne's Delicious Reds,* 2000. Colored pencil and watercolor pencil on Borden and Riley regular-finish Bristol board, 14" × 11". Collection of Adrienne Hirsch.

FULL-TITLE PAGE: *Golden Promises,* 2003. Colored pencil on Rising four-ply museum board, 18" × 14". Courtesy of Kristy Kutch.

OPPOSITE: *Salsa Time,* 1997. Colored pencil and watercolor pencil on Clearprint Papercloth, 10" × 8". Courtesy of Kristy Kutch.

PAGE 10: *Day Lilies,* 1989. Colored pencil on Canson Mi Teintes colored paper, 18" × 12". Courtesy of Kristy Kutch. Collection of Anco, Inc.

PAGE 50: *Joyce's Fruit,* 2003. Colored pencil and watercolor pencil on Borden and Riley regular-finish Bristol board, 14" × 11". Collection of Joyce Estes.

PAGE 98: *Grand Marais Harbor,* 2003. Watercolor pencil on Colourfix pastel paper, 10" × 8". Courtesy of Kristy Kutch.

Note: Great care has been taken to reproduce the colors in this book faithfully. However, because color reproduction is not always entirely accurate, there may be minor variations between the colors reproduced here and the color of purchased art supplies.

First published in the United States by
Watson-Guptill Publications
a division of VNU Business Media, Inc.
770 Broadway
New York, New York 10003
www.watsonguptill.com

Library of Congress Cataloging-in-Publication Data

Kutch, Kristy Ann.
 Drawing and painting with colored pencil: basic techniques for mastering traditional and watersoluble colored pencils / by Kristy Ann Kutch.
 p. cm.
 Includes bibliographical references and index.
 ISBN 0-8230-1568-8
 1. Colored pencil drawing—Technique. 2. Watercolor painting—Technique. 3. Water-soluble colored pencils. I. Title.
 NC892.K88 2005
 741.2'4—dc22

 2005010466

Printed in China

First printing, 2005

3 4 5 6 / 09 08 07 06

ACKNOWLEDGMENTS

I would like to give special thanks to the following people who so graciously helped and encouraged me while writing this book:

Bet Borgeson
Glenn Brill
Walt Bukva
Chuck Cannon
Vince Donofrio
Janie Gildow
Karl Heinz-Haberer
Janet Hoeppner
Edwina Kleeman
Rosi and Werner Kring
Nanette Mariani
Lynn Pearl
Rosemary Pelissier
Anne Polkinghorn
Til Quante
Candace Raney
Yevonne Reynolds
Lisa Ritchey
Linda Saft
Mark Shoham
Eric Valentine
Isabel Venero
Richard Warriner

And most of all: Edward Kutch

—Kristy Kutch

Executive editor: Candace Raney
Project editor: Isabel Venero
Senior production manager: Ellen Greene

This book is dedicated with love to my family:
Ed, Mary, Joe, and Eddie.
You are my creative energies.

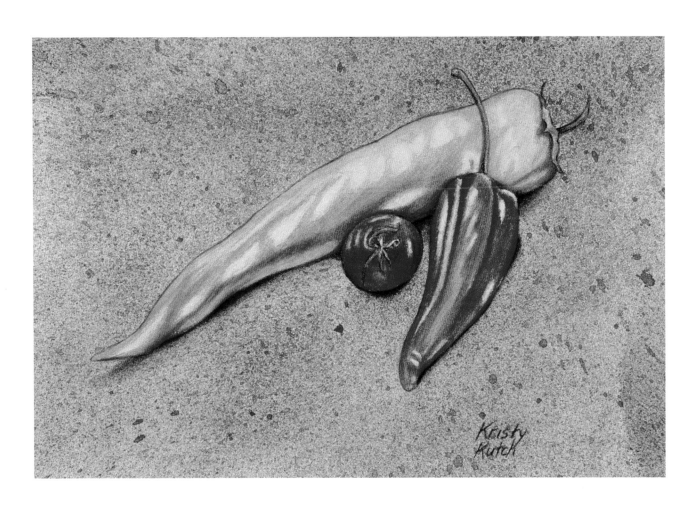

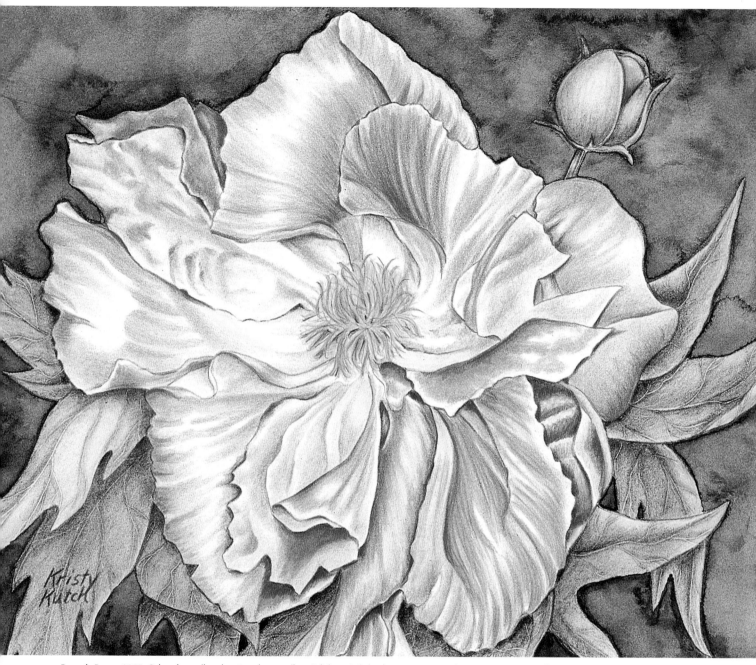

Peggy's Peony, 2003. Colored pencil and watercolor pencil on Fabriano Artistico hot-press watercolor paper, 10" × 8". Collection of Peggy Lasater.

Contents

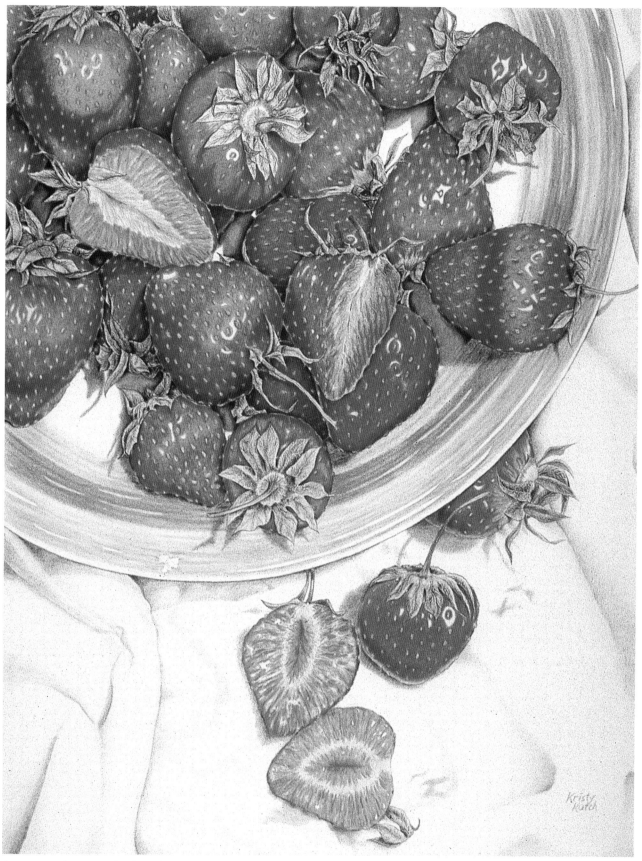

Summer Beauties, 2002. Colored pencil on Rising four-ply museum board, 16" × 20". Courtesy of Kristy Kutch.

INTRODUCTION

Drawing and painting with colored pencil offers exciting possibilities. Colored pencils, both traditional (wax- or oil-based) and watercolor, are nontoxic, portable, easy to control, and ideal for rendering many different subjects and effects. Whether the artist is trying to create a composition that is pointillistic and textured or photo-realistic and highly blended, this versatile medium satisfies a wide range of artistic styles and sensibilities.

Colored pencils date back to approximately 1834, when they became popular among school children for craft projects and mapmaking. Artists have used them since that time, including the renowned Henri de Toulouse-Lautrec, who incorporated colored pencil into his mixed-media art in the late nineteenth century. It was during the early 1980s, however, with the publication of Bet Borgeson's groundbreaking book *The Colored Pencil,* that a new awareness emerged of colored pencil as a fine art medium. Artists began using professional-grade pencils, which are highly pigmented and have a smooth, buttery "lay-down." Manufacturers of colored pencils responded to the increased interest, and artists now have many options regarding the types of pencils and paper surfaces with which to work. And with the many choices to be made, questions about how to use the medium to its best advantage invariably arise.

This book will serve as an essential companion for the artist working in colored pencil. Divided into three parts, it presents the reader with detailed descriptions of materials and easy-to-master techniques for traditional colored pencil and watercolor pencil, with lots of tips and suggestions along the way. With each new skill, the artist builds confidence and learns how to apply the techniques to the chosen subject. For the artist who needs a few ideas on what to draw and paint, plenty are provided with concise step-by-step demonstrations for still lifes, landscapes, seascapes, and the most popular fruits, vegetables, and flowers.

Part I is devoted to traditional colored pencil. The exhaustive materials chapter considers the various types of pencils (and their characteristics and handling), the many surfaces compatible with this medium, and methods for applying (including layering, blending, and burnishing) and lifting color (a process that removes a layer of color to correct a mistake or lighten an area on which color has been applied too heavily). An entire chapter is also devoted to creating textures, one of the critical features of any successful composition.

Part II discusses watercolor pencil. The materials chapter describes the pencils, surfaces (including papers and boards), and other tools needed when working with this medium, such as brushes. Techniques specific to watercolor pencil are demonstrated, as are drawings for 18 varieties of fruit, vegetables, and flowers, illustrating the luscious effects one can achieve.

Part III is the culmination of all the information presented in the book, incorporating the many techniques for both media to show artists how to create complete compositions, including an entire chapter on backgrounds. Combining traditional and watercolor pencil on the same composition is considered in the last chapter and illustrates how using both media for still lifes, landscapes, and seascapes is helpful in rendering the various effects featured in these three genres.

For beginners, this book will offer a wealth of advice and instruction, introducing them to the unique capabilities of colored pencils. The art featured within, while demonstrating various techniques and methods, will hopefully inspire and serve as artistic fodder. And for seasoned artists, this book will help refine skills and remind them of the reasons they chose this exceptional medium when their artistic pursuits began.

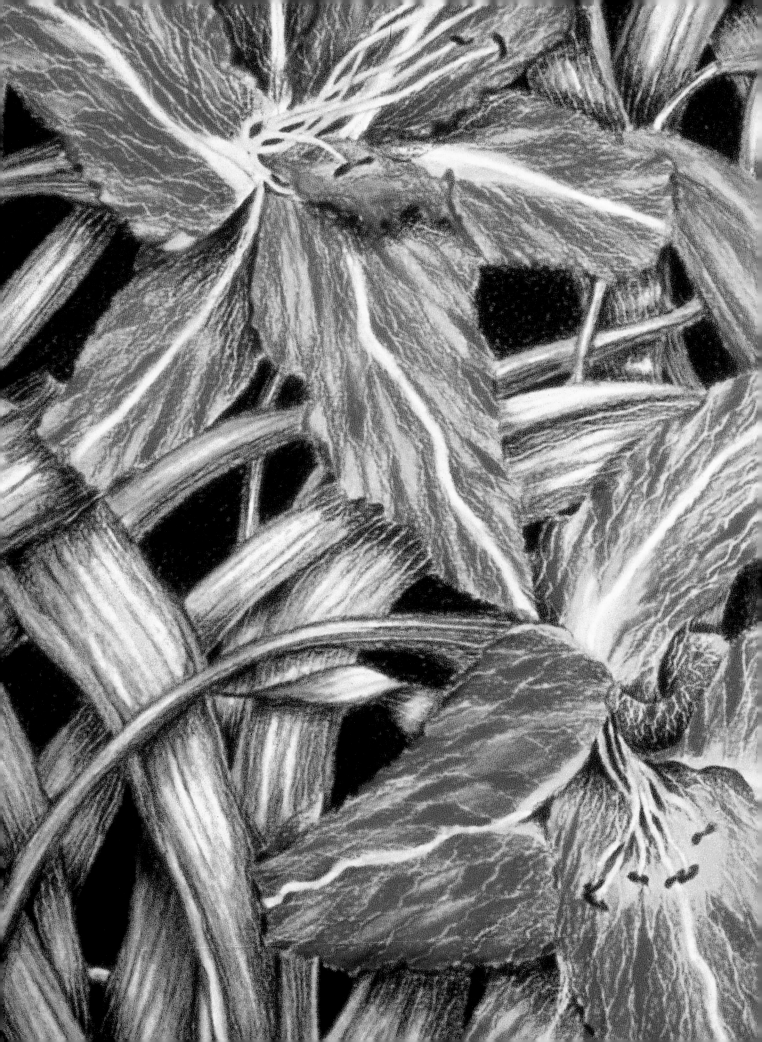

Traditional Colored Pencil

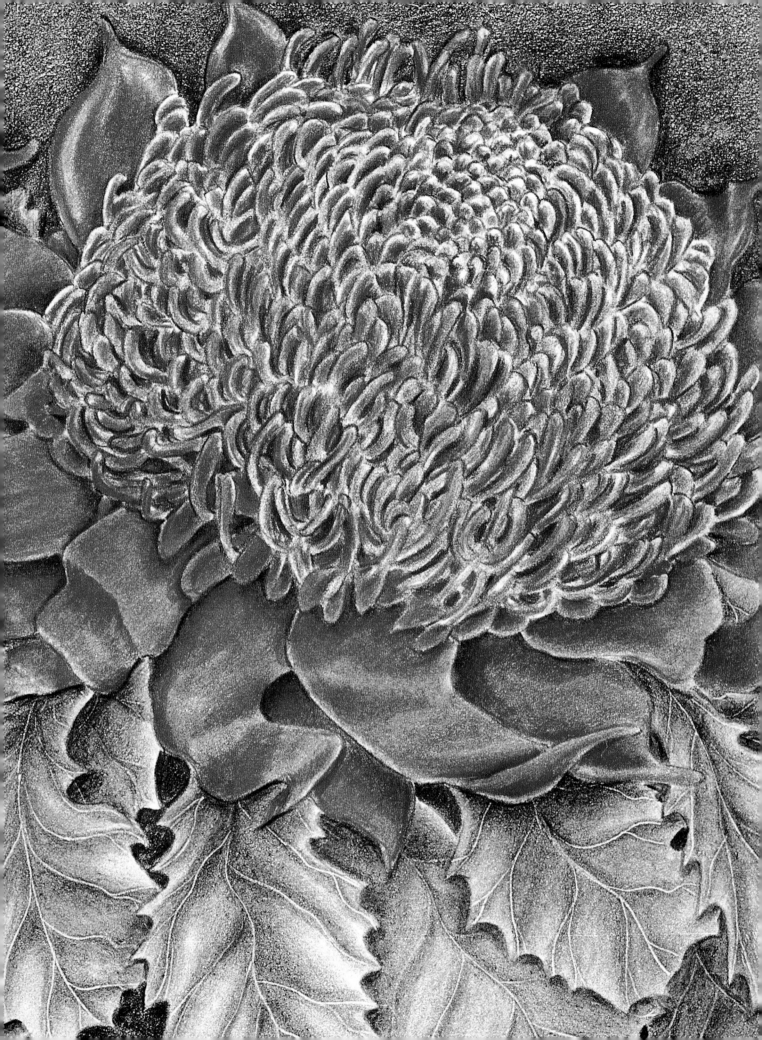

Materials for Traditional Colored Pencil

Great art begins with quality, artist-grade materials. No tailor would begin sewing without the proper fabric, and no chef would begin a recipe with inferior ingredients, so no artist should begin working on his or her art without the best materials. With the many colors, types of pencils, and variety of papers available, the following information will help in making informed choices.

COLORED PENCILS

Traditional, or nonwatersoluble, colored pencils are composed of pigment and binder(s) (that occasionally contain clay) and are extruded as a slender, colored (nongraphite) "lead." The lead is encased in wood and fixed in place by an adhesive. Some manufacturers use wax as the binder to hold the pigment, while others use liquid "oil" waxes or vegetable oil and modified cellulose material. Color from wax-based pencils generally does not smudge and stays where it has been applied. Four manufacturers of good wax-based pencils are Van Gogh, Staedtler, Sanford, and Derwent. These types of pencils hold a point longer than oil-based pencils, lay down color smoothly with a glossy sheen, and yield color that is highly saturated. The art throughout this book uses Sanford Prismacolor pencils, which are offered in a large assortment of colors. They are distributed internationally, making them widely available in open stock refills.

Oil-based pencils, on the other hand, have a buttery lay-down and tend to smear, but this makes them easy to blend. Faber-Castell and Lyra make some of the best oil-based pencils. The important thing to remember

Australian Waratah, 2003. Colored pencil on Fabriano Artistico hot-press watercolor paper, 10" × 8". Collection of Patrick Dunn.

OPPOSITE (DETAIL) AND ABOVE: This very complex blossom is the national flower of Australia. The center of the flower presented the greatest challenge, requiring patience for rendering its many sections. To create more muted pencil strokes, several thick sections of newspaper were placed under the drawing surface to cushion it.

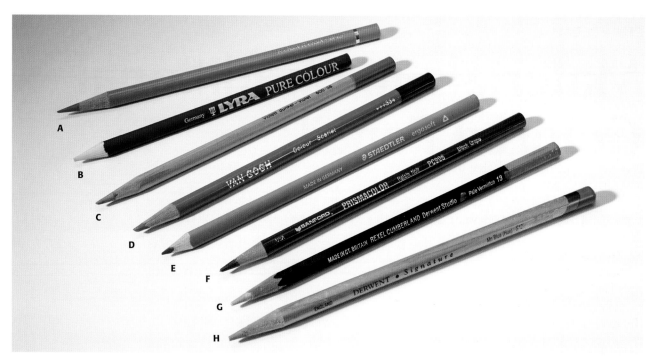

Different brands of traditional colored pencils each have their own characteristics. The following are eight good brands to choose from and are all widely available.

A Faber-Castell Polychromos: oil-based, excellent color saturation, and buttery lay-down.

B Lyra Purecolour: oil-based rod and well-suited to applying large areas of color. Good color saturation and buttery lay-down.

C Lyra Polycolor: oil-based, good color saturation, and buttery lay-down.

D Van Gogh: wax-based, very dry lay-down, and formulated for lightfastness.

E Staedtler Ergosoft: wax-based, triangular lead, and good color saturation with a glossy sheen.

F Sanford Prismacolor: wax-based, excellent color saturation, and buttery lay-down. Used in the art throughout this book.

G Derwent Studio: wax-based, relatively hard leads, well-suited to details, good color saturation, and dry lay-down.

H Derwent Signature: wax-based and formulated for lightfastness.

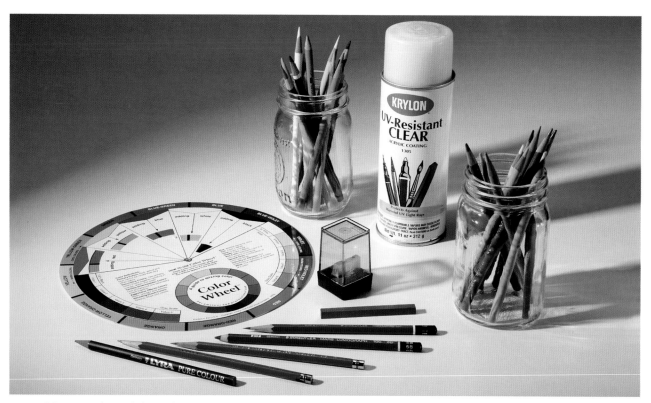

Some of the materials needed for colored pencil art: the color wheel, various pencil supplies (shown from left: Purecolour pencil; Verithin pencil; 9H, 6B, and HB graphite pencils; and Art Stix), pencil sharpener, assorted colored pencils, and workable fixative spray.

for either type of pencil is the higher the amount of pigment in the pencil, the better quality it is and the richer color it will yield.

Colored pencils are also available without a wood casing as chunky, square rods (such as wax-based Sanford Prismacolor Art Stix) or as tapered, circular rods (oil-based Lyra Purecolours). At first glance, the square rods look very much like pastels, but they feel waxy and smooth, not powdery like pastels. Both types of woodless rods are appealing because there is little waste (no wood shavings to discard), and because they can create large sweeps of color, covering broad areas quickly.

Sanford Prismacolor Verithin pencils are very hard and sharp, and they are not well-suited to applying color to large areas. However, they are perfect for wispy, delicate details, such as eyelashes and strands of hair, stamens and pistils on flowers, and fine-tuned edges on other subjects. They are a valuable (and economical) addition to the artist's supply case.

If uncertain about which colored pencils to purchase, begin with a small set of 24 artist-grade pencils. Given the choice of a large set of lesser-quality pencils or a small set of artist-grade pencils, always select the better-quality product. Individual colors can be added from open stock displays or art supply catalogs to gradually widen the range of hues. Don't worry about using different brands on the same work, as they can be combined and blended easily.

Personal taste and subject matter play a large role in which pencils an artist chooses. In addition to considering lay-down qualities and color saturation, the range of colors a brand offers is also important. A portrait artist may choose one brand because of the range of flesh colors offered, while a landscape artist may focus on the range of greens in order to render different types of vegetation. Artists should investigate the lightfastness ratings of pencil brands, too, as colors may change with age and light exposure. Remember to note which brands offer their pencils in open stock, so that it will be easy to buy individual refills of favorite colors.

Two essential tools that should be kept close at hand when using colored pencils are a color wheel and a sharpener. Whether a full-size chart or a pocket-size version, the color wheel is a helpful tool while learning the basics of color theory (which will be described in Chapter 4). Sharpeners are sold as small, handheld versions or larger electric versions. For sharpening many pencils at one time, an electric sharpener is best, but for daily use in the studio, the handheld sharpener is sufficient.

GRAPHITE PENCILS

Graphite pencils—or lead pencils, as they are commonly called—are very helpful in creating a colored pencil work. Graphite drawing instruments have been in existence for 500 years and are valuable for drawing either basic line drawings or fully developed graphite works of art. Available in a wide range, graphite grades vary in hardness and degrees of darkness. Graphite pencils are assigned letters and numbers to indicate their relative hardness and darkness. A 9B is the softest graphite pencil, for example, and is very soft, smudgy, glossy, and black. A graphite pencil in the B range can be combined with traditional colored pencils to dramatically emphasize the darkest shadows.

On the other end of the spectrum, a 9H is the hardest graphite pencil. It does not smear, yields at most a light grey color, and incises the paper with grooves, making it difficult to erase and rework errors. Any pencil in the 6H to 9H range is a necessity for rendering delicately impressed lines, which are used to create bristles, veins, strands of hair and fur, among many other textures.

Somewhere in the middle of the H and B grades is the HB pencil, similar to the commonplace #2 lead pencil. It produces marks that are dark enough to show on the drawing paper, but which are cleanly erased, leaving no incised lines in the paper. It is best utilized for line drawings in colored pencil compositions.

PAPERS AND BOARDS

There are many model surfaces for colored pencil art, from delicate, imported papers to heavy-duty, wood-based boards. The beginner should look for an acid-free paper or board that is sturdy enough to hold up to erasing, has a fine tooth (with little visible texture), yet is not too smooth to accept repeated layers of color.

Regular-finish Bristol board comes in economical sheets or pads. (Confusingly, Bristol board is actually paper, but retains the name from the earliest days of its manufacture when it was affixed to board.) Some manufacturers refer to their regular-finish Bristol board as "vellum finish" or "kid finish." It is a superb surface for novice and seasoned artists alike. Regular-finish

is preferable to the other Bristol board surface, called "plate-finish," which is shiny and slick and may become saturated too quickly with the colored pencil layers. If this happens, adding more layers of color will seem like "drawing on a wax candle," as one artist so aptly described it. The key is to find a paper that is fine enough to take delicate, precise strokes without feathering, but can also accept numerous applications of color.

Hot-press watercolor paper (at least 140-pound weight) is another surface well-suited to colored pencil art. The advantage of this paper is that it not only allows numerous layers of dry colored pencil, but it is also designed for wet watercolor pencil techniques, as its name suggests. Museum board is another good surface for colored pencil art and a personal favorite. Originally it was used as a backing board for framed art, because it did not affect or discolor the art with any acidity. It is 100 percent cotton, fine-tooth, and almost velvety to the touch. It has been readily adopted by colored pencil artists for these traits and for its relative speed in accepting color layers, quickly making them rich and intense. It is perfect for executing meticulous details, too. It comes in different thicknesses, or plies: two-ply is sufficient, but four-ply is ideal for the artist wanting a heftier board. Be aware that it is usually listed among

Close-up of museum board texture

An array of papers and boards: museum board (A), hot-press watercolor paper (B), Bristol board (C), transfer paper (D), and translucent drafting paper (E).

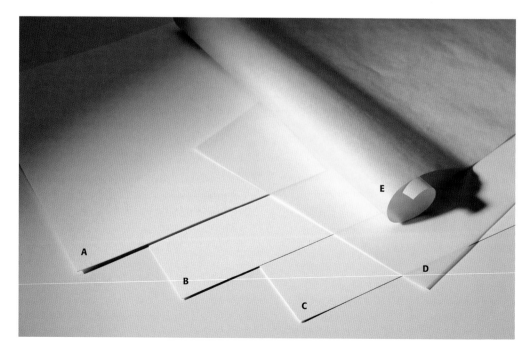

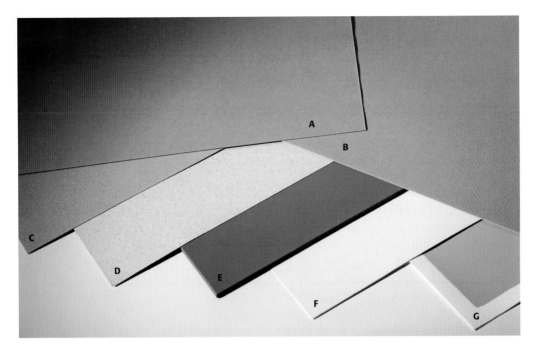

art suppliers as a framing material, not a drawing surface, so it may take some research to find it in a catalog or store. One disadvantage is that it comes as a large 32-by-40-inch sheet; inquire about cutting fees to have it trimmed into a number of smaller pieces. One 32-by-40-inch board yields four 16-by-20-inch pieces or sixteen 8-by-10-inch small boards at a budget-friendly price. It is well worth the research to find and keep patronizing a good source of museum board, whether it is a commercial art supplier or a professional framer. Whatever the final choice, Bristol board, hot-press watercolor paper, and museum board are designed for a wide range of subjects and effects.

There are other papers used for colored pencil art that are not used as the actual final surfaces, but which are helpful accessories. These include transfer paper, heavy tracing paper, and translucent drafting paper. Transfer paper is useful for the artist who would rather compose and revise a preliminary line drawing, then trace over this line drawing through transfer paper onto the final drawing surface. It is available from sewing and art supply stores, comes in several colors (including white), and can be reused several times. Easily erased or drawn over, the transfer lines become inconspicuous.

Heavy tracing paper and translucent drafting paper are used in a similar way for developing a preliminary line drawing that can be erased and reworked. The desired

Close-up of Colourfix pastel paper texture

line drawing is completed on the tracing paper, then it is used as the top layer of a "sandwich" of tracing paper, transfer paper, and art paper (in that order). The line drawing is then traced on the top layer of tracing paper. Drafting paper and heavy tracing paper are also used with line impression technique, described in Chapter 3.

PASTEL PAPERS AND BOARDS

Pastel papers and boards are specifically designed for pastels, but are very good surfaces for colored pencil. They are available in white, but the wide range of colors available are favored by artists, because color builds quickly on the ready-made base color. These papers can be fairly smooth, although not as smooth as Bristol board or hot-press papers. More commonly, pastel surfaces are textured and feel slightly gritty to the touch.

Some popular pastel papers, like Fabriano Tiziano, are relatively fine-tooth, lending themselves to shiny or glossy subjects, such as waxy magnolias or smooth water lilies. These papers allow fine, crisp details, too. One brand of pastel paper, Sennelier La Carte, derives its suedelike texture from dehydrated vegetable flakes. (Be sure not to get this paper wet, as water damages the surface.) Another brand of paper, Canson Mi Teintes, is smooth on one side and very textured on the other. Using this side of the paper lends texture to landscape features (like canyons and rough boulders).

Heavily textured, gritty papers and boards build color quickly, but because they are abrasive, they wear down pencils more easily. When using these surfaces, also keep in mind that the coarser the paper tooth, the less suited it is to crisp-edged details.

Colourfix sanded pastel paper (available in white and other colors) is screen printed and spread onto sheets, but unlike other papers, it is dried onto and bonded to acid-free, 140-pound watercolor paper. It holds up well to wet techniques and erasures, but line impressions are barely visible because of its rough texture. Wallis Sanded Pastel Paper is formulated with aluminum oxide grit, and Windberg papers and board-based panels are made with marble dust. Ampersand's Pastelbord, a clay- and gesso-coated hardboard, is also made with marble dust. As the name implies, it is rigid and is prepared on a hard board.

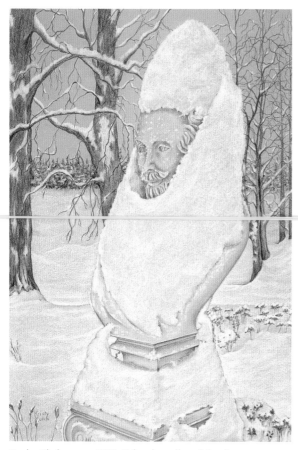

Purdue Shakespeare, 2001. Colored pencil on Colourfix paper, 16" × 20". Collection of Purdue University.

Purdue University's North Central campus in Westville, Indiana, features a garden that is comprised of the plants, flowers, herbs, and bushes mentioned in William Shakespeare's works. In the depths of winter, the white bust of Shakespeare in the garden covered in snow proved to be the best feature to draw. Colourfix paper in rose grey was used, as it seemed most compatible with the mood of the scene. The texture of the paper subtly enhanced the granular effect of the snow.

Snowy Pine, 1989. Colored pencil on Canson Mi Teintes colored paper, 16" × 20". Courtesy of Kristy Kutch.

Using colored paper for this winter scene lent a sense of completeness to the work in spite of the very few elements featured. Verithin pencils in a variety of greens and a touch of metallic gold were used for the long, feathery pine needles, and soft blues completed the shadows on the white snow.

ERASERS AND COLOR-LIFTING SUPPLIES

Colored pencil is a forgiving medium, but it does not lift or erase well with materials such as gum erasers or pink erasers (which may stain the paper). Some of the best materials for erasing and lifting (lightening color by removing a layer) can be found in office supply or discount stores.

A grey, kneaded eraser is excellent for removing graphite lines and smudges. It is also helpful in subtly lifting an area of color by dragging it through colored pencil layers. Once a section on the eraser is soiled, pull and knead it around to a clean spot.

White plastic or vinyl erasers, commonly found among school supplies, have long been favored by drafting students, because they erase without damaging the paper or other drawing surfaces. They may be found as eraser blocks; cartridge-type; refillable, penlike tools; large, rechargeable appliances; or as handheld, battery-operated devices.

Handheld, battery-operated erasers are a boon to colored pencil artists. Quick and inexpensive, these erasers are available in office supply and arts-and-crafts stores. To the beginner, the concept of battery-operated erasers may sound strange indeed, but they are ideal for cleaning up smudges, undoing errant strokes, and erasing small or large areas. (Keep a small sheet of sandpaper or an emery board handy for cleaning pigment smudges off the white eraser tip.) Look for these erasers among the drafting supplies, and be sure to stock fresh batteries and refill erasers.

Reusable putty adhesive (the type used to hold up posters without damaging walls) is sold under a variety of brand names and can be found in hardware and variety stores, usually with the glues and school supplies. Formulated to be gentle to walls, this material is excellent for lifting and texturizing without damaging the drawing surface. It is inexpensive and when soiled can be kneaded and pulled around to a clean area. Be sure to store this adhesive in its own foil packet or plastic bag, as it readily picks up tiny stray bits of pigment and wood shavings.

In addition to erasers and adhesives, low-tack frisket film is a product often used by airbrush artists for masking out areas to be protected from the airbrush paint mist; it is available in sheets or rolls. It is an excellent product for precisely lifting color or texturizing larger areas. It is also gentle on papers and boards and leaves no residue (when removed promptly).

Various types of tape are also useful for lifting and texturizing colored pencil. Scotch Removable Tape is sold at office supply stores by the roll in the familiar plastic dispenser. Use low-tack versions of it to prevent lifting too much color. Drafting tape or inexpensive, low-adhesive masking tape is also good to keep on hand.

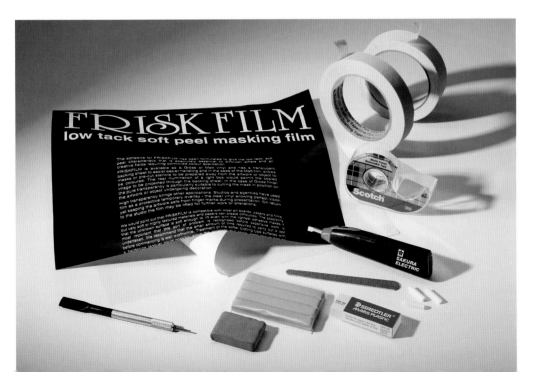

Materials needed for lifting and erasing: ball burnisher; frisket film; grey, kneaded eraser; reusable putty adhesive; white vinyl eraser; emery board (for cleaning pigment from white erasers); battery-operated eraser with white vinyl refills; Scotch Removable Tape; drafting tape; and masking tape.

MATERIALS FOR BLENDING AND BURNISHING

Blending techniques are very important for portraying certain types of smooth surfaces in colored pencil. Most of the materials for blending colored pencil are affordable and easy to find. In fact, many of them may already be on hand at home among the cosmetics or school supplies.

Manual blending involves gently buffing the colored pencil layer for a more uniform texture. Any clean, soft cloth is helpful for this, as are cotton balls and cotton swabs.

Some cotton swabs are available with tiny, spear-shaped tips, and these are terrific for blending small areas.

Grey, cardboard blending stomps are very effective and popular with artists working in other media, such as pastel, graphite, and charcoal. Sponge cosmetic accessories—such as wedge-shaped makeup applicators—work well for large areas, while eye shadow applicators are ideal for blending smaller areas.

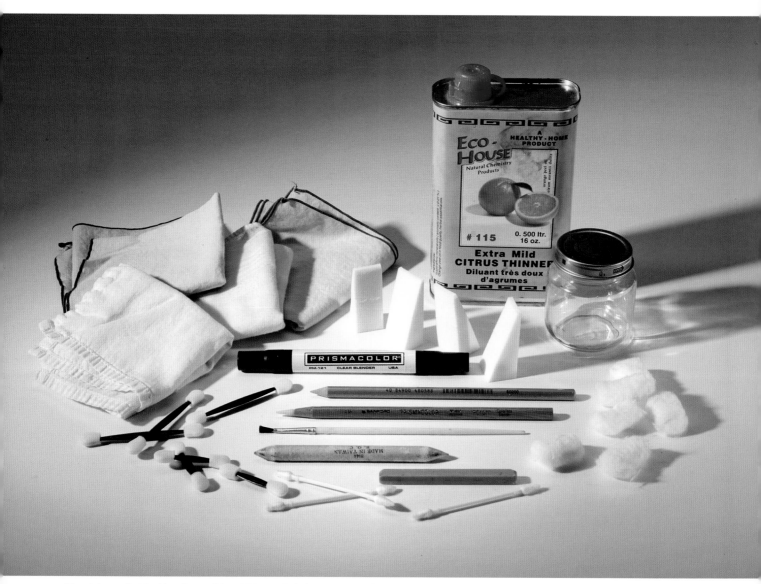

Materials needed for blending and burnishing: soft cloths, sponge makeup wedges, Eco-House Extra Mild Citrus Thinner #115, jar for solvent, cotton balls, cotton swabs, eye shadow applicators, Sanford Prismacolor Colorless Blender Marker, unpigmented blending pencils, brush for applying solvent, cardboard blending stomp, and Prismacolor Art Stix Clear Blender.

Various types of solvent help to blend colored pencil by breaking down the binders that suspend the pigment. Eco-House Extra Mild Citrus Thinner #115 is citrus-based and nontoxic. To use it, pour it into a smaller container, and then apply it with an inexpensive brush. It instantly dissolves the binder, making the color very smooth and almost washed in appearance.

Sanford Prismacolor Colorless Blender Marker works similarly to brushed-on solvent, but offers the added convenience and control of a marker. It is an alcohol-based solvent that comes with two applicator tips, allowing the artist to either blend large expanses of color or very small details.

Unpigmented blending pencils and rods are very recent inventions, but have already become necessities for artists who want to burnish (a method used to create highly blended, very saturated color) areas on a composition. A new addition to the blending pencil family is Prismacolor Art Stix Clear Blender, which is a square rod that can be applied to large areas of color.

SPRAY FIXATIVE

Spray fixative is used for either sealing and protecting a finished work of art, or to add tackiness to a surface that seems unable to accept more color layers so that additional layers of colored pencil can be applied.

Colored pencil generally does not smudge (although some brands of pencils do tend to smudge more easily than others). As a precaution, however, it is a good idea to apply a few light coats of fixative spray to the finished colored pencil work. This seals it and helps to preserve the art. One fixative product even protects a work from harmful UV rays.

Before applying the fixative to the actual art, read all labels and precautions on the can. Proper ventilation is important; spray outdoors, if possible, and avoid inhalation of fixative fumes. If uncertain about how the fixative spray will affect the colors on the work, make a line of colored pencil swatches. Cover the upper half of the band of color swatches with a piece of paper, spray the exposed part, and let it dry. Once it has dried, remove the protective paper and compare to see whether the fixative altered any of the colors.

Do not place the art upright on an easel, since the fixative may dribble and dry with visible drips. Instead, place it flat on sheets of newspaper, and hold the can about two or three feet above the work, spraying in a back-and-forth misting action. Allow this layer to dry for about 20 minutes, and then repeat with another application, again, allowing ample time for drying.

Workable fixative dries as a matte finish, as opposed to the glossy sheen of other fixatives. If the tooth of the art paper is so slick and saturated with color that further layering seems impossible, spray on the workable fixative, and let it dry. The tackiness acts as an extension of the tooth, allowing two or possibly three more layers of color to be applied. This added layer of dried fixative changes the nature of the drawing surface, making it a little more coarsely textured. Spray again when completely finished, and let it dry before having the piece photographed, matted (insist on acid-free materials), or framed.

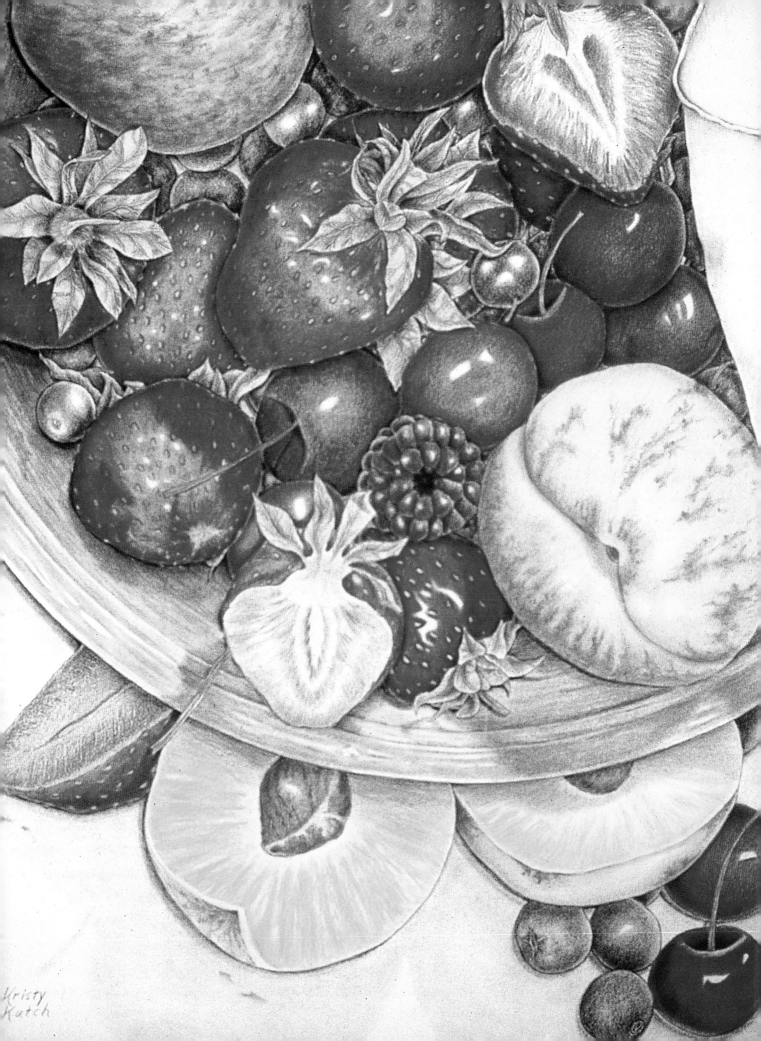

Kristy
Kutch

Techniques for Applying and Lifting Color

How does an artist plan a composition in colored pencil? And once it is planned, what techniques for applying and lifting color will best serve the subject matter? This chapter discusses in detail the various techniques used to create a finished work of art in traditional colored pencil.

Beginning a work can be an intimidating process. In order to feel more comfortable with rendering elements in a composition, most artists make preliminary thumbnail sketches. From there, the artist makes a line drawing, which serves as a rough guideline as to where the elements are on the drawing surface. At this point, the colored pencil process begins.

The techniques for applying color discussed here capitalize on the uniqueness of the medium: it offers the artist the control of a drawing implement and yields color as rich and vivid as paint. Many different effects can be achieved by employing the methods described. By blending and burnishing, the artist can greatly enhance the vibrancy of most colored pencil works. And by learning simple lifting techniques, a variety of textures, such as the unevenness of flecked or mottled surfaces, can be realistically executed. (The techniques for applying and lifting color here are applicable to water-color pencil, though they may not be as successful.)

Berried Pleasure, 2003. Colored pencil on Rising museum board, 16" × 20". Courtesy of Kristy Kutch.

OPPOSITE: June at the local farmers' market is full of inspiration, with lots of beautiful, luscious fruit with many textures and vibrant colors. Using museum board, it was possible to apply several layers of color, building the intensity and saturation with each successive layer. As a result, the many hues of red and peach appear rich and lustrous.

PLANNING A COMPOSITION

Before beginning a work in colored pencil—or any medium for that matter—many artists find it helpful to get a sense of the work with preliminary thumbnail sketches. These are quick, loose drawings done with a graphite pencil. These drawings feature the objects of the composition in different arrangements or shown from different views; various lighting options are explored as well. They also help the artist evaluate the overall color palette for the work and the values (the relative lightness and darkness) of the colors used.

Once these sketches are done, it is time to make the line drawing. Using an HB or #2 pencil, lightly sketch the outline of the objects, making the pencil lines dark enough to be seen yet light enough to be easily erased. Check often for accuracy, and for these first attempts, keep it simple. Note the relative sizes and shapes of the objects and where the lines of the objects' borders intersect. Keep an eraser handy, and if the graphite lines are too heavy, dab at them with a kneaded eraser to lighten them. (With yellow or peach-colored subjects, choose a shade of a related color, such as terra-cotta, for a preliminary line drawing, as graphite lines can be too dark.)

The next step is to consider the range of values in the composition. Try to think of it as a black-and-white photograph. This necessitates a shift in perception; frequently art teachers recommend squinting while looking at the composition to aid this black-and-white visualization. Sometimes it is useful to make black-and-white photocopies of reference photos the artist is working from, if applicable. Another tool that some artists find helpful is a sheet of red cellophane (available at greeting card, gift wrap, and party shops): look through it to distinguish the full range of values.

If using white paper, "map out" the highlighted areas by "saving" them. (Saving allows the white of the paper to remain untouched by color either by working around an area or by applying masking fluid or a wax-resist stick.) When working with a colored paper, map out the bright highlights by sketching and filling them in with a white or cream colored pencil. Highlights may be shaped like a boomerang, crescent-shaped with irregular edges, or crisp and straight. Sketch them exactly as they appear. Using the same color as the subject—for example, a light orange pencil on a salmon-colored flower—outline the highlight.

Next, consider where the darkest values are. Using a slightly darker color than the native color, softly sketch these areas. Indicate where the cast shadows fall using a light touch of a hue of violet, red, or blue. Once the very lightest zones have been saved and the darkest areas sketched, it becomes much easier to visualize the midrange values. At this point, choosing colors and application techniques becomes much easier.

Make preliminary sketches for a composition before beginning to draw on the final surface in order to determine the best arrangement or view of the objects to be featured. Once this decision has been made, a line drawing is created on which the darkest and lightest areas are indicated. The artist is then ready to apply the midrange values and complete the work.

LAYERING

Beautifully saturated and rich colors are easily achieved by layering colored pencil. The colors build with a gradual intensity, allowing less of the texture of the paper to show as the layers are applied. To better understand the effects one can create by layering, experiment with a few swatches of color.

Apply several swatches of color over one another with light pressure. Notice that a subtle layer of yellow over an equally light layer of red yields orange. Layer red over blue, and purple emerges. Be sure to keep the pressure light, as it is important to first acquire a feeling for delicate layering, and sometimes this is all that is required for the desired effects. Allow the tooth of the paper to show while learning this range.

Once this has been mastered, try it again, but apply the colors with more pressure. The colors will become bolder and more saturated. To see the effects of using the same color layered in two or three applications, repeat the process using a single color.

To see the difference between using the side of the pencil and the pencil point, apply a layer of color using both, graduating from light pressure to heavy pressure. Note how deep the colors become with heavy pressure or repeated layering.

DIFFERENT STROKES

Artists use a variety of strokes depending on their personal style and subject matter. Some artists use oval or circular strokes. These types of strokes can lightly cover an area without leaving obvious "tracks" and will create an illusion of smooth surfaces. Others favor delicate vertical strokes, with very fine, directional lines that blend with great subtlety. Cross-hatching is especially good for drawing fabric or woven textures.

Directional strokes follow the contour of an object. To employ them, simply let the curves and shapes of the object dictate the direction of the strokes. This type of stroke lends a feeling of flexibility or even movement to an object.

Three layered swatches of colored pencil: yellow over red yields orange (A), red over blue yields violet (B), and blue over yellow yields green (C).

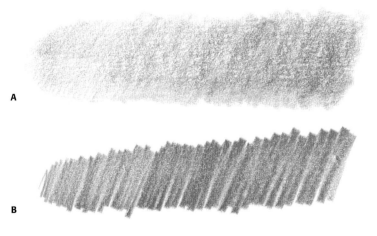

Using the side of the colored pencil allows coverage of a broad area with a relatively soft effect (A), while using the sharp point yields color that is crisper, less granular, and more well-defined (B).

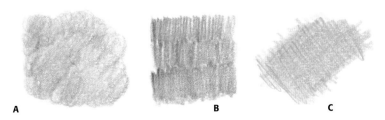

Types of strokes: circular or oval (A), vertical (B), and crosshatched (C).

BLENDING

Colored pencil paintings often look so realistic they resemble photographs. Blending tools and techniques are the secret ingredients to these impressive effects.

MANUAL BLENDING

Soft cloths (such as handkerchiefs), pressed-cardboard blending stomps, cotton swabs, eye shadow applicators, and makeup wedges are all useful for manually blending color pencil. A soft cloth is suitable for lightly blending (but not rubbing) the colored pencil layers, and it can be easily laundered. Simply lightly buff the surface that has at least several layers of colored pencil. This creates a nice sheen, which is particularly evident when the paper is held to the light.

Blending stomps, which are shaped like tapered rods, are very inexpensive and are popular with pastel artists. They can also be used for light blending and are well-suited to oil-based pencils. If the stomp becomes soiled with pigment, rub it against sandpaper. Cotton swabs and sponge makeup

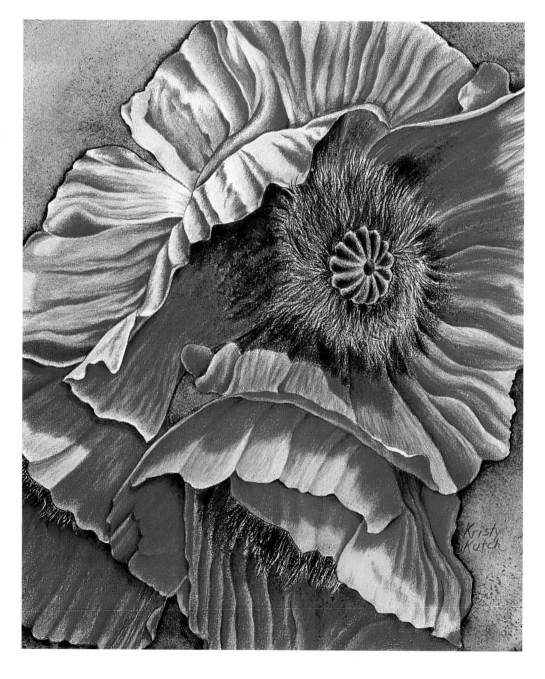

Poppy Trio, 2004. Colored pencil and watercolor pencil on hot-press watercolor board, 9" × 12". Courtesy of Kristy Kutch.

The bold, vibrant color of the three poppies in this drawing was created by using solvent on an initial layer of crimson red, scarlet lake, and poppy red pencil. Once the solvent dried, more layers of Tuscan red, crimson red, scarlet lake, poppy red, lemon yellow, and cream were applied, enhancing the color intensity.

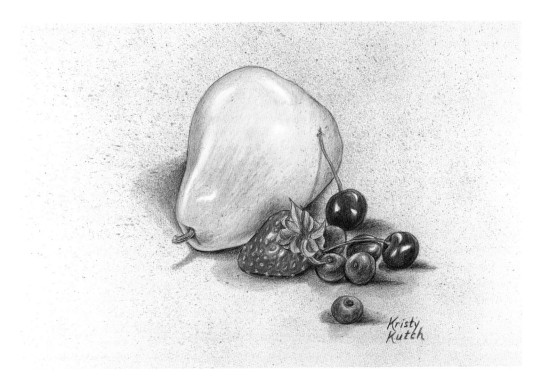

Rochester Fruit, 2001. Colored pencil and water-color pencil on Borden and Riley regular-finish Bristol board, 14" × 11". Courtesy of Kristy Kutch.

The pear and strawberry in this sunlit arrangement have shiny, reflective surfaces. To create this effect, a Colorless Blender Marker was stroked on the first layer of color. After this dried, more layers of color were applied using limepeel, olive green, and cream on the pear and crimson red, scarlet lake, and poppy red on the strawberry. The cherries were drawn using black cherry, Tuscan red, crimson red, and a touch of canary yellow, and the blueberries were drawn using indigo blue, Tuscan red, and black grape.

products blend colored pencil by being applied in small circular strokes. (Such products are inexpensive enough that they can be thrown away when they become soiled or too saturated with color.) When used on their sides, makeup wedges are ideal for blending large areas, such as skies.

BLENDING WITH SOLVENT AND COLORLESS BLENDING MARKERS

Brushed-on solvents can be used effectively to dissolve the colored pencil binder and make the color look very smooth. To use solvent, first pour a little into a smaller container with a lid, such as a clean baby food jar. Use an inexpensive brush to dip into the solvent, dab off any excess, and brush it onto the colored pencil layers. Be sure to use solvent on an area that has at least two or three applications of color. Allow the solvent to dry. This dissolved pigment layer can stand alone or can be followed with more colored pencil for a richer, saturated effect.

Colorless Blender Markers work in a similar manner to dissolve the binder and create a smooth effect, because the toothy flecks of the paper are filled in with liquefied color. Colorless Blender Markers have a fine tip on one end of the marker and a chiseled, wedge-shaped tip on the other. The fine tip blends details with great precision, and the

broad tip covers and blends larger areas with a few easy strokes. To use a Colorless Blender Marker, prepare one or more layers of colored pencil. Choose the size of tip to be used and simply stroke the marker over the penciled layer. Replace the cap when finished to avoid drying out.

When greater color intensity is desired, allow the area where the solvent was applied to dry for a few seconds. Repeat by layering one or more applications of color. Avoid too many reapplications of the liquid marker in the same area, as the successive layers of color can become muddy.

Remember to test the marker on swatches of color before using it on a finished work. Purples, such as dark purple, can become very bright when blended with this type of marker.

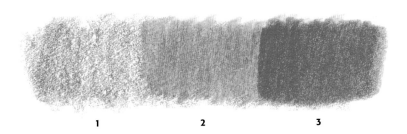

1 **2** **3**

To build intense color by using a Colorless Blender Marker, apply a layer of colored pencil, which will look granular (1). Stroke the color with a Colorless Blender Marker so the color dissolves (2). Apply another layer over the layer of dissolved pigment, and the result will be very smooth, saturated color (3).

Burnishing is an easy method for creating very intense color. It entails applying a blending pencil, Art Stix Clear Blender, or a light-colored pencil with medium pressure over an initial layer of color. After the blending product has been applied, another layer of the initial color is applied. The resulting color is very rich and dense.

Burnishing is ideal for rendering extremely shiny surfaces, such as apples, cherries, glossy ceramics, enamel, and various kinds of metal, including silver, copper, brass, or gold. Before beginning this kind of subject, note the lightest highlights on the object to be rendered, and save them by working around them. Then proceed with the burnishing process as described above on the rest of the object.

BURNISHING WITH A LIGHT COLOR

White, cream, ivory, and even yellow pencils are perfect for burnishing. Why does using these pigments work so well for? It's due to their ability to reflect light.

When burnishing a light or medium blue area, choose a white pencil, since the faint yellow in cream or ivory will add a greenish tinge. When a golden effect is desired, burnish with a yellow pencil. Oil-based pencils in ivory or cream impart a lovely sheen, which is almost pearlescent. Even a soft, wax-based pencil in a very light blue can be used as a burnishing color.

Be aware that aggressive, heavy burnishing can compress the tooth of the paper so much so that it may become too slick to accept many subsequent layers. Heavy-pressure burnishing and blending can also cause a milky haze on the surface of the drawing known as wax bloom. If this occurs, simply buff the bloom area lightly with a soft cloth. If the bloom rises again, repeat the process. Spraying the finished art with a light layer of fixative seals the work and prevents any further wax-bloom problems.

Burnishing color with white or cream can yield subtly different results. The two swatches here demonstrate this difference using the same color of green. A layer of color is applied to the paper (1), white and cream are then applied over it (2), and another layer of green is applied on top of that layer (3). The green in the swatch using white is deeper and truer to the original color, and the swatch using cream has a yellow tinge to it.

Using unpigmented blending pencils is perfect for achieving dense colors quickly. To do this, apply a layer of color to the paper—Copenhagen blue was used here (1). Follow with a layer of unpigmented blending pencil, using medium-to-heavy pressure (2), and then add two more layers of color (3 and 4) to achieve the desired results.

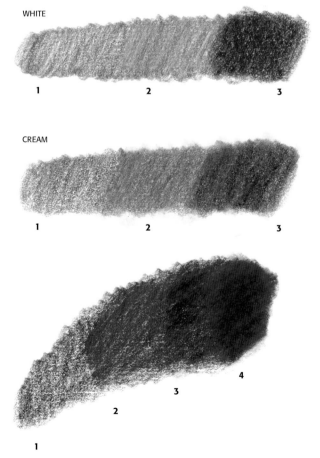

WHITE
1 2 3

CREAM
1 2 3

Combining Methods for Brilliant Color

Sometimes a work of art features different textures and requires several techniques and materials to render them realistically. This composition—with a smooth-skinned, red pear; very shiny, red cranberries; and matte autumn leaves—is a good example. Brushed-on solvent, Colorless Blender Marker, and an unpigmented blending pencil are used to achieve these varied surfaces.

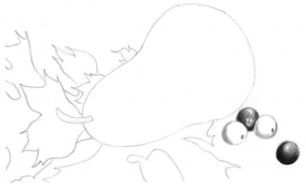

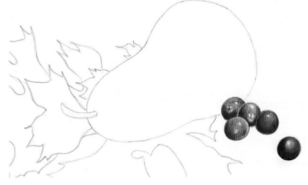

STEP 1 Prepare a line drawing of an arrangement of cranberries, leaves, and a pear using light pressure with either a light-colored Verithin or an HB pencil. Determine where the highlights fall on the cranberries, since color will be avoided there. Use a dark green pencil to indicate the shadowy underside of each cranberry. Next, add layers of crimson red, scarlet lake, and a little lemon yellow. Dip a small brush into a container of liquid solvent. Brush it across each cranberry.

STEP 2 Complete the other cranberries in the same manner, skipping around to nonadjacent cranberries so the color from one does not bleed into another.

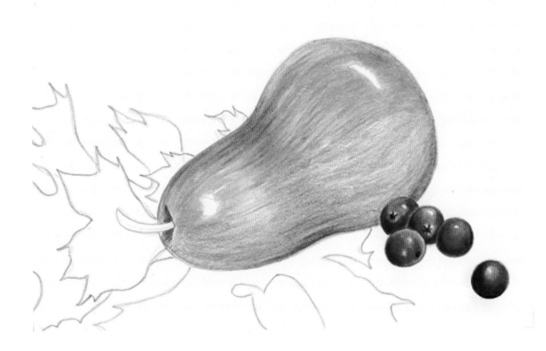

STEP 3 Once the solvent is dry, use more of the same colors on the berries to further intensify the color. Sketch the highlights on the red pear with yellow pencil. Working around the highlights, apply layers of crimson red, scarlet lake, lemon yellow, and a little dark green (on the underside of the pear), following the curves of the fruit with each stroke.

STEP 4 Apply a Colorless Blender Marker to the entire surface of the pear, and then repeat the colors for added brilliance. If there are still undesired white flecks of paper showing through this layer, use the fine tip of the Colorless Blender Marker to touch the marker solvent to these flecks. For more color saturation, repeat the colors again, apply a blending pencil, and repeat the colors yet again. This process can be repeated as many times as desired, depending on the nature of the paper. Keep in mind that applying color with heavy pressure will compress the paper tooth more quickly, limiting future layers.

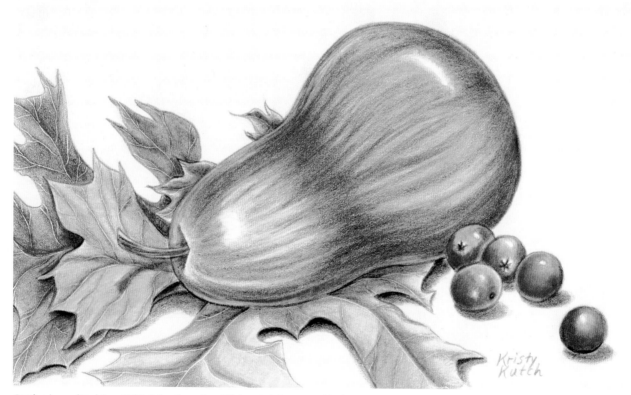

Cranberries and Red Pear, 2004. Colored pencil on Fabriano Artistico Extra White hot-press watercolor paper, 9¹/₂" × 7". Courtesy of Kristy Kutch.

STEP 5 Apply vivid autumn colors, such as canary yellow, spring green, poppy red, crimson red, and Tuscan red to the leaves. Blend with a Colorless Blender Marker, and apply the color again. Add shadows with black grape and some touches of yellow (to indicate the reflected colors). If desired, use a Tuscan red or indigo blue Verithin pencil to refine the edges.

LIFTING COLOR

There are many reasons why an artist may need to erase or lift color: the hand slips and creates an unwanted line; an area of color is too heavy or saturated; a missing highlight needs to be restored; or an area that looks flat and one-dimensional needs a more mottled texture. Various types of erasers are used to accomplish this. Grey, kneaded erasers are helpful for cleaning smudges, and white vinyl or plastic erasers are good because they are a bit more precise due to their shape. White battery-operated erasers erase right through colored pencil layers. Do not expect them to return the paper to the original white surface (although in some cases they might). They will, however, lift

layers without damaging the surface. After using these erasers, be sure to blow away the eraser crumbs because they contain pigment.

Low-tack frisket film, low-tack, Scotch Removable Tape, and masking or drafting tape can all be used to lift color in a similar way. Gently apply—be sure not to rub—the sticky side of the film or tape on the area to be lifted. Take a fine, blunt object, like the point of a dull pencil or a ball burnisher, and rub it over the film or tape. Gently peel back, and the color will be removed with no damage to the paper.

Reusable putty adhesive is also a useful tool. Simply press it onto the area to be lifted and peel back to remove flecks of color.

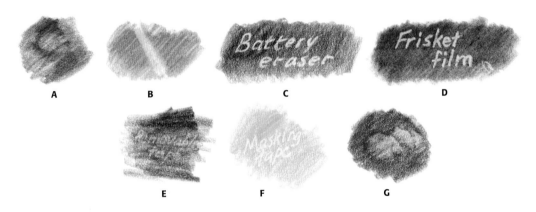

Examples of lifted color using various methods: grey, kneaded eraser (A); white vinyl or plastic eraser (B); battery-operated eraser (C); frisket film (D); Scotch Removable Tape (E); masking tape (F); and reusable putty adhesive (G).

FINISHING TOUCHES

Once a composition has been finished, it may still need some adjustment to sharpen the focus of various elements. To do this, use an indigo blue, Tuscan red, or violet Verithin, which will work well with any color scheme. The key is to sharpen the Verithin pencil until it has a very sharp point. (Do not hesitate to resharpen frequently, as needed.) Along the outer edge of the object to be defined, lightly stroke in a series of fine lines, dashes, or dots. The objective is to create subtle-but-crisp contrast, without making it look like the object was obviously outlined. This edging is also a useful technique when defining something with a light value against a white background, such as a white blossom or light-colored fruit.

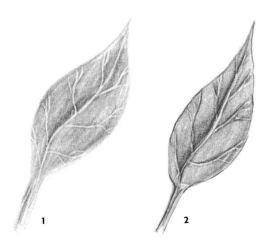

Use Verithin pencils to refine details on any object. Shown here is a green leaf before (1) and after (2) using a Verithin pencil along the edges and on the veins.

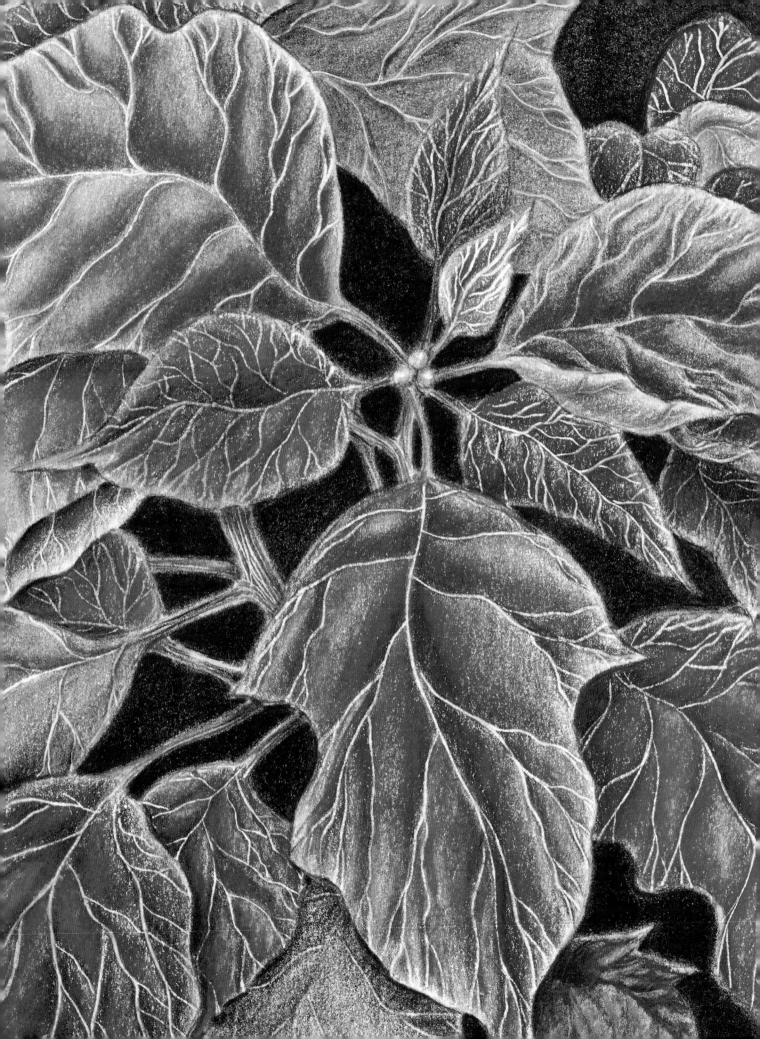

CHAPTER 3

Creating Textures

The medium of colored pencil excels at creating a wide range of interesting textures. Two important techniques for textured surfaces are frottage and line impression. Frottage is best for rough and rugged textures from nature or even textured backgrounds. These effects are executed by placing a coarsely textured surface underneath the art paper and sweeping the side of the pencil on the paper. It is based on the same principle as children's leaf rubbings.

Line impression technique allows the artist to achieve crisp, fine-lined tracery as well as textures that are fuzzy, furry, or wispy. If a feature in a work requires a light line against a darker background, this technique should be used. Works featuring elements drawn using line impression are often beautifully detailed, lending a certain charm to a composition.

To draw outdoor subjects that are somewhat uneven, such as soil, ravines, and fields, or downy and fuzzy objects, such as peaches, lifting color with low-tack adhesive products is very helpful, as is paper with a visible tooth.

FROTTAGE TECHNIQUE

To use this technique, the artist must choose an appropriate textured surface that will be placed underneath the art paper. Depending on the effect desired, this could be a paper doily, fabric with a visible weave, coarsely grained flat wood, flat leaves, pressed flowers, or even very coarse sandpaper. The art paper should be thin enough for the texture to show through when the pencil is applied. Keeping the art paper firmly in place, use the side of the colored pencil with broad, sweeping strokes.

OPPOSITE (DETAIL) AND RIGHT: Using line impression technique is essential to create the many veins in the poinsettia leaves. In this work, some of the leaves have fine, white veins, and others have impressed lines in other colors (achieved by impressing lines over a base color).

Holiday Poinsettias, 2005. Colored pencil on hot-press watercolor board, 12" × 9". Courtesy of Kristy Kutch.

Spruce Trees with Frottage Technique

The challenge in rendering evergreen trees, such as the spruce trees here, is creating the densely massed boughs and thousands of tree needles. Using frottage will help in this effort considerably.

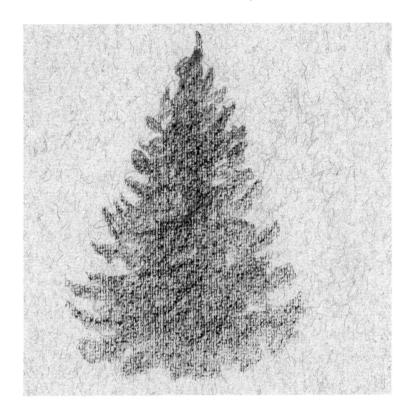

STEP 1 Prepare a line drawing of two spruce trees using a periwinkle pencil on a lightweight paper. (Fabriano Tiziano pastel paper was used here.) Underneath the art paper, place a sheet of very coarse sandpaper. Keeping the sandpaper in place, use the side of a spring green pencil (left tree), and stroke the paper following the outlines of the line drawing. Try to leave some gaps between the boughs, and do not make the tree too perfectly triangular. (The sandpaper should remain in place until finished with the complete drawing.)

STEP 2 Add layers of dark green to add dimension, and in the very darkest areas, add touches of Tuscan red.

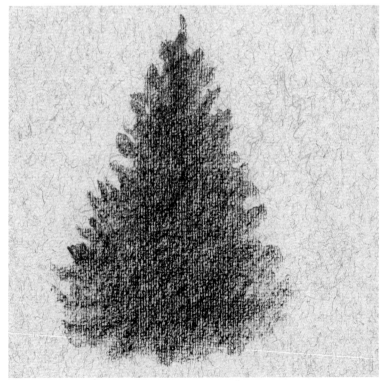

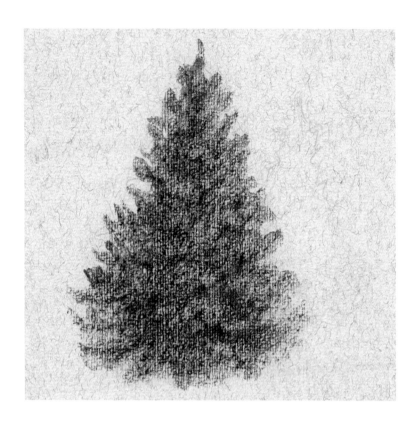

STEP 3 Take a small wad of reusable putty adhesive and press it on the color layers to lift some color in order to indicate the more sunlit areas. Accent the darkest areas again with touches of Tuscan red or black cherry.

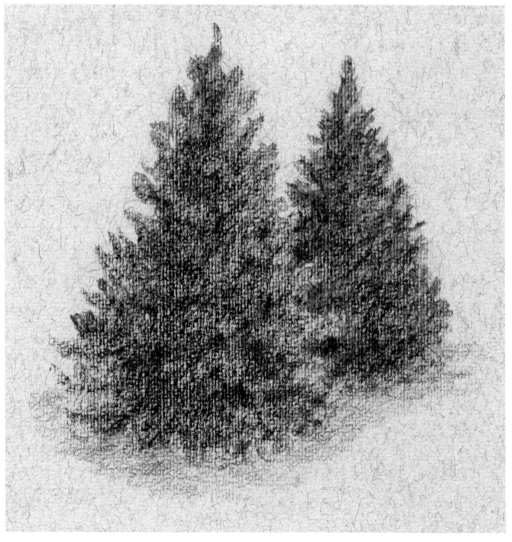

STEP 4 Repeat the steps with the spruce tree on the right. Add touches of periwinkle or blue violet lake to both trees. Indicate the ground immediately underneath the trees with strokes of yellow ochre and Tuscan red.

LINE IMPRESSION TECHNIQUE

Works that feature elements rendered with line impression technique, also called line incising, are eye-catching because of their delicate intricacy. For this technique, lines can be applied with long, curved strokes (for highlighted or frosted strands of hair) or short and choppy ones (for the downy fuzz on kiwis or the stems of some flowers). It is ideal for creating furry, bristly, ribbed, lacey, or striated textures. And it is essential for veins in leaves, whiskers in portraits, and so many other examples of light-against-dark tracery.

While it may seem painstaking, the technique is relatively easy. All that is needed is a fine-tooth paper soft enough to receive the impression, tracing paper, a very sharp graphite pencil (in the 6H to 9H range), and colored pencils.

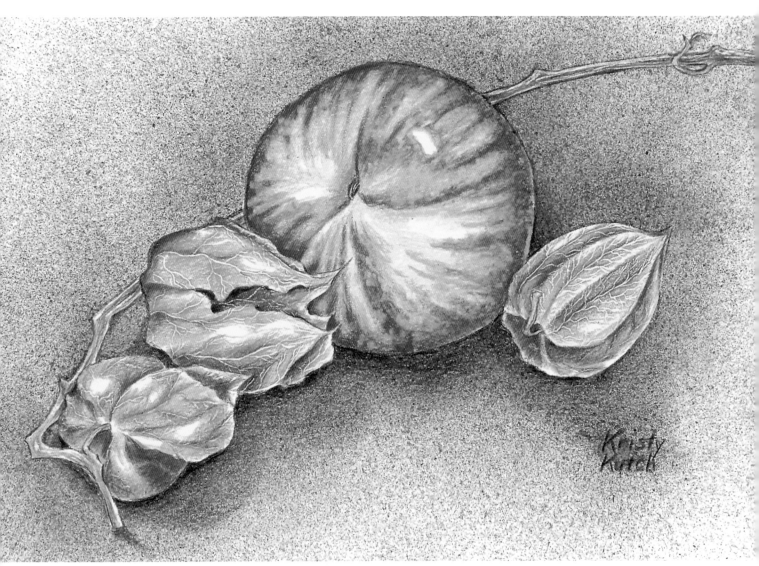

Chinese Lanterns, 2002. Colored pencil and watercolor pencil on Borden and Riley regular-finish Bristol board, 14" × 11". Courtesy of Kristy Kutch.

A combination of warm autumn colors was used on the papery Chinese lantern flowers in this work. Line impression technique was used to draw the veins and ridges on the thin outer layer of the flowers, enhancing their very delicate nature.

Leaf with Line Impression Technique

Learning this technique can take some practice, so for first attempts, use a piece of scrap paper.

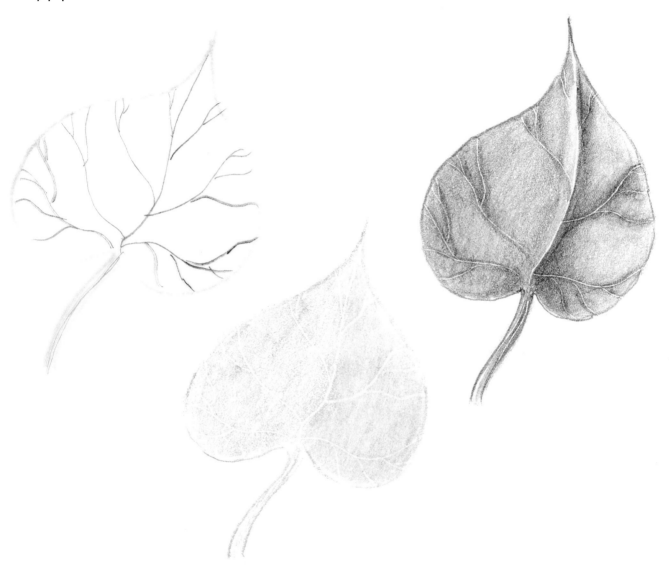

STEP 1 Prepare a line drawing of a leaf using an HB pencil on regular-finish Bristol board. Lay a piece of heavy tracing paper or translucent drafting paper over the drawing. Holding the paper overlay firmly in place, take a very sharp graphite pencil and with heavy pressure draw the veins of the leaf on the tracing paper.

STEP 2 Remove the paper overlay, and set it aside. With the side of a limepeel pencil, apply color to the whole leaf; the veins that were impressed in Step 1 are now visible. Stroke a Colorless Blender Marker over the drawing, so the veins appear slightly muted.

STEP 3 Add another layer of color in a deep green, such as dark green, and the veins become even more dramatic and defined. Alongside the edges of the veins, skim a Tuscan red pencil.

USES FOR LINE IMPRESSION

- Some artists use line impression to sign their works, which allows the white signature to be read easily against the dark background.
- Corduroy or fluted fabric and lacey or ribbed surfaces are convincingly rendered using this technique.
- Very fine, crisp highlights can be created with impressed lines, which are perfect for detailing a glistening orange section or the shiny skin of a strawberry, for example.
- Textures found in nature, such as pine needles, wood grain, intricate vegetation and brush, the woven texture of straw and wicker, spider webs, and burrs, are easily executed with line impression.

- This technique should be used for complicated flower centers, such as those found in sunflowers and poppies. Use a layer of dark sepia brown and burnt carmine over the impressed lines, and the centers instantly take on definition.
- Feathers look finely detailed when drawn with impressed lines.

TIPS FOR ACHIEVING THE BEST RESULTS WITH LINE IMPRESSION TECHNIQUE

While impressed lines add visual interest to a composition, sometimes a pure white line peeking through the color looks too stark.

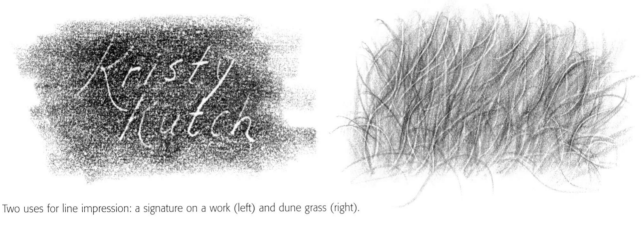

Two uses for line impression: a signature on a work (left) and dune grass (right).

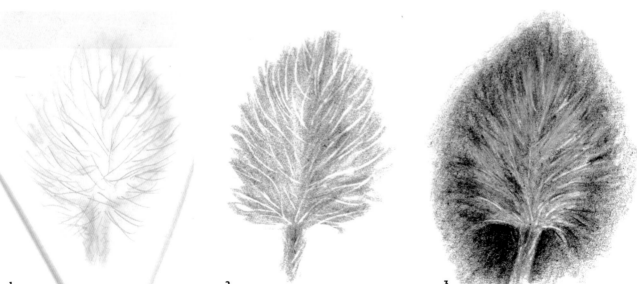

The most effective way to render the unique surface of burrs is to use line impression. To begin, lightly sketch the outline of a burr with light umber pencil. Place heavy tracing paper on the drawing, and with a 9H graphite pencil (or similar hard pencil) and heavy pressure, incise the bristles of the burr (1). Remove the tracing paper and skim over the burr with a layer of light umber, adding Tuscan red in the depths of the burr and just underneath it (on the stem) to give it dimension (2). As the final step, add canary yellow and black cherry to lend fullness to the burr, followed by a dramatic background layer of black cherry and black grape (3).

To avoid this, make a line drawing of the object, and then apply a light layer of color to it. This will be the base color. For a more neutral base color, the artist may choose a shade of light blue, such as periwinkle or blue violet lake. For a darker, more dramatic base layer, a light layer of Tuscan red will work well. For a warmer effect, choose yellow or yellow ochre. After the base layer is applied, place the tracing paper over it, impressing the lines with heavy pressure. Remove the paper, add a layer of the native color of the object, and the lines in the base color will peek through.

Occasionally when creating a line impression, the tracing paper and pencil may slip, leaving impressed lines in an unwanted place on the drawing. To remedy this, simply take a pencil in the desired "repair" color, and sharpen it to a very fine point. Place it near a warm light bulb for about five seconds, and immediately apply it to the error, filling in the incised line. The warmth of the light bulb softens the wax content of the pencil, allowing it to melt into the fine line. Another method is to use the fine tip of the Colorless Blender Marker to drag the pigment from the adjacent area. This "coaxes" the desired color into the accidentally gouged line and camouflages it. Follow this repair process with a burnishing layer of unpigmented blending pencil and more color, and the error will be well concealed.

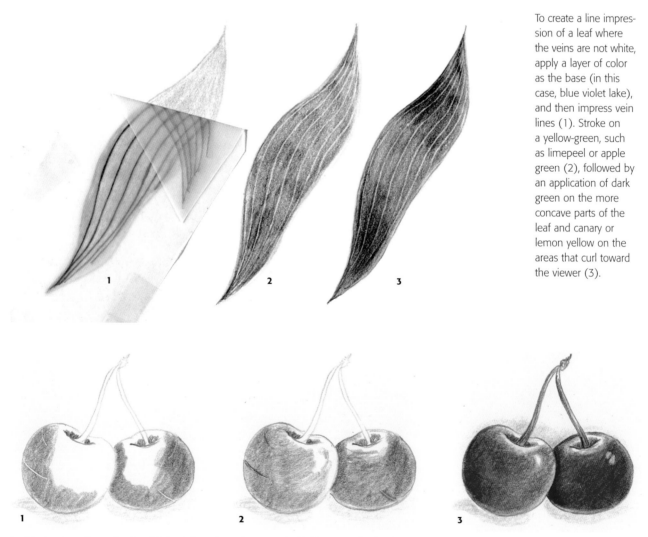

To create a line impression of a leaf where the veins are not white, apply a layer of color as the base (in this case, blue violet lake), and then impress vein lines (1). Stroke on a yellow-green, such as limepeel or apple green (2), followed by an application of dark green on the more concave parts of the leaf and canary or lemon yellow on the areas that curl toward the viewer (3).

In this drawing of two cherries (1), both have been impressed with lines mistakenly. This can be fixed by either sharpening the red pencil to a fine point, softening it by placing it against a warm light bulb, and applying it to the impressed line (left cherry in 2), or by using the fine point of a Colorless Blender Marker to drag the red pigment into the line (right cherry in 2). Additional layers of color can be added to further cover the line (3).

CREATING UNEVEN OR DOWNY SURFACES

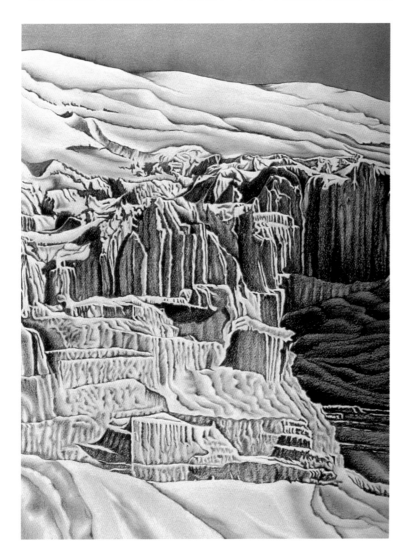

To render these effects and others like them, a toothy paper is very helpful, as are materials for lifting color, like reusable putty adhesive and masking tape.

The texture of the paper showing through the layers of color can be a great asset for suggesting soft, slightly fuzzy, or nonshiny surfaces. These can range from the skin of a peach to the fine-grained texture of sand or soil. When using this type of paper, keep pressure light while applying color to avoid compressing the tooth.

Lifting color with erasers, tape, or putty adhesive is perfect for creating uneven surfaces. Putty adhesive is best for shallow dimples on an object, such as oranges. Small wads of masking or drafting tape gently lift color to create the many textures found on a forest floor, such as tree needles, twigs, and rocks, and can create muted and soft-focused effects.

Sculpted Dune, 1992. Colored pencil and watercolor pencil on Canson Mi Teintes paper, 16" × 20". Courtesy of Kristy Kutch.

The Indiana Dunes National Lakeshore Park is the jewel of southern Lake Michigan, with fine-grained sand dunes that shift with the wind and force of the waves. This high-contrast scene needed to convey the gritty texture of sand, and certain papers—such as the Canson Mi Teintes paper used here, which has a very visible tooth—enhance that effect nicely.

To render a furrowed field or ravine (or similar outdoor subjects), use low-tack frisket film and a blunt object. First, apply layers of greens, browns, and ochre to the paper, and gently lay down a sheet of frisket film over the area to be lifted, sticky side down. Use the spatulalike end of a ball burnisher or another blunt object, and stroke it to create lines that resemble furrows (1). Peel back the frisket film, revealing the lifted color (2). Add additional layers of color as desired (3).

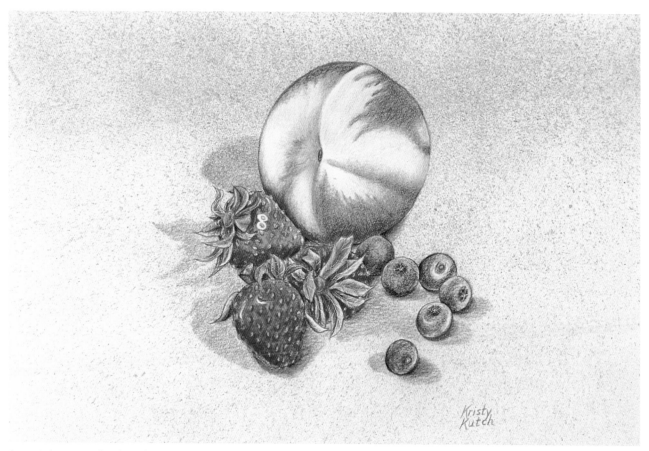

Sunny Fruits, 2002. Colored pencil and watercolor pencil on Borden and Riley regular-finish Bristol board, 14" × 11". Courtesy of Kristy Kutch.

To represent the skin of the peach in this work, several layers of color were applied using the side of the colored pencils. After the color layers were applied, reusable putty adhesive was used to lift some of the color to further enhance its fuzzy texture.

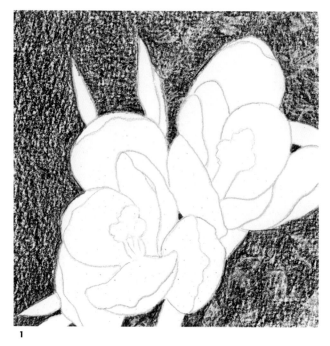

1

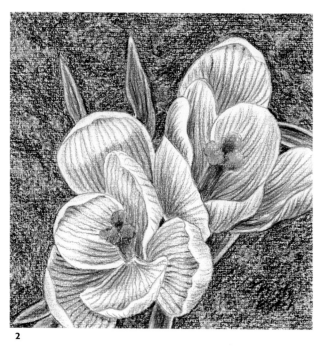

2

Forest floors—like the one here with crocuses coming through the soil—can be drawn realistically with the appropriate paper and lifting tools. Choose a cold-press watercolor paper, and sketch the line drawing. The background should be drawn with broad, heavy strokes of a dark green, such as olive, plus a burgundy (such as Tuscan red). Crumple masking or drafting tape into a loose wad and dab randomly at the background (1). Follow this with layers of yellow ochre and limepeel; draw the flowers in the foreground (2).

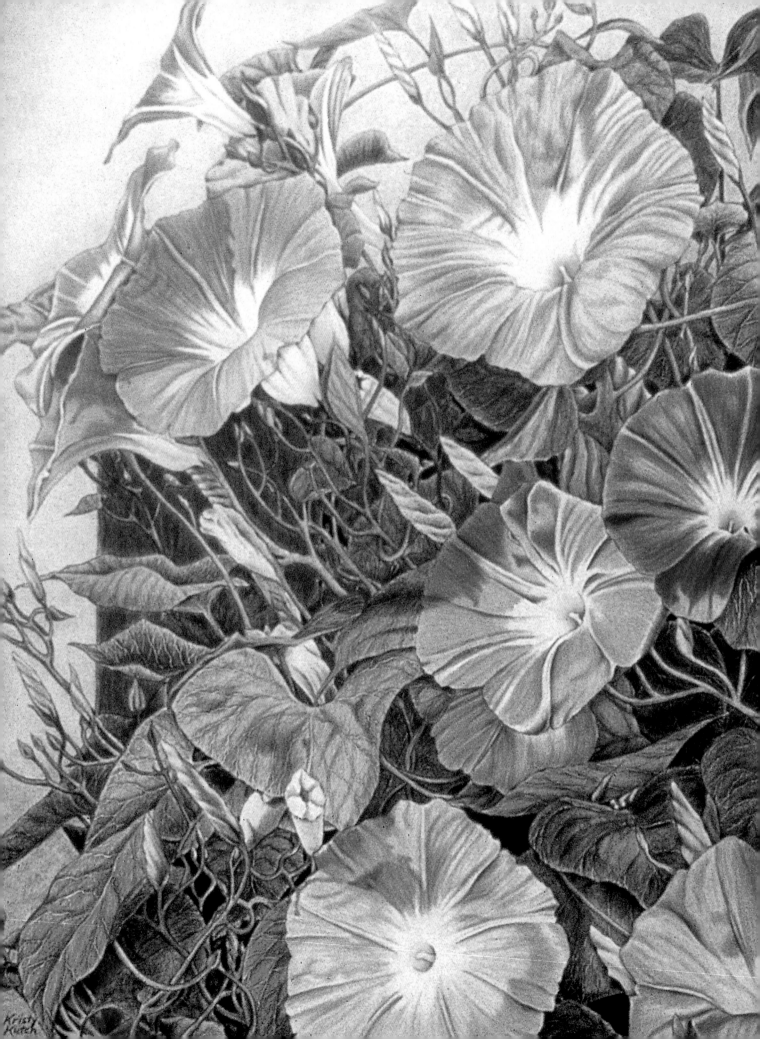

Understanding Color Theory

It is a great thrill to witness the development of a colored pencil artwork. Beginning with a simple line drawing and then adding many layers of color, the composition begins to emerge as the three-dimensional effects belie the two-dimensional surface on which they were drawn. Understanding color theory is essential to creating these realistic effects. This chapter will explore the basics of color theory, including a discussion of primary, secondary, and tertiary colors; using complementary colors to create vibrancy; and applying the theory of warm and cool colors to modeling (the use of light and dark values to give an object dimension).

THE COLOR WHEEL

In the early eighteenth century, Sir Isaac Newton studied the colors of the light spectrum and devised a system of arranging those colors in a continuous wraparound cycle, called the color wheel. Later color theorists refined Newton's scheme and determined the following as primary and secondary colors:

PRIMARY	SECONDARY
Red	Orange
Yellow	Green
Blue	Violet
	(and variations of these colors)

Primary colors are the basis of all other colors in the spectrum, and secondary colors are created by combining primary colors. There are a few versions of the color wheel, but all are based on commonly accepted, basic tenets of color "mixology" and harmony.

Glorious Morning, 1998. **Colored pencil on Rising museum board, 16" × 20". Courtesy of Kristy Kutch.**

OPPOSITE AND LEFT (DETAIL): Executing this work was a challenge because of the tangled thicket of green leaves, tendrils, and vines, which were rendered with a wide range of warm and cool colors. By using this combination of color, various elements in the thicket advance or recede, adding dimension and avoiding what could have been an undifferentiated mass of green.

Arranging the color wheel so that yellow is at "twelve o'clock", note that violet is its exact opposite, or complement, at the "six o'clock" position. Likewise, the complement of red is green, and the complement of blue is orange. What about blue-green, yellow-green, or yellow-orange? Complements of combinations of the primary and secondary colors (called tertiary colors) can also be easily located as exact opposites on the color wheel.

Why are color complements important? Placing complements side by side creates a dynamic intensity. Ever notice how often still lifes feature oranges alongside blue dishes, or how artists frequently use red and green together to give a composition extra "punch"? And while featuring complements next to each other without blending them creates a vibrant composition, layering complementary colors also enhances a work because the lively neutrals these blends yield are much more appealing and realistic than black or flat grey for shadowy areas.

In the early nineteenth century, Johann Wolfgang von Goethe and Charles Hayter in their own respective studies and publications advanced a theory about warm and cool colors. According to this theory, colors range from "feeling" cool on one side of the color wheel to "feeling" warm on the other. Warm and cool colors are:

WARM	COOL
Yellow	Blue
Yellow-green	Blue-green
Orange	Violet
Red-orange	Red-violet

Warm colors seem to advance, giving the impression of projecting toward the viewer, and cool colors give the impression of receding. When trying to remember the difference between the two, think of icy, wintery hues for cool and fiery or hues associated with summer for warm.

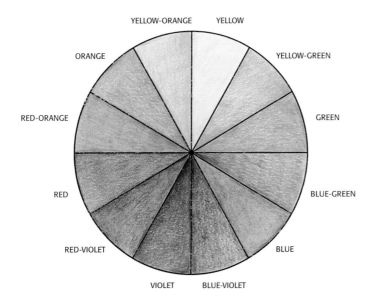

The twelve-hue color wheel

Blending complements using the colors of the twelve-hue color wheel creates lively neutrals, which are ideal for vibrant shadowy areas. The blended complements at right are: orange and blue (A); red and green (B); violet and yellow (C); yellow-green and red-violet (D); blue-violet and yellow-orange (E); and blue-green and red-orange (F).

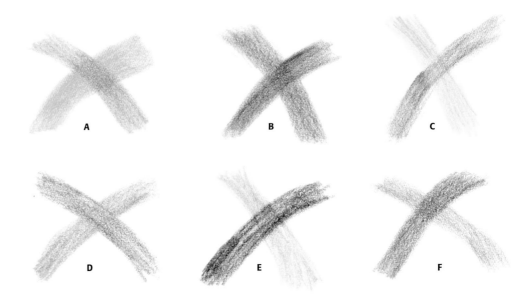

APPLYING COLOR THEORY TO MODEL

If the concept of cool and warm colors is employed when modeling an object, it gives the object the effect of three-dimensionality very quickly. Consider the drawing of the red delicious apple (below) rendered only with scarlet lake. It looks like an apple, of course, but it looks flat and lacks dimension. To avoid this, apply a layer of a cool color, such as a hue of blue, dark green, or red-violet, around the edges, inside the hollow where the stem grows, and along the area where the sides of the apple curve away from the viewer. This creates the impression of volume. Then select a warm color, such as a yellow hue, and subtly layer that over the part of the apple that projects toward the viewer. Note how this simple addition seems to make that part of the apple "pop," enhancing its three-dimensionality. (Using a shade of gold, like a yellow ochre, would also be effective, since it too is a warm color.) Repeated layering with red hues

and alternating layers of unpigmented blending pencil will create a beautifully modeled apple.

Another way to make a drawing like this is to create an underdrawing with a complement of the object's native color. See the caption below for step-by-step instructions on how to draw an apple using both of these methods.

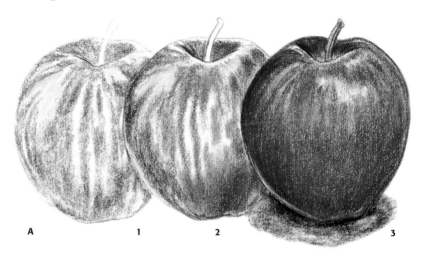

A 1 2 3

B

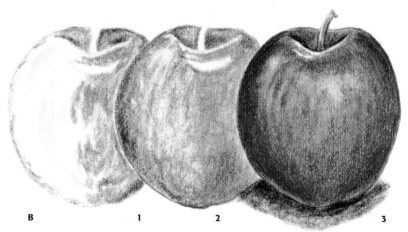

1 2 3

This red delicious apple (above) looks unrealistic because it was drawn with one color, scarlet lake. There are two ways to create a more realistic apple: with related, analogous colors (which are adjacent on the color wheel), like example A, and with complementary colors, like example B.

To create the apple using analogous colors in example A, save the highlights and apply scarlet lake for the base color. Apply canary yellow on the crest of the apple, and follow that with crimson red along the receding areas (1). Apply Tuscan red along the curves and in the recessed stem area (2). To complete the apple, apply

the same colors, but with heavier pressure. Use the line impression technique for the stem, and then apply apple green and Tuscan red on it. Draw the shadow beneath the apple in black grape (3).

To create the apple using complementary colors in example B, use dark green to outline the apple, and layer canary yellow on the crest and on the areas that project toward the viewer. Apply scarlet lake, leaving a highlighted area (1). Apply more layers of scarlet lake and crimson red, followed by yet more layers of canary yellow, scarlet lake, and crimson red (2). To complete the apple (3), follow the directions in the third step of example A.

Objects from Uncommon Vantage Points

Objects shown from an unexpected point of view can add visual interest to any composition. They can, however, present unique challenges to rendering them convincingly. By employing complementary colors, the artist can greatly enhance the realism and limit any difficulties.

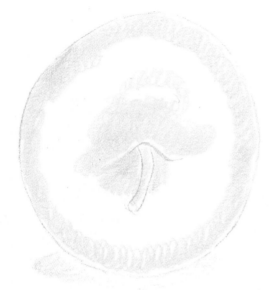

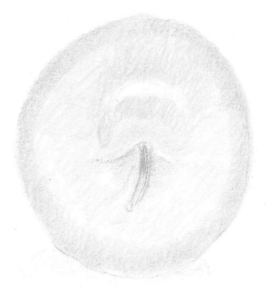

STEP 1 With a light blue pencil on hot-press watercolor paper, draw a golden delicious apple on its side so the top of the apple faces the viewer. As a sketch, it looks much like a simple bull's eye. With curved strokes, apply lemon yellow and cream on the lighter areas. Save a highlight on the crest of the apple. Include an underlying shadow in a soft violet, such as lilac.

STEP 2 With light pressure, apply a light layer of violet, such as lilac, which is the complement of yellow, around the curved edges and within the recessed stem area. Add a stem shadow in lilac. Apply lemon yellow around the edges and on the crest.

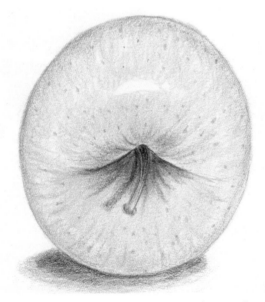

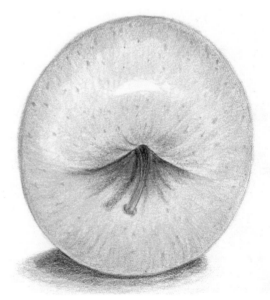

STEP 3 On the crest of the apple, apply more lemon yellow. Draw light streaks of bronze following the curved contours of the fruit. Add bronze and limepeel inside the stem area, and darken the deepest shadows with a light touch of a deep violet, like black grape. Layer some reflected yellow into the shadow underneath the apple.

STEP 4 Apply limepeel and Tuscan red to the stem. Add another layer of lemon yellow and a deeper yellow (such as canary yellow) to the apple skin. Lightly emphasize the shadow of the stem with black grape, and deepen the darkest part of the shadow beneath the apple using a subtle touch of black grape.

CHALLENGES WITH MODELING

Various features and subjects of a composition can be very problematic to model realistically. While it may be instinctive to create shadows with black or grey, building shadows with other dark colors produces a much richer, more complex work. Clusters of similar objects, such as grapes, should be rendered with subtle differences in hue and value in order to enhance the distinctiveness of each one. Perhaps the biggest challenge for any artist is modeling light-colored or white objects. Again, it seems appropriate to model them with black, grey, or brown, but, in fact, other colors will better serve this purpose. The following section offers suggestions for overcoming common pitfalls in creating a full-bodied work of art.

CREATING RICHER SHADOWS

The French Impressionists of the nineteenth century were heralded for their unique use of color. One of the techniques they developed was mixing very deep values of cool, dark colors from a combination of colors. By doing so, they were able to achieve intense, convincing dark colors, but these deep values were not derived from actual black paint, which was thought (by some) to be deadening. In much the same way, cool darks for backgrounds or negative space and shadows can be created in colored pencil by layering a variety of dark colors, such as indigo blue, Tuscan red, black grape, or dark green, to name a few.

Shadows—even the most subtle ones—look beautiful and vibrant when rendered with light pressure and the side of the pencil using lilac, periwinkle, blue violet lake, or even a light touch of black cherry, black grape, or indigo blue. Add a hint of reflective color (warm or cool) from neighboring objects.

Using golden brown to model yellow subjects, such as flowers, can make them look dark, bruised, and withered. Instead of golden brown, choose a hue of the complement of yellow, such as light violet. Lightly layer a touch of lilac or blue violet lake where the shadows appear, followed by shades of yellow. The modeling will have been achieved without sacrificing the luminous yellows.

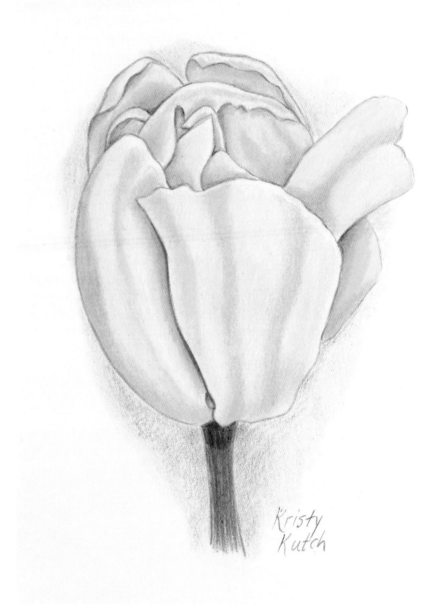

Solitary Yellow Tulip, 2005. Colored pencil on Fabriano Artistico hot-press watercolor paper, 6" × 8". **Courtesy of Kristy Kutch.**

To render shadows on this yellow tulip, lilac was applied, followed by touches of black grape on the darkest shadows. The petals were drawn using a range of colors, including cream, lemon, canary yellow, and yellow ochre.

REFINING DETAILS

Color complements add subtle vibrancy to objects and are particularly effective in adding depth and dimension to nature subjects. Use a sharp Tuscan red Verithin pencil for enhancing veins on green leaves. Try edging indigo blue along the margin of a slice of cantaloupe. This nicely sets off the object on the paper, making it more distinct.

Drawing realistic green foliage can be challenging: every landscape artist wants to avoid trees that look like lollipops. To create shadowy depths in trees and bushes, use loose oval or circular strokes to layer on cool reds, such as Tuscan red or black cherry, and follow with patches of a variety of warm and cool greens.

DEFINING CLUSTERED OBJECTS AS INDIVIDUALS

If a composition includes clusters of similar objects in a tight group, such as grapes or berries, drawing them identically will ensure that they appear flat and one-dimensional. By scrutinizing these subjects closely, subtle differences in value and hue will emerge, and trying to recreate these varied colors will result in a more realistic rendering.

GIVING DIMENSION TO WHITES

Creating a sense of dimension with very light-valued objects, especially white ones, troubles even the most experienced artist. If the shadows are too pale, the entire subject looks washed out. Apply the colors too heavily, and the object loses its pure whiteness.

If a reference photo is available, it may be helpful to judge the range of values of the subject to be drawn by working from a black-and-white photocopy of it. Once that is done, it is possible to consider alternatives to flat, cool greys alone to model it. Consider a selection of cool colors, such as lilac, blue violet lake, periwinkle, jade green, or celadon green. French greys and warm greys are nice choices, too. These can be further enhanced by light touches of pale blues, greens, or light violets. Keep the pencil pressure very light while applying the colors in overlapping, oval strokes or subtle, vertical strokes. Layer a dramatic accent of a darker value of the color (such as indigo for blues or Tuscan red for reds) where the deepest shadows appear on the object.

If the artist wants to set off whites so they do not disappear against a light background, simply edge the white area with a sharp Verithin pencil in lavender, indigo blue, or Tuscan red to add a bit of contrast.

Trees can often look flat if only shades of green are used (right). To avoid this, layer Tuscan red or any deep red (the complement of green) on the boughs (far right).

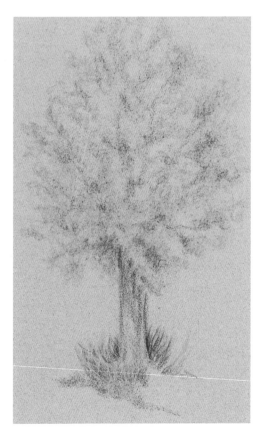

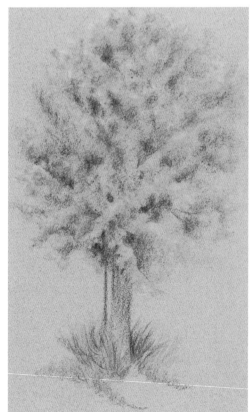

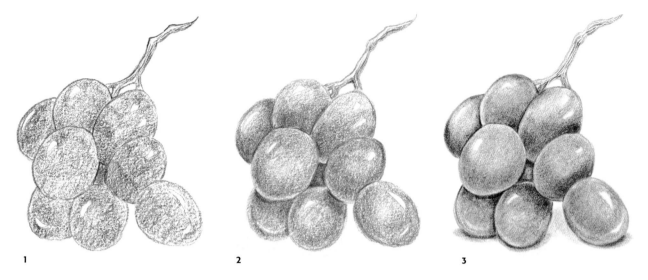

1 2 3

Clustered objects that are similar, such as these grapes, can look flat and unrealistic when rendered with a single color (1). To avoid this, using a range of hues related to the overall color of the object, apply color (beginning with the light values and finishing with the dark values) so that each grape looks distinct (2). Applying touches of warm lemon or canary yellow, indigo blue, and black grape further enhances the realism (3).

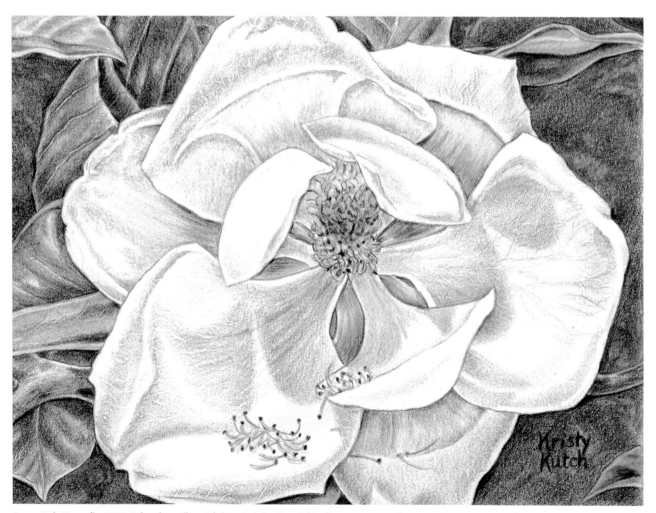

Jeannette's Magnolia, 2004. Colored pencil on Fabriano Artistico Extra-White hot-press watercolor paper, 8" × 6". Courtesy of Kristy Kutch; reference photo courtesy of Jeannette Buckley.

The delicate petals of the magnolia in this work were drawn using celadon green, jade green, cloud blue, blue violet lake, yellow ochre, and even a touch of Tuscan red. The subtle shadows—so essential to the effect of their concave shape—were created with dark green, Tuscan red, and indigo blue pencils.

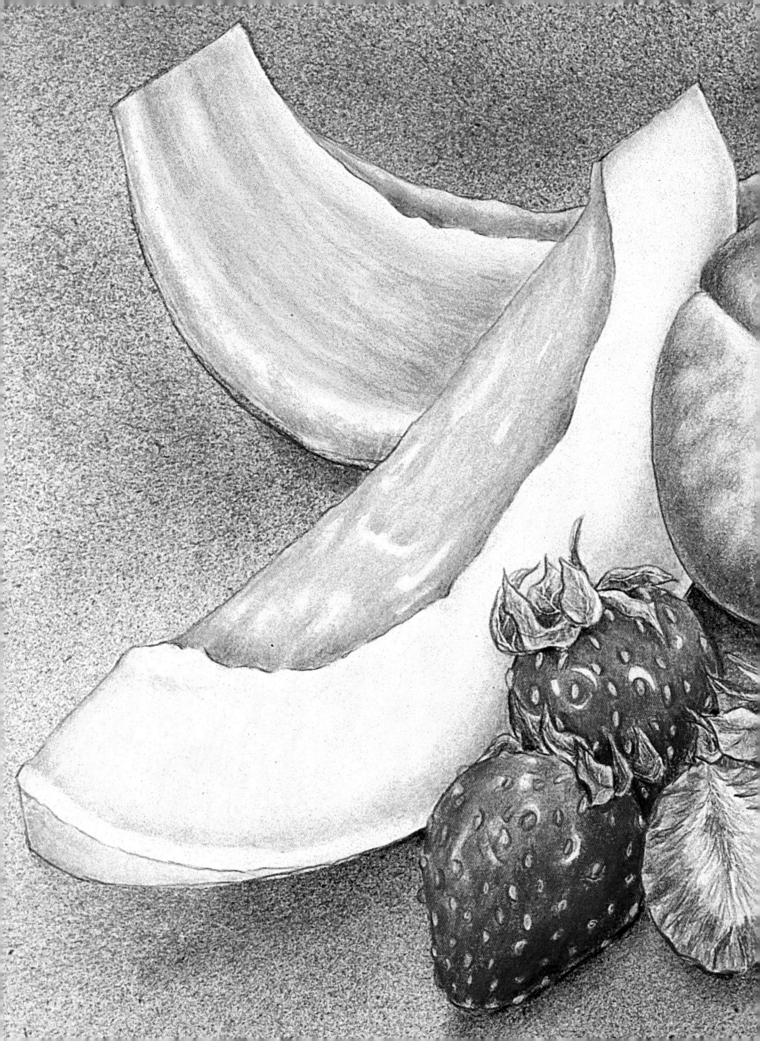

PART 2

Watercolor Pencil

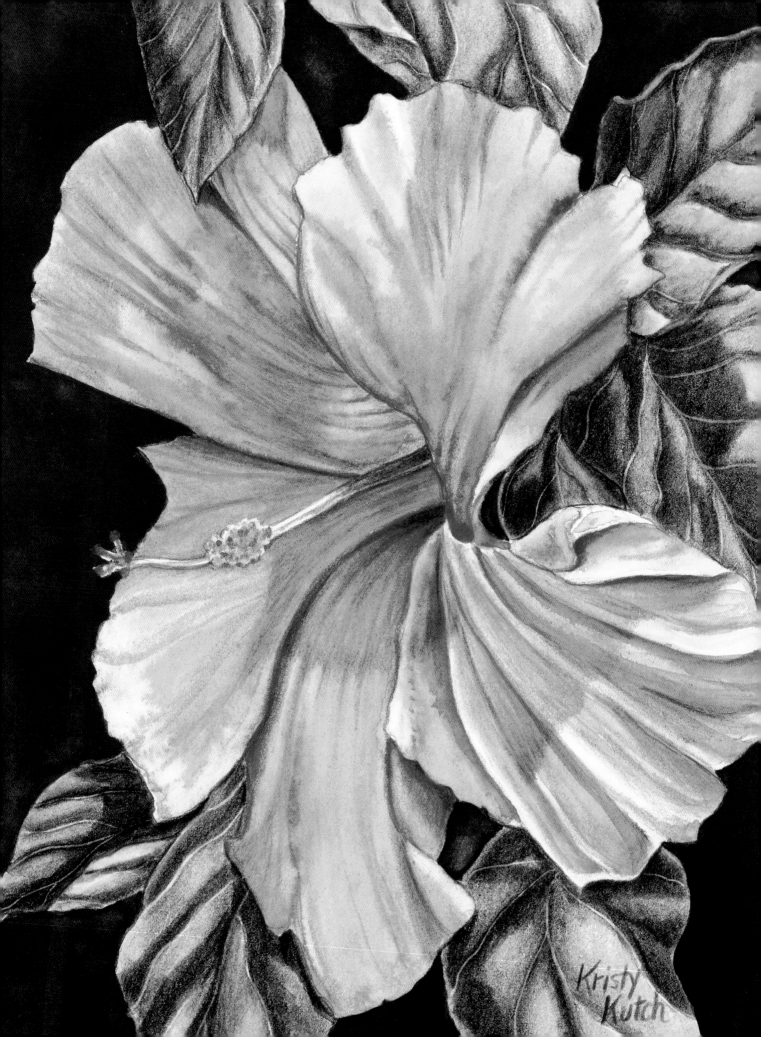

CHAPTER 5

Materials for Watercolor Pencil

Watercolor pencils offer painting potential like that of watercolor paint, as one might assume, but they provide a few important advantages: because the watercolor pigment is in pencil form, the color can be applied much more precisely. For those artists who love the soft veils of color so characteristic of watercolor paint, but want more control over where the pigment flows, watercolor pencils are ideal. Unique effects created by grating the watercolor pencil lead, so that pigment shavings sprinkle the painting's surface, also distinguish it from watercolor paint in a pan.

Perhaps one of the most significant enticements of this medium, however, is the simple joy an artist receives by watching a drawing transform into a beautiful watercolor painting by simply adding water.

WATERCOLOR PENCILS

The watercolor pencil is a newer invention than its traditional, nonwatersoluble counterpart, dating back to at least the early 1930s. The watercolor pencil lead is composed of several ingredients: pigment, inorganic fillers, clays, binder, waxes, oils, and suitable emulsifiers (to bring together the waxes and water). Not surprisingly, watercolor pencils are made from materials similar to watercolor paint that comes in a cake or pan.

Much like wax- or oil-based colored pencils, the proof is in the pigment: artist-quality watercolor pencils have richer pigmentation than the cheaper variety store type. They do cost more per pencil, but they are well worth it, so buy a set in an affordable size. Better-quality pencils yield saturated hues and colors that keep their richness when wet, with very little fadeback even after

drying. (A little lightening is not unusual.) Reds are excellent barometers of pigment quality. If the reds fade and turn pink after being wetted, consider another brand.

Watercolor pencils come in two forms: those that are encased in wood and the woodless variety. One of the most popular brands of watercolor pencils is Faber-Castell Albrecht Dürer. They are available in 120 colors, are distributed widely throughout the world, and have colors named with easily recognizable pigment terms. The art throughout this book uses these pencils. Woodless pencil rods, such as Cretacolor Aquamonoliths, are very dense, and with no wood casing or shavings, there is less waste. Using this type of woodless pencil on its side covers a large area quickly. It can also be sharpened for more precise drawing.

Marco Island Hibiscus, 2004. Watercolor pencil on Fabriano Artistico hot-press watercolor paper, 7" × 9¹/₂". **Courtesy of Kristy Kutch.**

OPPOSITE: The brilliant colors in this hibiscus flower were created using watercolor pencil in shades of pink, such as rose carmine and fuchsia. Each petal was wetted with a #2 rigger brush loaded with pigment from a madder pencil. The dense background was drawn with heavy layers of mauve, creating a beautiful contrast to the bright flower.

It is important to remember that while oil- and wax-based pencils can be sharpened to a very fine point, watercolor pencils (because of their composition) do not lend themselves to needlelike points. Try to sharpen watercolor pencil points when dry. If a point breaks off, save it, and place it in a plastic milk jug lid. Add a few drops of water to dissolve it into a thick, concentrated wash, and apply it with a brush.

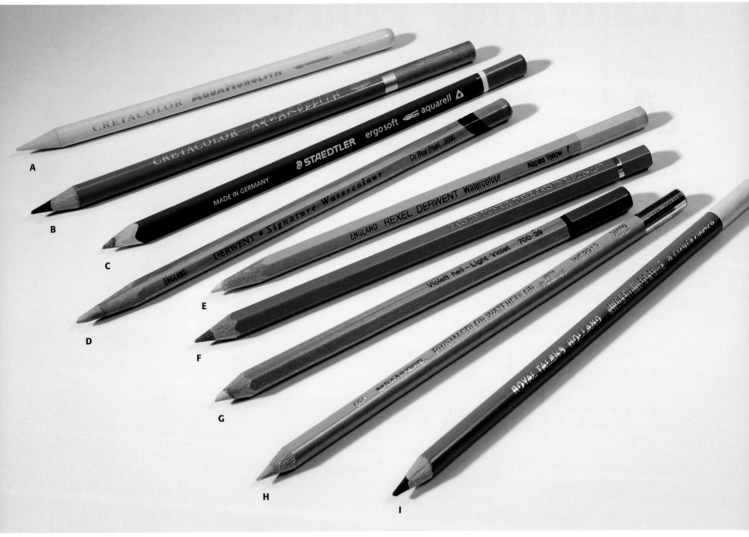

The following are nine good brands of watercolor pencils that are all widely available. Each brand dissolves into a smooth wash, but some have better color saturation than others.

A Cretacolor Aquamonolith: woodless rod that is good for applying color to large areas. Good color saturation.

B Cretacolor Aquarellith: applies color precisely, but not ideal for applying color to large areas. Good color saturation.

C Staedtler Ergosoft Aquarell: triangular lead with good color saturation. Limited palette.

D Derwent Signature: formulated for lightfastness and excellent color saturation. Limited palette, but the range of greens and earth tones is extensive.

E Derwent Studio: applies color precisely, but not ideal for applying to large areas.

F Faber-Castell Albrecht Dürer: available in the widest selection of colors (120) and has excellent color saturation. Used in the art throughout the book.

G Lyra Aquarell: excellent color saturation.

H Sanford Prismacolor: excellent color saturation. Limited palette.

I Van Gogh: formulated for lightfastness. Limited palette.

WATERCOLOR PAPERS AND BOARDS

Watercolor papers and boards come in finishes ranging from ruggedly textured (rough) to smooth (hot-press), with moderately textured styles known as cold-press. (Fabriano's subtly textured cold-press paper is known as "soft-press.") As discussed in Chapter 1, some watercolor papers and boards are suitable for both traditional and watercolor pencil. Generally, watercolor pencil lends itself well to the hot-press style, although some artists may prefer the additional texture of cold-press papers. (In order to remember which style refers to which texture, think about the fact that a hot household iron will best smooth out wrinkles in a garment.)

The heaviness of papers is indicated by their pound weights. For example, a 300-pound paper means that one ream (500 sheets measuring 22 by 30 inches) of that paper weighs 300 pounds. A 140-pound paper means that 500 full-size sheets will tip the scales at 140 pounds. (Usually 90-pound paper is considered student-grade, but to avoid buckling when wet, it would be wise to choose paper of at least the 140-pound weight.) Paper in the 300-pound weight is popular with artists working with water media whose art features large areas of wet color, but usually 140-pound paper is suitable for most work using watercolor pencil. The more water applied to a work, the heavier the paper needs to be. Some artists first tape the paper (with masking or drafting tape) along its margins to a backing board to provide more stability. Other artists presoak the paper and allow it to dry before using it; this keeps it taut and less prone to buckling. However, light applications of a wet brush in a few small areas at a time on a composition will probably require neither a backing board nor presoaking.

Other papers and boards recommended for traditional colored pencil are also well-suited to watercolor pencil, including Multimedia Art Board, Wallis Sanded pastel paper, and Colourfix paper.

Close-up of Claybord Textured surface

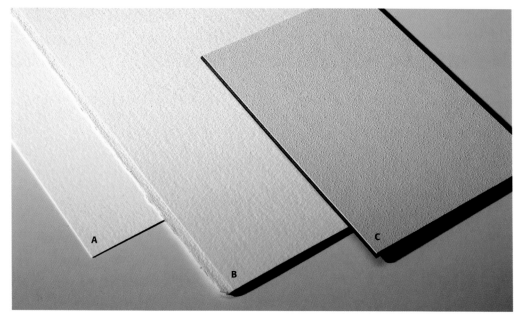

An array of watercolor boards and paper: Multimedia Artboard (A), Fabriano cold-press watercolor paper (B), and Claybord Textured (C).

Bonded boards are superb surfaces for watercolor pencil. They are convenient for travel and also eliminate worry about buckling and unwanted puddling. Watercolor board is made by bonding watercolor paper to a much heavier, paperlike board. Claybord Textured, while not a paper, is a durable, gritty surface bonded to a hard board that has been tempered without any harmful oils. Both types of boards take lifting and erasing very well.

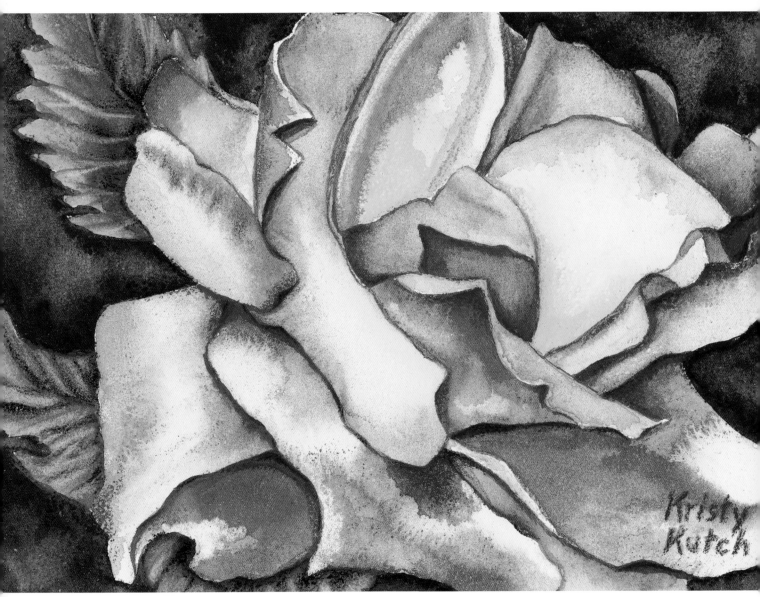

Canadian Rose, 2004. Watercolor pencil on Claybord Textured, 7" × 5". Courtesy of Kristy Kutch.

Surfaces such as Claybord Textured can receive large amounts of watercolor pencil pigment because of their abrasiveness. *Canadian Rose* illustrates how intense the colors can be using watercolor pencil on this surface, with very little of the fadeback that frequently occurs with many types of watercolor paint. Each petal was wetted individually, allowing plenty of time to introduce bursts of rich color.

WATERCOLOR BRUSHES AND OTHER SUPPLIES

The great advantage of watercolor pencils is control: the color stays where it has been applied. Make the most of that control with suitable brushes. Watercolor brushes come in a huge variety of shapes, sizes, materials, and price ranges. Synthetic or "white sable" brushes are budget-minded and cost a fraction of the true sable brushes. Nonetheless, synthetic brushes have a good capacity for fluids and "snap" (the ability to reach easily into tight spaces with precision). Never rest the brush with bristles down into the water; this can quickly distort the bristles, making it hard to regain the shape of the brush. Wash brushes with a mild soap and rinse well, setting the brush down horizontally or in a special brush rack to dry.

If in doubt about the huge selection of brushes on the market, buy a few basic brushes to begin. Start with a #6 round brush (good for petals, leaves, and fruit), a smaller #2 round brush (great for small, precise corners), a #10 or #12 round brush (for wetting larger areas smoothly), and a one-inch-wide flat brush (for skies and ridges). A #2 rigger or script brush, both with long, wispy hairs, is ideal for fine, wheatlike vegetation, such as dune grass. Fan brushes are not an absolute necessity, but they do work well for brushing in distant rows of grasses or wheat in a landscape, for example.

Rubber-bristled brushes, known by their brand name Funny Brushes, are available in three sizes. They are excellent for drawing tree boughs and bushy vegetation in landscapes. They clean up easily with soap and water and can last for decades.

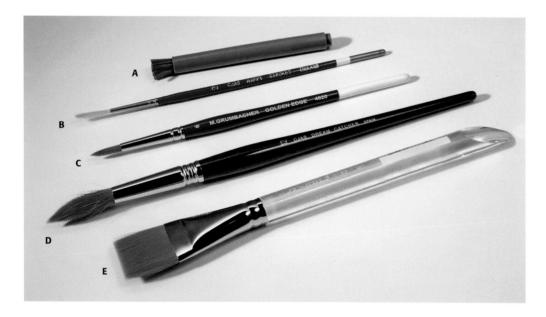

Rubber-bristled brush (A), #2 rigger brush (B), #6 round brush (C), #12 round brush (D), and one-inch-wide flat brush (E).

To quickly create shrubbery, apply strokes of green watercolor pencil (such as grass green or leaf green) on a piece of scrap paper, and wet it so that it becomes a puddle of color. Dip a rubber-bristled brush into this wash, and dab the brush onto the paper to create bushes.

Other items used with watercolor pencils are inexpensive and probably close at hand. Cotton swabs and cotton balls are ideal for blotting excess moisture and for softening wet edges on the painting. Tissues not only work well for slightly lifting color, but also for lightly wicking away excess moisture without actually blotting. Paper towels (the more textured and rugged, the better), natural sponges, and table salt or coarse Kosher salt are also helpful for adding textured effects to watercolor pencil washes. Toothbrushes are used to spatter pigment on a work to produce different effects, such as a spray of ocean water in a seascape.

Sometimes it is necessary to save a highlight or pure white area on a work, protecting it from the colored wash while swabbing over it with a wet brush. Masking fluid and wax-resist sticks work well for this purpose.

Masking fluid resembles liquid rubber cement, is sold under different brand names, and is available in white, grey, yellow, or light blue. A wax-resist stick resembles a clear, uncolored crayon. These inexpensive sticks can be found in arts-and-crafts stores, as well as in Easter egg dyeing kits. Wax from these sticks stays put and cannot be removed, so apply it carefully. Because of its consistency, it is best suited to blurry, soft-focus highlights.

Watercolor pencils are forgiving, much like traditional colored pencil. Many colors can be lifted or erased depending on the staining power of the pigment applied. Once the painted area has dried—and only after it has dried thoroughly, otherwise the damp paper can be damaged—a kneaded eraser, a white plastic eraser, or a white battery-operated eraser can be dragged through a tinted area to lift out soft highlights.

Materials needed for watercolor pencil art: two containers of clean water, cotton balls, tissues, paper towels, natural sponge, masking fluid, battery-operated eraser, kneaded eraser, soft toothbrush, cotton swabs, wax-resist stick, emery board, and Kosher salt or table salt.

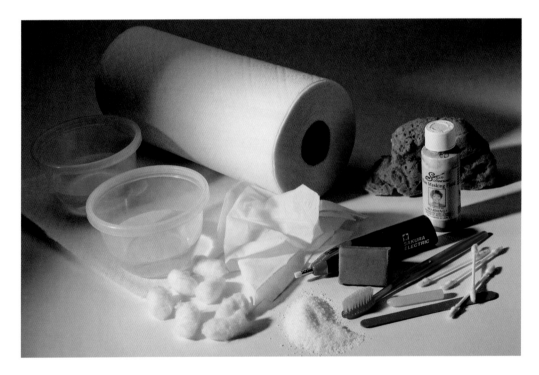

To protect white areas from watercolor washes, masking fluid can be stroked onto the area to be saved (1). Allow it to dry before wetting the area around it. Once the watercolor pencil layer has been wetted (2), and allowed to dry completely, the rubbery masking fluid can be peeled away.

1

2

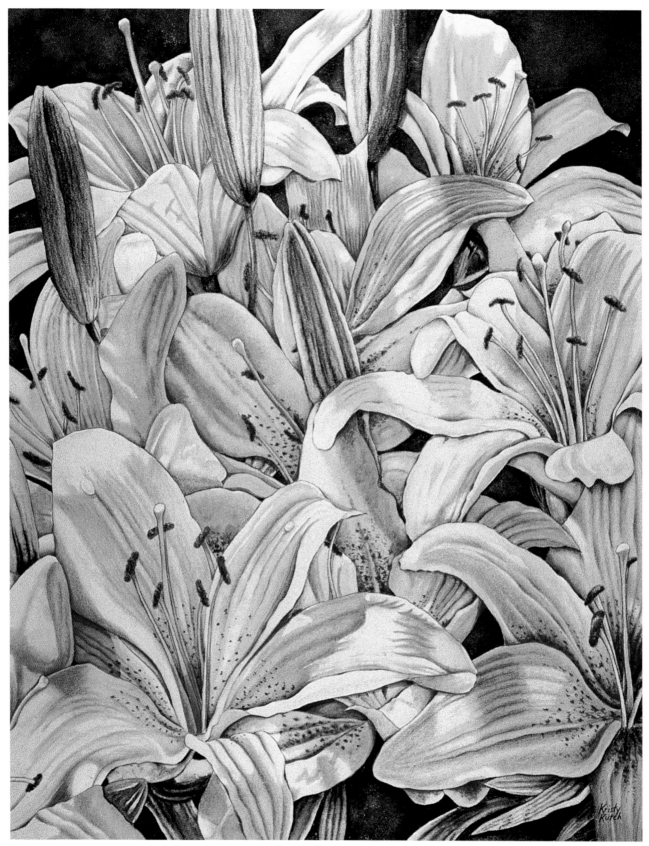

Sun-Kissed Lilies, 2000. Watercolor pencil and colored pencil on Hannemühle Hamburg hot-press watercolor paper, 16" × 20". Courtesy of Kristy Kutch.

The late afternoon summer sun cast its rays through these lilies, producing a strong backlit effect to the petals and many highlights. To create them, a battery-operated eraser was applied to the ribs on the petals.

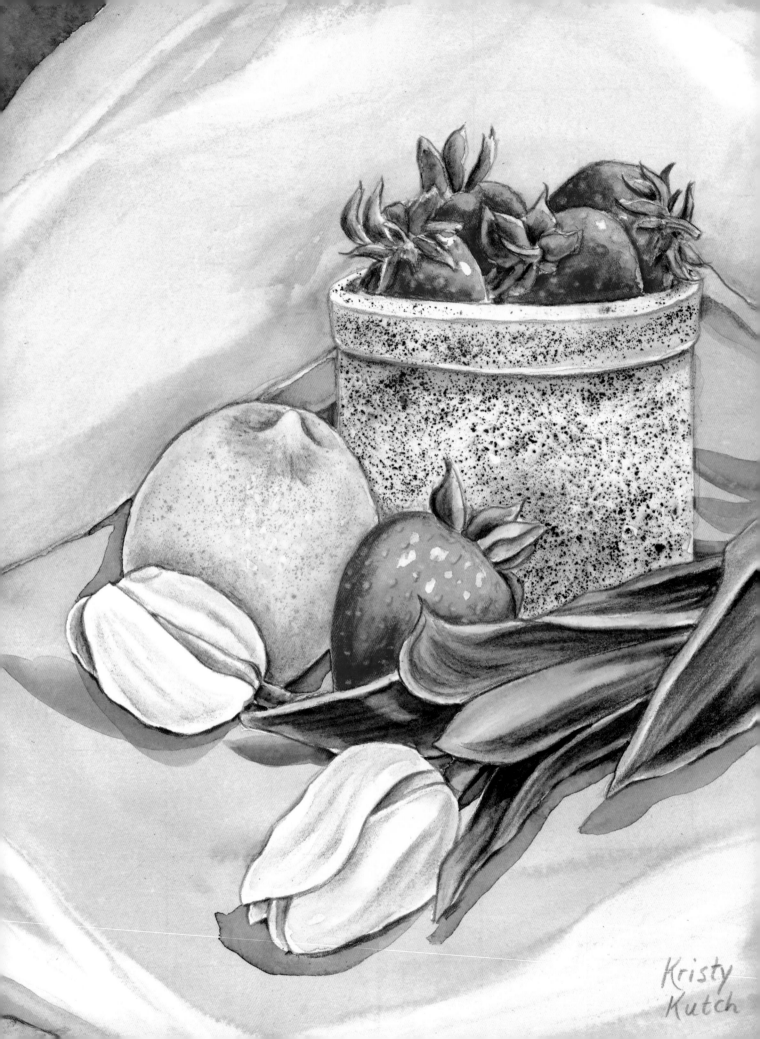

Kristy
Kutch

Watercolor Pencil Techniques and Demonstrations

Getting acquainted with the extraordinary capabilities of watercolor pencils can be a bit intimidating for the artist who has only explored dry techniques with colored pencils. But once these skills are mastered, artists will revel in the glorious creations they can produce.

What are the most effective techniques for creating watercolor pencil paintings? Three are explored in this chapter, each with its own advantages. Whether a composition needs an extra jolt of color concentrated in one area or if it needs a sprinkling of grated pigment to render a mottled effect, watercolor pencils offer the artist several options.

Because they are highly pigmented, watercolor pencils lay down color quickly and yield color that is very saturated. Many artists opt to use them dry for this reason. When water is added to layers of watercolor pencil, the color retains its density, but with a smooth, aqueous finish. This chapter will explore using wet and dry watercolor pencils for a variety of popular subjects well-suited to this medium: fruit, vegetables, and flowers. These easy-to-find subjects offer a wealth of opportunities to portray many types of surfaces and vivid colors.

Kitchen Abundance, 2005. Watercolor pencil on Fabriano Artistico hot-press watercolor paper, 8" × 10". Courtesy of Kristy Kutch.

In this still life of flowers and fruit, wet and dry watercolor pencil techniques were used to create the glossy surface of the strawberries and the more matte surfaces of the crock, tulips, and fabric. Cool blues were used for the background fabric, which was loosely drawn and then wetted with a very large watercolor brush. The cloth in the foreground, drawn with shades of violet, light ultramarine blue, and touches of light red violet, was executed in a similar manner. An underpainting of violet and light ultramarine blue was used to create a base layer on which more layers of dry watercolor pencil were applied to the crock, fruit, and flowers. The speckled surface of the crock was created by wetting it with a brush and grating indianthrene blue pencil on top of the wet area.

UNDERSTANDING WATERCOLOR PENCILS

In advance of mastering watercolor pencil techniques, a few exercises will be helpful in getting comfortable with the characteristics and handling of this medium.

Gather a few sheets of paper and watercolor pencils, and begin to doodle and dabble. Practice different types of strokes, and note the difference between using the pencil point and the side of the pencil. For smooth coverage that dissolves easily, use the side of the watercolor pencil. Heavy pressure with the pencil point will produce obvious lines, which are more difficult to dissolve. Keep in mind, however, that unless the watercolor pencil will remain dry in the finished work, stroke direction will not be critical to the final result.

Next, try applying swatches of different colors with light and heavy pressure to see how varying the pressure will affect the color saturation. Once the dabbling with dry watercolor pencils is done, move on to the following three exercises to explore the effects of adding water.

TIP
Some artists find it convenient to keep a roll of toilet tissue (taped shut, to prevent unwinding) in the studio. It is cheap, mildly absorbent, and wicks away just the right amount of water from a dripping brush.

EXERCISE 1

1 Prepare several swatches of vivid colors. Apply some of the swatches with light pressure (top half of A and C) and some with heavy pressure (top half of B and D). Dip a medium-size watercolor brush, such as a #6 round, into clean water and slightly dab it with tissue to draw off the excess water. The brush should be completely wet but not dripping.

2 Wet each swatch of color, rinsing the brush between the swatches, and note the dramatic change. What once was textured and granular has become a smooth wash, with just a quick stroke of the brush (bottom half of A, B, C, and D). Using superior quality watercolor pencils will ensure such flawless washes.

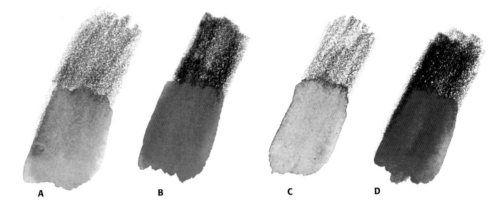

A B C D

TIP
For customizing a blend of pigments into a small, home-made palette, heavily layer two or more watercolor pencils on a small sheet of scrap watercolor paper. Add a few drops of water and mix well with a brush. Use it to paint small details.

EXERCISE 2

1 Lightly layer two different colors with a dry watercolor pencil, such as red and yellow (A), and note the immediate blending of these colors into a shade of orange. Try it again with red and blue (B), which yields violet, and blue and green (C), which yields blue-green.

2 Swab a wet brush over the swatches of combined hues (see the brushstroke on the top right of each swatch). Note how easily the swatches dissolve and mix into a new color. This illustrates the potential of even a small set of quality pencils, as just a few colors when blended can yield a much bigger palette.

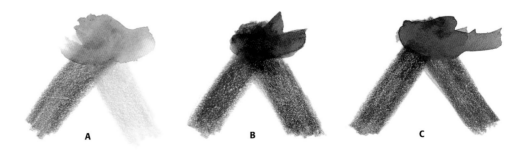

A B C

EXERCISE 3

1 Prepare two identical color swatches like swatch A, graduating the pressure (moving left to right) from very light to very heavy. The color intensity and saturation will increase with added pressure.

2 Wet a brush, dab off the water slightly, and run it along the first swatch of color, starting on the left where the color was applied with light pressure and moving across it to the right (B).

3 Rinse the brush with water, dab off any excess, and wet the other swatch of color, this time stroking the brush in the opposite direction, from right to left (C). Note the difference between the two swatches: the color saturation of swatch C is much greater than B due to the fact that the brush moved across the swatch starting from the area of the heaviest application of color.

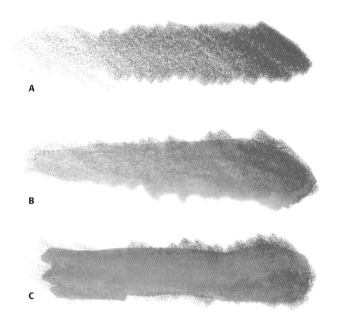

A

B

C

MASTERING WATERCOLOR PENCIL TECHNIQUES

While watercolor pencils lay down color very well when dry, perhaps the best qualities of the medium are revealed when water is applied. It is exhilarating to watch a dry work, with its visible pencil strokes, become a beautiful watercolor painting quickly by applying a wet brush. The quality of the washes can fool even experienced watercolorists into thinking that the work was made with watercolor paint, because the washes are so smoothly dissolved.

With the following three techniques discussed here—wet-into-wet, pencil-point-into-wet, and grating—it is possible to enhance a wet wash with dynamic details and concentrated areas of color. (For those acquainted with watercolor techniques, these techniques may sound familiar though they use different tools.) Wet-into-wet effects are attractive and typical of watercolor paint at its best. Taking a wet brush and loading it with pigment from either the tip of a watercolor

pencil or a homemade palette will create intense bursts of color. Simply touching an area of the composition with this brush will add a dose of saturated color to the stroked area. Fine-pointed brushes, such as rigger brushes, are designed to apply these concentrated areas of color.

The pencil-point-into-wet technique involves dipping a watercolor pencil in water and then using the wet pencil to draw into a wet area, leaving a somewhat diffused line of very intense pigment. Use this technique for rendering soft-edged creases and furrows.

The grating technique is unique in that it is only possible with watercolor pencils and therefore not borrowed from traditional watercolor. By grating the lead of the pencil over wet areas on a composition, specks of color are created. Flecks on a piece of pottery, freckled spots on a flower, or clusters of moss on a boulder, for example, are all represented realistically with this technique.

Wet-into-Wet Technique

Using this technique created the darker ridges on the petals of this rose-colored peony.

STEP 1 Prepare a line drawing of a peony blossom using either a light blue, lavender, or an HB pencil on hot-press watercolor board or paper.

STEP 2 Save the central light-colored stamen area of the peony with masking fluid, and allow it to dry.

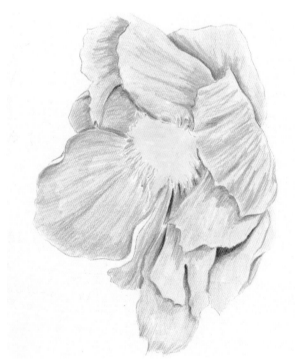

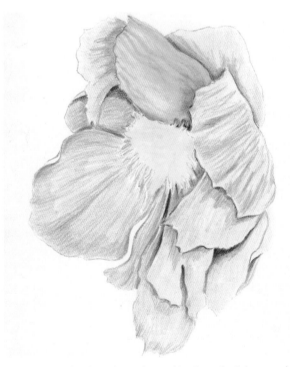

STEP 3 Stroke on dry layers of these watercolor pencils, beginning with the lightest values and ending with the darkest: light magenta, pink madder lake, light purple pink, fuchsia, and mauve.

STEP 4 Dissolve these layers by stroking from the lightest to the darkest areas with a damp #6 round brush. Wet only one petal at a time. The top petal in this illustration has been wetted and the pigment dissolved into a wash.

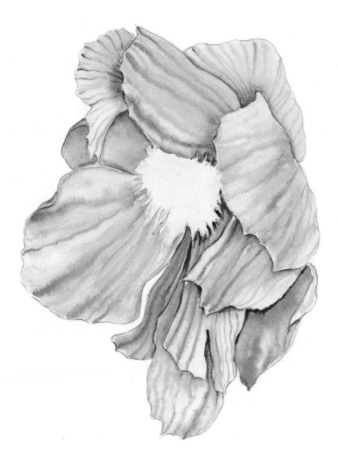

STEP 5 Touch a wet #2 rigger brush directly to the lead of a violet or pink carmine watercolor pencil so the entire brush is saturated with pigment. Lightly dab the brush's tip on a tissue. Touch this brush directly to a wet petal area, and drag it through the length of the petal in one continuous stroke. Only brush in one direction. The wetter the petal, the more the color will spread and flow. Repeat this process for each petal, but be sure to wait until adjacent petals are dry to keep each petal distinct.

STEP 6 When the entire blossom is dry, peel away the masking fluid, and apply strokes of cadmium yellow and cadmium orange to the stamens. Wet them with either the fine tip of a Colorless Blender Marker or a wet #2 round brush. If desired, enhance the colors with either traditional or watercolor pencils in the appropriate colors. Use a Tuscan red Verithin pencil on the stamens and along the petal edges to refine these details.

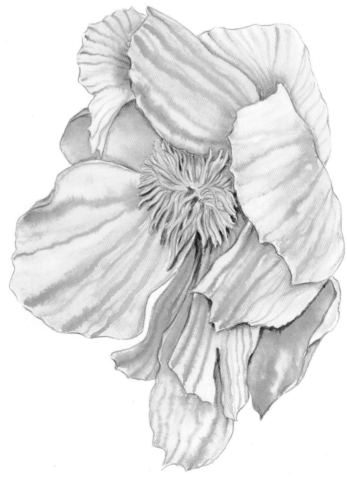

Pencil-Point-into-Wet Technique

The soft streaks of the lily pod in this demonstration were created by dipping several different pencils into water and running them through a slightly wet area.

STEP 1 Prepare a line drawing of a lily pod using a light-colored pencil or an HB pencil with very light pressure on hot-press or cold-press watercolor paper.

STEP 2 Apply dry pencil strokes of dark cadmium yellow and accents of earth green yellowish in the green areas.

STEP 3 With a #6 round brush, wet one half of the pod so that the colors flow together and blend. Move quickly to the next step.

STEP 4 Dip a cadmium orange pencil into water, and then streak lines through the lily pod. Repeat the same process with earth green yellowish and pine green pencils. While the pod is still damp, gently tilt the paper back and forth to enhance the flow of pigment. Allow this half of the pod to dry. Wet the other half of the pod, and repeat the streaks with wet watercolor pencils. For the stem, apply streaks of pine green to show the striations, and indicate the pod shadow at the top of the stem.

Grating Technique

The speckled surface of an orchid can be brilliantly achieved by grating watercolor pencil with sandpaper or an emery board over a composition. When using this technique, it is important to have all materials (watercolor pencils, brush, clean water, and sandpaper or emery board) within easy reach, because a good result depends on working when the paper is still wet. Because of this relatively brief window of time, this technique works best when one small area at a time is dampened.

STEP 1 Prepare a line drawing of an orchid with a light-colored pencil, such as yellow or lavender, on hot-press watercolor paper.

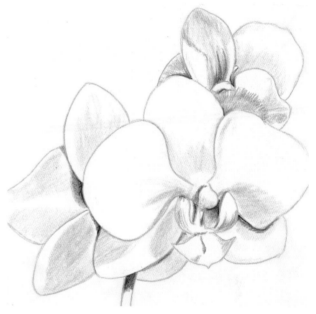

STEP 2 Sketch the petal shadows and the various values found on the petals using soft shades of violet and mauve with a touch of May green on the upper right orchid. Stroke juniper green on the stamen and pistil, which will serve as a shadowy underdrawing to create a vibrant red later. Use juniper green and caput mortuum violet for the stem shadow.

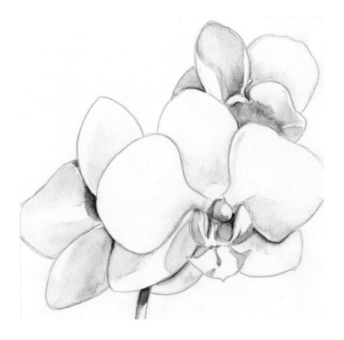

STEP 3 Using a #6 round brush, wet each petal, brushing from the lightest areas to the darkest. Skip around to nonadjacent petals so the color from one petal does not bleed into another. Do the same with the stamen, pistil, and stem; dissolve the underdrawing with a #2 round brush. Allow this to dry completely.

STEP 4 Since it is important to move quickly for this step, keep the following materials close at hand: sandpaper or emery board and magenta, light red-violet, and violet watercolor pencils. Wet one petal with clean water and a #6 round brush, leaving no dry spots. Hold a watercolor pencil one to two inches above the wet area and grate it so that little bits of pigment are sprinkled on the damp petal. The grated pigment only adheres to wet areas. If desired, gently tilt the paper to allow the color to flow. When finished, blow away the excess pigment dust.

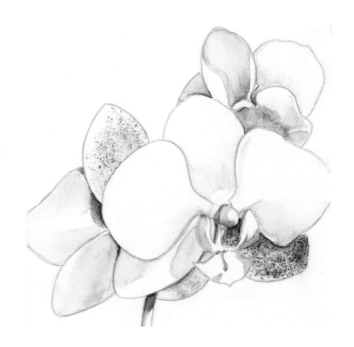

STEP 5 Grate pigment over the remaining petals, using lighter shades on the more muted petals and more intense magenta on the bolder ones. Apply madder to the central stamen and pistil and wet with a #2 round brush. Finish the stem with caput mortuum violet and wet with either a #2 round brush or the fine point of a Colorless Blender Marker. If desired, edge the petals and stems with a lavender or violet Verithin pencil.

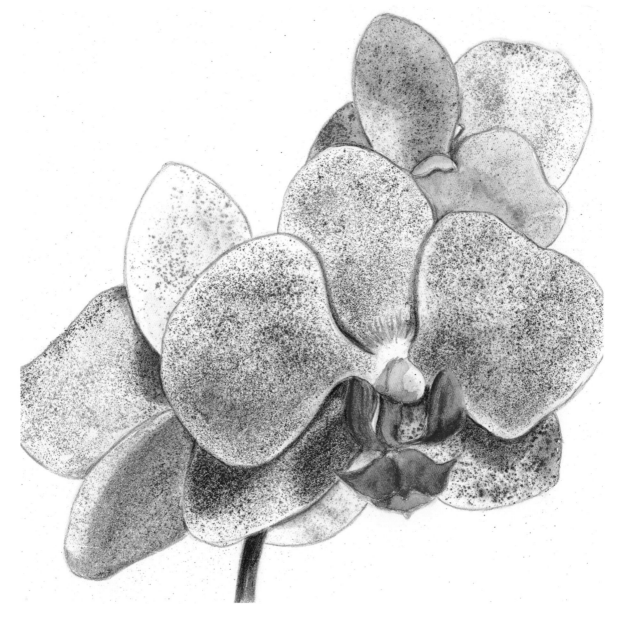

FRUIT, VEGETABLES, AND FLOWERS

Some of the favorite subjects of artists working in this or any medium are fruit, vegetables, and flowers. Because they are readily available, artists can try their hand at as many different examples from these three groups as desired. For the artist new to watercolor pencils, drawing and painting objects so familiar to them will help to build confidence. And for the experienced artist, they afford an opportunity to consider their beauty anew.

Before beginning any of these subjects, first consider its texture in order to determine which techniques and papers or boards are best. Fruit and vegetables with dusky, fuzzy, velvety, or rough skins need to be rendered with somewhat granular layers of color. Layers of watercolor pencil left dry are ideal for these matte surfaces.

By contrast, using various wet techniques with watercolor pencils is perfect for smooth, unflecked surfaces. Jewel-like strawberries, glossy magnolias, shiny eggplants and cherries, and waxy lilies are realistically represented with washes of color. Color intensity and saturation can be controlled, so a range of effects—from light and delicate to rich and dense—are possible.

Whatever the subject, watercolor pencil painting moves surprisingly swiftly, and because of this, the artist can quickly assess how successful his or her attempts are at representing the given subject. Don't be discouraged if these early works are disappointing, as beginning again is as simple as taking out another sheet of paper.

September Gifts, 2005. Watercolor pencil on Fabriano Artistico hot-press watercolor paper, 10" × 8". Courtesy of Kristy Kutch.

Using watercolor pencil for this arrangement of fruit nestled in a piece of fabric was very effective in capturing all the still life's different textures.

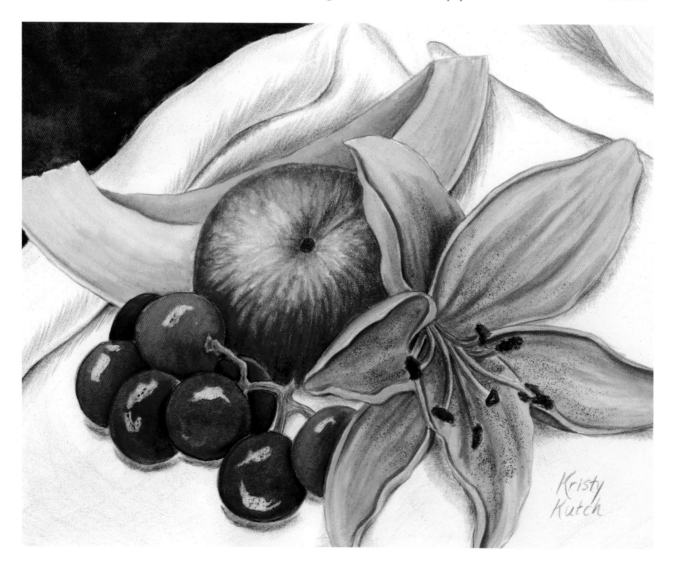

Fruit

Throughout the centuries, nature has offered much inspiration to artists, and works of art featuring luscious fruit have abounded for hundreds of years. This is no doubt because fruit offers so many aesthetic possibilities.

BLUEBERRIES

Blueberries, with their simple shape and dusky skin, are probably the easiest fruit to draw on any kind of watercolor surface. Their matte finish only requires dry watercolor pencil.

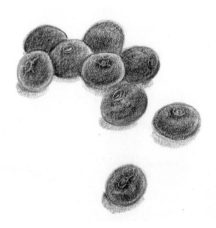

STEP 1 Prepare a line drawing of blueberries using an HB pencil on any watercolor surface. (Fabriano New Artistico hot-press water-color paper was used here.) If desired, indicate either the blossom end or the stem end by line impressing their features with a graphite pencil in the 6H to 9H range through heavy tracing paper. (One end looks like a series of tiny concentric circles, and the other resembles a star.)

STEP 2 Lightly stroke on a layer of indigo or indianthrene blue with touches of scarlet red, light cadmium yellow, May green, and/or mauve. Using a kneaded eraser or a small wad of reusable putty adhesive, lightly dab at the blueberries to lift a little color, which will create a mottled effect. If too much color is lifted, lightly stroke in a layer of indianthrene blue. Add a shadow underneath the berries with burnt carmine or a similar cool red for contrast.

STEP 3 Either wet the shadow with a #2 round brush, or leave it dry. (A smooth shadow provides contrast to the textured berries.) Use a sharp Tuscan red or indigo blue Verithin pencil to refine the edges. (Blueberries can also be rendered using similar hues in traditional colored pencil.)

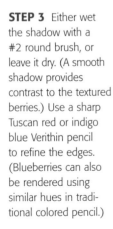

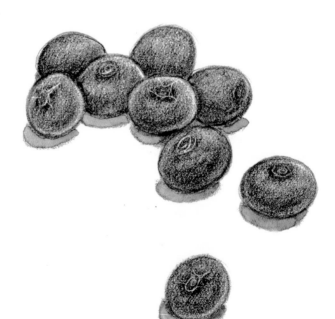

KIWIS

Kiwi fruit has a fuzzy, slightly rugged surface, so leave the watercolor pencil layers dry to enhance this distinctive texture.

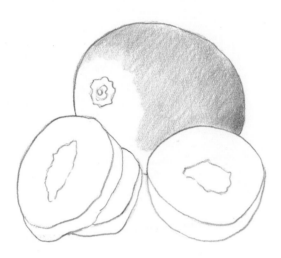

STEP 1 Prepare a line drawing of a few kiwis (one whole and one cut into slices, revealing the flesh inside) with an HB pencil on watercolor paper. (Fabriano Artistico soft-press watercolor paper was used here, but a cold-press surface would also work.) Layer a base of green gold or a shade of ochre on the unsliced kiwi. Add a light touch of burnt carmine around the edges.

STEP 2 With a very sharp, H-grade graphite pencil and heavy tracing paper, impress short, choppy lines close together. Lightly layer dry May green and another layer of a cool color, such as burnt carmine.

STEP 3 Save the highlights on the flesh of the kiwi slices with dots of masking fluid, and let it dry.

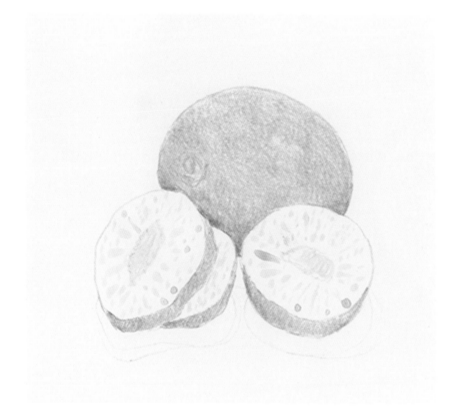

STEP 4 Stroke in May green, being careful not to disrupt the masked areas. Wet the green areas with a #2 round brush and while it is wet, load the brush with juniper, and run dark streaks through the lighter green. Allow this to dry completely.

STEP 5 Gently rub or peel off the dried masking fluid. If the masked highlights are too large, stroke in (with a dry pencil) May green or juniper green. With a combination of dark indigo or indianthrene blue and dark sepia, heavily dot in the seeds. To enhance any lighter streaks, wait until the painting is completely dry, and stroke a dry cream pencil in the lightened areas. Indicate a shadow with hues of light red-violet, light ultramarine blue, and a touch of cobalt blue. Define the crisp edges with a Tuscan red Verithin pencil.

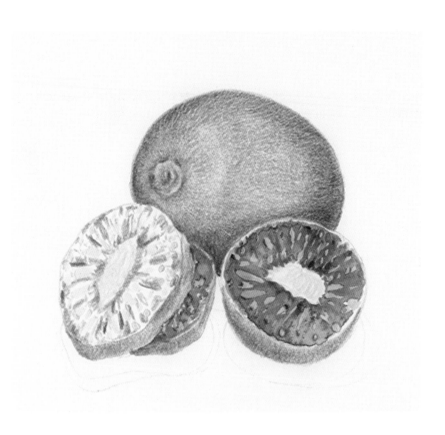

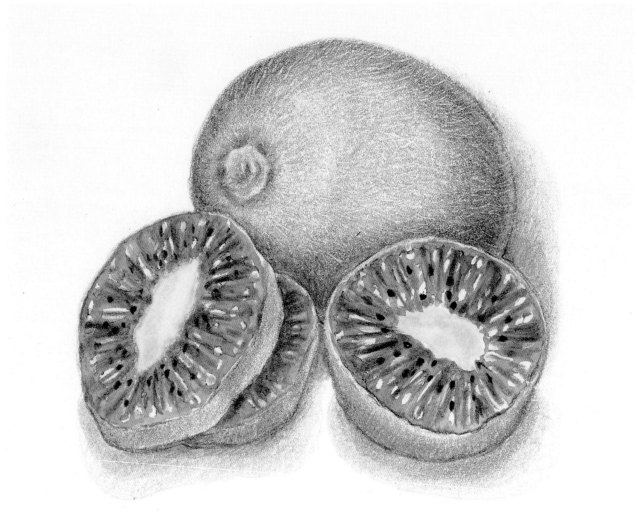

PEACHES

Peaches have skin with a velvety, downy fuzz. Work with the tooth of the paper to render this texture—such as hot-press paper, cold-press paper, or sanded pastel paper—by allowing it to show through the colored pencil layers. Apricots have a similar texture and can be rendered in much the same way.

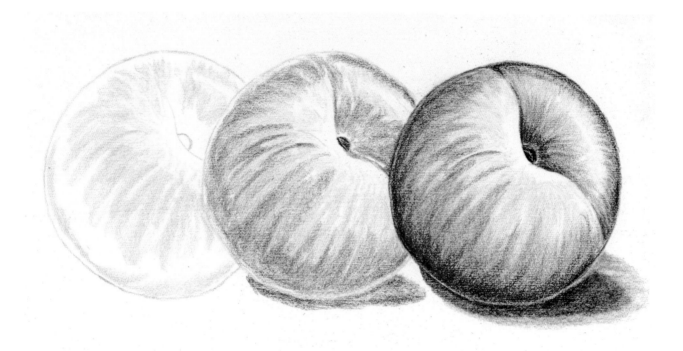

STEP 1 Prepare a line drawing using either a yellow or tan pencil, such as terracotta, on a textured watercolor or pastel paper. (Wallis Sanded pastel paper was used here.) Note the fruit's highlights. There is no need to keep the borders of the saved highlight areas sharp and crisp; keep the edges a bit muted (because fuzzy surfaces yield soft, subdued highlights.) Depending on the lighting, the highlighted region(s) may not be white; if so, represent them in a light value, such as cream or a pale yellow, like Naples yellow. Layer cadmium yellow and light yellow ochre along the contours of the peach with directional strokes.

STEP 2 Again using directional strokes, add scarlet red and a deep red, such as madder. Indicate a shadow beneath the peach with cobalt blue.

STEP 3 Layer light ultramarine blue along the cleft and inside the stem area. Apply several more layers of cadmium yellow, scarlet red, and madder in the darkest areas. (Remember not to apply so much pressure that the tooth of the paper is compressed.) Stroke burnt carmine along the edges and inside the stem area. Add light ultramarine blue to the underlying shadow. (Peaches can also be rendered using similar hues in traditional colored pencil.)

NECTARINES

Nectarines are fragrant and colorful like peaches, but they have smooth, shiny skins. While highlights on peaches are softly diffused, nectarine highlights are brighter and crisper, and call for a fine- or medium-tooth paper and a dissolved wash of watercolor pencil. Remember to sharpen watercolor pencils for more defined details, and clean off any bits of sawdust. This is an important step for keeping the watercolor wash pure and smooth.

STEP 1 Prepare a line drawing of the creased or shadowed areas of a group of nectarines with light ultramarine blue (or any light violet or blue-violet color) pencil on hot-press or cold-press watercolor paper. (Hot-press watercolor paper was used here.) Dissolve this layer of color with a damp #12 brush, making certain not to wet adjacent sections when damp. Allow this underpainting to dry.

STEP 2 Save any bright highlights with either a wax-resist stick or masking fluid.

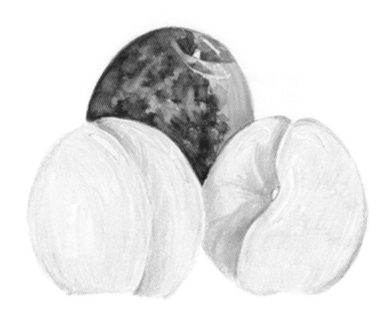

STEP 3 Apply strokes of dark cadmium yellow or light yellow ochre, and then wet with a damp brush for a smooth base layer. While this layer is still wet, load a damp #6 round brush or a #2 rigger brush with alizarin crimson or scarlet red pigment by touching it directly to the pencil tip. Streak the brush through the wet yellow or ochre.

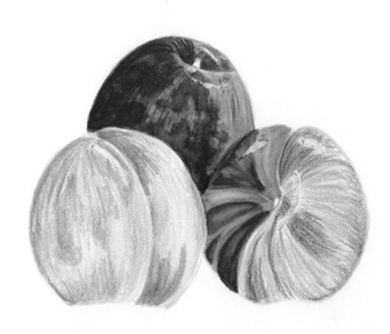

STEP 4 For more intense color, work quickly to load the brush with a cool, deep red such as madder or burnt carmine, and streak it through the damp reds. Another option is to draw all of the streaks using dry pencils in yellow, ochre, and red.

STEP 5 After applying the dry streaks of color, if applicable, wet the yellows and dissolve the streaks with a #10 round brush. Then take a brush and run it through the reds, and allow the reds and yellows to mingle.

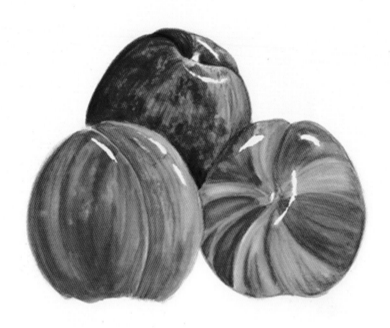

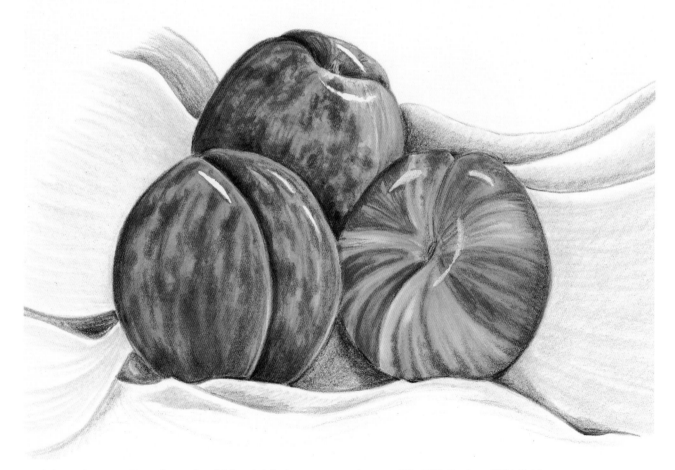

Nestled Nectarines, 2004. Watercolor pencil on Fabriano Artistico hot-press watercolor paper, 10" × 7 1/2". Courtesy of Kristy Kutch.

STEP 6 Once the nectarines are dry, retouch the streaks with dry colored pencils. To establish some lighter "freckles" in the red zones, touch the dried surface with a battery-operated eraser; it will lift the color and allow touches of various yellows and golds to show through the other layers of color. Use an indigo blue Verithin pencil to refine the edges, and sketch in the folds of the cloth background.

PEARS

Pears are wonderfully forgiving to draw and paint: if the pear is a little lumpy or lopsided, it won't be too distracting since these types of imperfections are natural with this fruit. There are many different types of pears, with various colors and textures, from the shiny skins of green bartletts to the matte-finish of boscs.

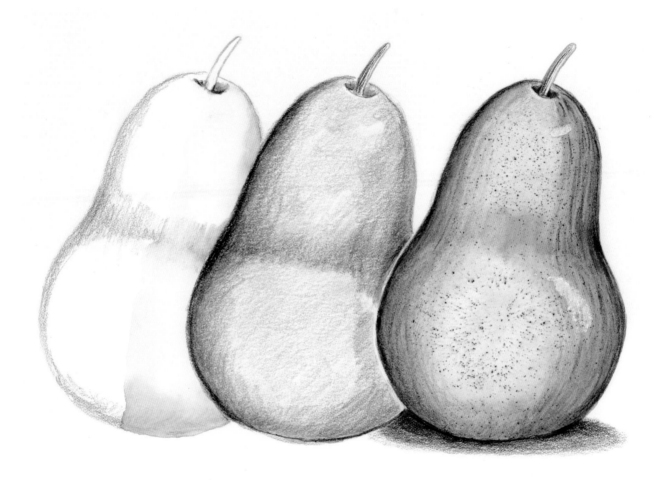

STEP 1 Prepare a line drawing of a pear with an HB pencil on any type of watercolor paper. (Fabriano New Artistico hot-press watercolor paper was used here.) Layer a base color in a complement of yellow-green, like a red-violet such as magenta. At the base of the neck of the pear (where it begins to bulge), stroke in a light layer of magenta. Do the same along the sides and in the recessed area at the base of the stem. Wet these areas with a #12 round brush, and let them dry completely. Note if there are any highlights, and be sure to save them with masking fluid or a wax-resist stick.

STEP 2 Impress fine lines in the stem. Follow with a layer of reddish brown, and wet the stem with a Colorless Blender Marker. Stroke on a layer of May green over the entire pear and a light layer of zinc yellow on the bottom half and the top part by the stem.

STEP 3 Lightly wet this layer with a #12 brush. Be careful not to brush the dried magenta contours too heavily as the colors will become muddy. Load a #2 rigger brush with deep red or madder, and streak it through the blush side of the fruit. With sandpaper, grate the tips of juniper green and caput mortuum violet pencils over the damp pear to indicate the dotted surface of the skin. Gently blow away any excess pigment, and allow this to dry. Using a dry watercolor pencil, add a few layers of pencil to the red streaks. Refine any ragged edges with a Tuscan red Verithin pencil. Add a dry shadow of caput mortuum violet or mauve with a touch of May green. After the entire pear is dry, gently peel back any masking fluid to reveal highlights.

CHERRIES

Plump, shiny cherries come in a variety of rich colors, from golden Rainier cherries to bright-red sour cherries. Their glistening skins can be deftly executed using wet techniques with watercolor pencils.

STEP 1 Prepare a line drawing of a small bunch of cherries with either an ultramarine blue or HB pencil on hot-press watercolor paper, being sure to draw the recessed stem area. Line impress the stems through heavy tracing paper with a very sharp graphite pencil in the 6H to 9H range.

STEP 2 Outline the highlights and save with masking fluid; allow the fluid to dry. Apply a light layer of juniper green inside the recessed stem area and along the curved, shadowy areas. Wet and let dry completely.

STEP 3 Apply layers of red, such as scarlet red, crimson, and/or madder to the cherry (with darker hues concentrated on the shadowy areas), working around the dried mask.

STEP 4 Stroking from the lighter to the darker hues, wet the fruit with a #6 round brush. Intensify the rich reds by loading the brush with madder pigment and touching it into the darker, wet areas.

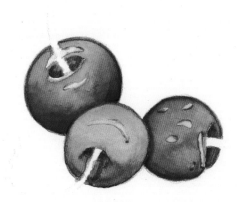

STEP 5 Load a #6 round brush with cadmium yellow pigment and stroke on the yellowish parts of the cherries. Allow this to dry.

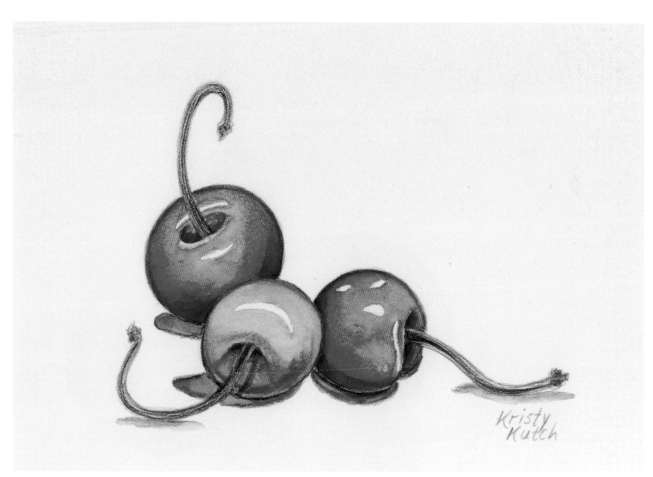

Cherry Trio, 2004. Watercolor pencil on Fabriano Artistico hot-press watercolor paper, 8" × 6". Courtesy of Kristy Kutch.

STEP 6 Apply a layer of burnt umber or sepia to the stems and wet with the fine point of a Colorless Blender Marker to slightly dissolve the color. Once the entire fruit is dry, peel off the masking fluid. Refine the edges with a sharp Tuscan red or indigo blue Verithin pencil. Indicate the underlying shadows with ultramarine blue or indianthrene blue, either leaving them dry and textured or dissolving them with a #6 round brush. Intensify the colors, if desired, with light strokes of dry watercolor in the appropriate hues.

LEMONS

The dimpled skins of lemons lend themselves to a textured paper, such as a cold-press watercolor paper or a sanded paper that will accept water media. The key is to let a hint of the paper's tooth peek through the color to create the illusion of the uneven surface.

STEP 1 Prepare a line drawing of a group of lemons in terra-cotta or violet on cold-press watercolor paper. Indicate the curved or receding areas by stroking on a dry layer of violet.

STEP 2 Note any highlights, and save them with masking fluid or a wax-resist stick. Wet the violet layer slightly using a #6 round brush. Allow some of the tooth of the paper to show. Allow this to dry completely.

STEP 3 With dry pencils, apply a layer of yellows, ranging from light ochre or dark cadmium yellow (in the shadowy areas) to cadmium yellow and light cadmium yellow on the brighter areas. Add a little May green on the yellowish green areas on the skin.

STEP 4 Brushing from the light cadmium yellow and cadmium yellow areas to the light ochre and dark cadmium areas, lightly wet the entire surface of the lemons with a slightly damp #6 round brush. Leave some of the pigment undissolved. Be careful not to brush the underlying violet layer too much.

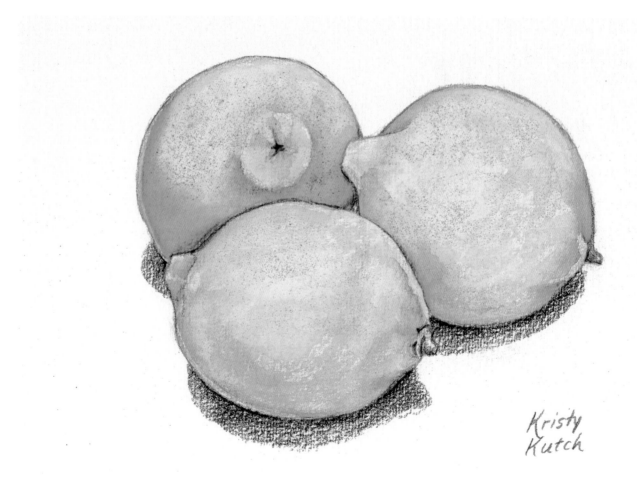

Three Lemons, 2004. Watercolor pencil on Fabriano Artistico soft-press watercolor paper, 8" × 6". Courtesy of Kristy Kutch.

STEP 5 While this is still wet, gently grate a little light ochre, dark Naples ochre, and/or a very light green (such as May green) pencil to enhance the skin texture. Blow away the excess grated pigment. Line impress the stems, and accent them with dry strokes of May green and a terra-cotta or Tuscan red Verithin pencil. Allow the lemons to dry completely, peel off any masking fluid, and add an underlying mauve or dark violet shadow beneath the fruit. Either leave the underlying shadow dry and textured, or wet it with a #6 round brush for a smooth effect.

STRAWBERRIES

Strawberries are a favorite subject of many artists because of their ruby red skin, tiny, curved leaves, and unique texture. Although the seeds on their surface may seem painstaking to render, they are actually quite simple to draw.

STEP 1 Prepare a line drawing of a few whole strawberries (with stems and leaves) and one in cross section with light-colored pencil (such as yellow or light violet) or an HB pencil on hot-press or soft-press watercolor paper. (Fabriano Artistico hot-press watercolor paper was used here.)

STEP 2 For the berry shown as a cross section, line impress the spokelike features of the flesh. Then line impress the veins of the leaves and the textured stems for all the strawberries.

STEP 3 Layer Hooker's green or juniper green on the shadowy areas (as shown in the second and third strawberries). Save the tiny highlights with masking fluid, and let it dry. Skim over the berry shown in cross section with a dry scarlet red pencil using light pressure. Then draw over each berry with deep red or madder on the darker regions and light cadmium red and cadmium yellow on the "shoulders," or broad part, of the berry.

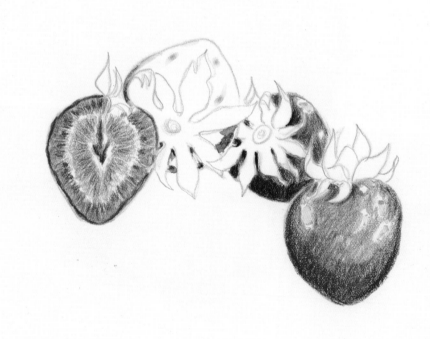

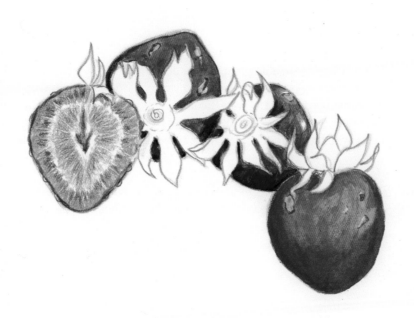

STEP 4 With a wet #6 round brush, stroke the red layer, and let it dry completely. In order to keep the line impressions distinct, do not use the damp brush on the cross-sectioned berry.

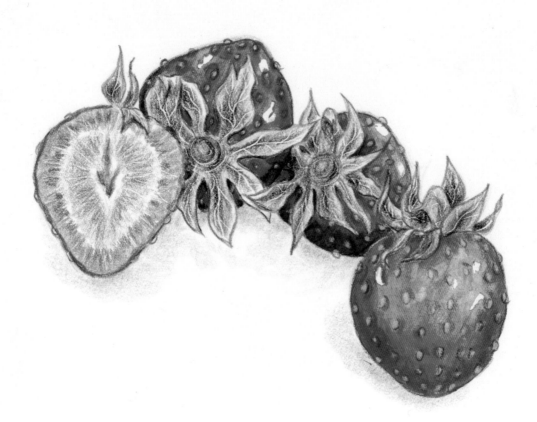

STEP 5 Peel away the dried masking fluid. Using a fine point on a battery-operated eraser, erase tiny spots from the skin where the seeds will be. Using a Tuscan red or dark green Verithin pencil, draw the seeds on the surface of the berry, and refine the edges. Skim over the line impressed leaves and stems with earth green, May green, and/or juniper. Wet with the fine tip of a Colorless Blender Marker, and define the leaf and stem edges with a Tuscan red Verithin pencil. Beneath the berries, indicate shadows using light ultramarine blue. Add touches of Indian red, juniper green, scarlet red, and cadmium yellow to lend some variety and dimension to the many leaves. Either leave the underlying shadow dry and textured, or dissolve it into a smooth wash with a #6 round brush.

Vegetables

Vegetables of many varieties are a frequent feature of still lifes. They lend a feeling of humble simplicity to a composition, perhaps because the viewer associates them with backyard gardens and homemade cooking. Dry watercolor pencil is well-suited to the flat or nonshiny surfaces of vegetables, such as sweet potatoes. Wet techniques are best for the three smooth-skinned vegetables demonstrated here: tomatoes, peppers, and eggplants.

TOMATOES

The glossy slickness of tomato skins of any color (they are available in green, gold, orange, and of course, red) contrasts nicely with their green, fuzzy stems and leaves.

STEP 1 Prepare a line drawing of a group of tomatoes using an HB pencil on any fine-tooth watercolor paper. (Fabriano New Artistico hot-press watercolor paper was used here.) Line impress the striations in the stem, vine, and veins in the leaves.

STEP 2 Note any highlighted areas (such as on the crest of the middle tomato), and save these highlights with a wax-resist stick or masking fluid; if fluid is used, let the mask dry. (Wax-resist stick was used on the highlights here.) Indicate the underlying shadows with a soft layer of light ultramarine blue. Apply a layer of a warm red, such as light cadmium red, to the tomatoes. Add a touch of cadmium yellow on the curved areas that are closer to the viewer. With dry watercolor pencil in a dark, cool red (such as madder or dark red), indicate the receding, curved areas.

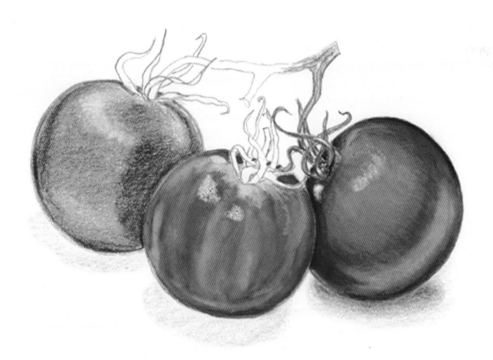

STEP 3 Leave one tomato dry (left) and wet the others to see which effect is desired. Wet the middle and right tomatoes with a #6 round brush. Load the brush with pigment from a dark red pencil, and add a burst of color to the base of the stems. Allow the pigment to dry completely, and peel away any dried masking fluid, if it was used. Apply dry watercolor pencil in May green, olive, or earth green to the stems and leaves.

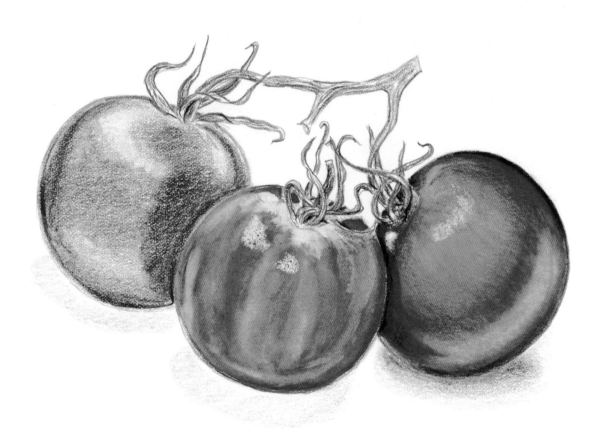

STEP 4 Finish the stems, vines, and leaves with May green or any shade of olive green pencil. If desired, dissolve the green with the fine point of a Colorless Blender Marker. In the shadowy parts of the stem or vines, add a touch of Tuscan red Verithin pencil and define the edges with that pencil, as well. Leave the shadow textured and dry, or wet it with a #6 round brush.

PEPPERS

Pepper skins are much like tomatoes in their smoothness. Their shapes, however, differ considerably. Some are large and stout, while others are small and lantern-shaped. The following are two approaches (one using complementary colors and the other using analogous colors) to create beautifully modeled peppers. Using complementary colors creates very vibrant effects; employing analogous colors produces equally satisfactory results (with color that is slightly less brilliant), but is for the artist who is less comfortable using complementary colors.

STEP 1 Prepare a line drawing of a group of orange peppers using a terra-cotta or light blue pencil on hot-press watercolor paper. (Fabriano Artistico hot-press watercolor paper was used here.) Line impress the stems and their bases.

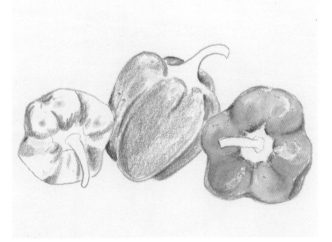

USING COMPLEMENTARY COLORS: STEP 2 Save any highlights with masking fluid or a wax-resist stick. Apply a light layer of light ultramarine blue (the complement of orange) to the furrows and curved, shadowy areas on the body of the pepper. Next, wet this cool, blue layer (as shown on the middle pepper) with a #6 round brush, and allow it to dry completely. Apply dry watercolor pencil in various hues of orange (such as light cadmium red, vermilion, or dark cadmium orange) and yellow (such as dark cadmium yellow). Wet this layer of orange and yellow (as shown on the right pepper) with a #6 round brush, taking care not to brush the underlying blue layer. Allow it to dry.

USING ANALOGOUS COLORS: STEP 2 Save any highlights with masking fluid or a wax-resist stick. Let the fluid dry, and draw the darkest furrows on the peppers with heavy strokes of a reddish orange, such as dark cadmium orange. Add strokes of a yellow-orange (such as dark chrome yellow) on the pepper (as shown on the middle pepper) and cadmium yellow on the lightest areas. Stroking from the light to the dark areas (as shown on the right pepper), apply a wet #6 round brush, pushing the darker orange pigment into the furrows.

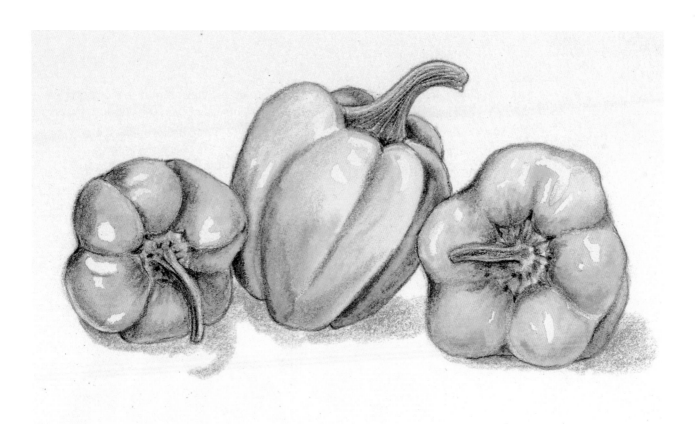

USING COMPLEMENTARY COLORS: STEP 3 Once the watercolor layer is dry, stroke the stems and their bases with grass green and juniper green. Leave the colored pencil layer dry or dissolve it slightly with a Colorless Blender Marker. Define the pepper edges with a Tuscan red or indigo blue Verithin pencil. Add shadows on the stem and its base using Tuscan red or burnt carmine. Peel away any dried mask. If desired, enrich the colors on the body of the peppers with touches of dry pencil. Indicate a shadow with light ultramarine blue underneath the peppers. Leave the shadow dry and textured, or dissolve it into a smooth, fluid wash with a #6 round brush.

USING ANALOGOUS COLORS: STEP 3 Follow Step 3 above for complementary colors.

EGGPLANTS

Eggplants have a simple shape and are uniform in color, but they nevertheless add richness to autumn compositions. Whether they are dark purple or creamy ivory with lavender streaks, their glistening skins are very tactile.

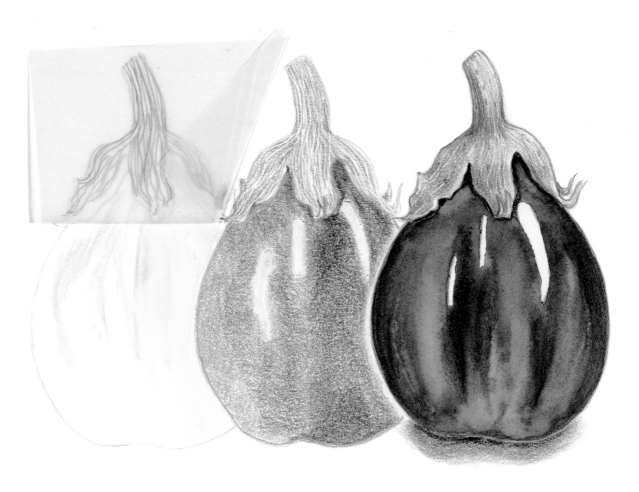

STEP 1 Prepare a line drawing of an eggplant using a light-colored pencil or HB pencil on a fine-tooth watercolor paper, such as hot-press paper. Note the lightest areas, and save them with masking fluid or a wax-resist stick. To add some vibrancy to the deep purple, begin with an under-painting of a layer of light cadmium yellow or canary yellow. Dissolve it into a wash (see right side), and let it dry completely. Line impress the eggplant stem and its base to show textured striations.

STEP 2 Add layers of burnt carmine, followed by Delft blue and mauve. Notice how the underlying yellow layer adds a lively glow.

STEP 3 Apply dry strokes of earth green, May green, and/or olive green yellowish to the stem. Add a little burnt carmine or indianthrene blue to the shadows and leaf contours. Either leave it completely dry or wet it slightly with a Colorless Blender Marker. Using smooth strokes and a large round brush (a #6 or larger), wet the entire eggplant surface, stroking from the lighter values on its face to the darker areas along the edges and soft furrows. Load the brush with extra pigment from the tip of the mauve or Delft blue pencils. While the surface is still wet, touch this pigmented brush to the darkest regions of the eggplant (and remember the dark areas just under the leaves). Allow it to dry completely, and peel away any masking fluid. Add color to the shadows underneath the eggplant, such as burnt carmine or light ultramarine blue, leaving them dry and textured.

Flowers

Flowers have captivated artists for centuries, no doubt because of their varied symbolic meanings and their ability to evoke a mood. The several types of flowers demonstrated here range from the spare sophistication of the calla lily to the buoyant informality of the poppy.

LILIES

The lily is an appealing flower for novices and experienced artists alike because of its simple elegance and slender silhouette. Before beginning, look at a lily from all vantage points to be sure the best angle at which to draw it is chosen.

There is one big challenge in drawing lilies: saving the light stamens and pistil either with masking fluid or by working around them. These details are vital to rendering the flower convincingly, and they should not be an afterthought.

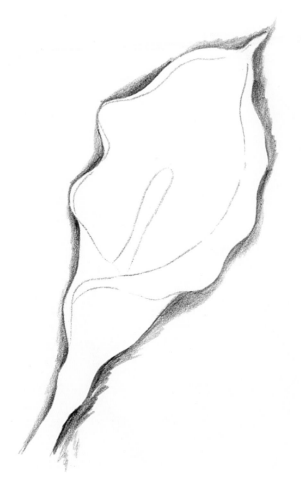

STEP 1 Prepare a lightly sketched calla lily and its stem with a blue Verithin pencil on hot-press watercolor paper. Apply layers of Prussian blue watercolor pencil around the edges.

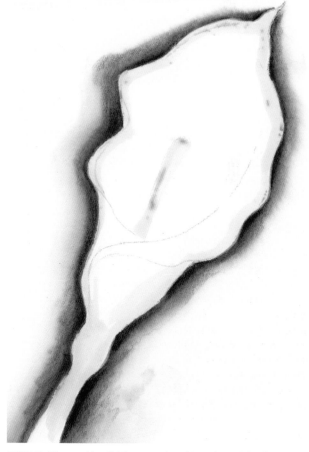

STEP 2 Use masking fluid to save the white edges of the lily petal and the pistil in the center; let it dry. Wet the blue edges with a #12 round brush, stroking from the tip of the flower down to the stem. Rewet the brush, dab off slightly, and run it along the edge of the other side of the flower and stem. To allow the water to flow more freely, tilt the paper slightly back and forth; let it dry.

STEP 3 Prepare a homemade palette by blending mauve and a touch of ultramarine blue. Wet the inner part of the lily with clean water using a #12 round brush. With the same brush, dip into the blended colors on the homemade palette, and touch the brush to the wet, inner area of the lily. (Test its color intensity on a bit of scrap paper that has also been wetted.) This wash creates a soft, subtle shadow.

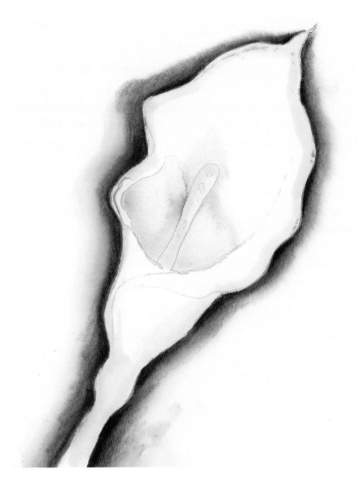

STEP 4 Allow this to dry completely, and then, using dry watercolor pencils, draw over the mauve shadow with streaks of apple or May green, cadmium yellow lemon, and a touch of juniper green. Moving from the top of each streak down to its base, drag either a damp #6 round or #2 rigger brush through the streaks, allowing them to flow together slightly. At the tip of the lily, add a layer of cadmium yellow lemon and a touch of May green. Draw light blue shadows directly under the curling lip of the petal with a thin line of ultramarine blue. Wet this with a damp #6 (or smaller) round brush, and let it dry. (This will create a hard edge, but it works well as a crisp shadow.) Using clean water and a small brush (such as a #2 round), wet the petal where it gently dips and drop in some very diluted smalt blue from a homemade palette.

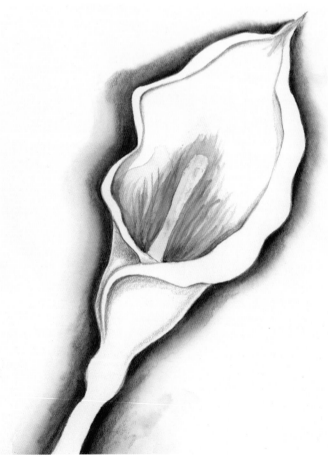

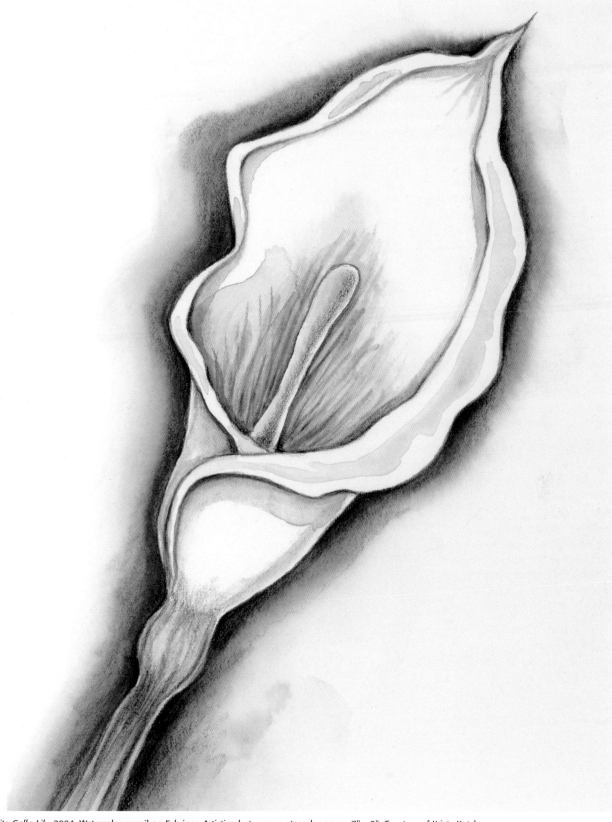

White Calla Lily, 2004. Watercolor pencil on Fabriano Artistico hot-press watercolor paper, 7" × 9". Courtesy of Kristy Kutch.

STEP 5 Peel back the masking fluid from the pistil and the edges. Using circular strokes, apply layers of various hues in this order: light chrome yellow, cadmium yellow lemon, May green, and a touch of juniper green. Add a touch of Tuscan red Verithin pencil at the base of the stalk.

Note the striations and the parallel vein pattern in the lily stem. With May green, cadmium yellow lemon, and juniper green, draw striped lines on the stem. Drag a #2 rigger or #6 round brush through these streaks, stroking from the top to the bottom. Allow the colors to gently flow together. Add subtle contours of burnt carmine to show curves and shadows on the stem, and add warm accents of yellow or cream on the bulging part of the stem. Use an indigo blue or lavender Verithin pencil to refine edges.

MORNING GLORIES

Morning glories are indeed glorious as they unfurl to the early daylight. Their curling tendrils and blossoms reaching for the light seem to move even on paper. The centers of these flowers are uncomplicated, making them appealing to novices. Before beginning, note the range of values in the petals and how they can vary from rich orange-yellow to almost white in the centers, to richly saturated blues toward the outer edges.

STEP 1 Prepare a line drawing of two morning glories (one in profile and the other facing the viewer) with a blue pencil on hot-press watercolor paper. (Fabriano Artistico hot-press watercolor paper was used here.) Save the white of the central pistil with masking fluid, and apply strokes of cadmium yellow and cadmium orange around it. Save any of the very lightest (or brightly sunlit) parts. Graduate the values of blues on the petals by using light, medium, and dark phthalo blue. Draw the darker furrows of the flower with dark phthalo blue, wet them, and let it dry. Using a damp #6 round brush, stroke the flower, starting at the lightest areas and moving toward the darkest. On the blossom in profile, draw the base with cadmium yellow.

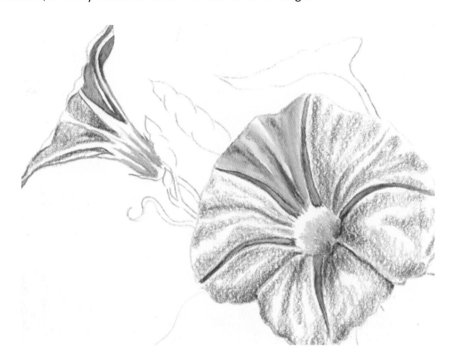

STEP 2 Allow the blue areas to flow together. If any parts of the blossom still need to be lightened, dab the area with a slightly wet brush, or wait until the paper is completely dry and use a battery-operated eraser to lift out the highlights. (Never use the eraser while any part of the painting is still wet.)

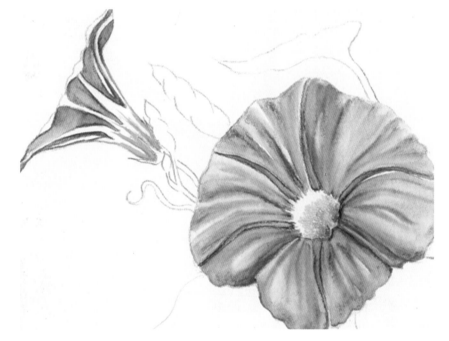

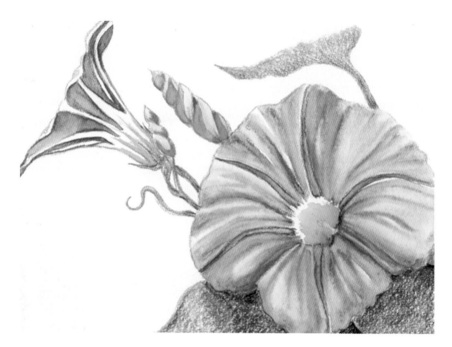

STEP 3 If there are tightly wound, spiral buds, draw with shades of ivory, cream, and grass green, and then wet with a #6 round brush. While that area is slightly damp, paint light touches (from a homemade palette) of a diluted violet wash. Once the bud is dry, add a touch of dry juniper green in the creases. Use a yellow-green, such as May green, as the primary color for leaves, but add some variety with juniper green and/or olive green. Morning glory leaves are often partly hidden or totally recessed in the shadows. Try applying a layer of a very cool color, such as caput mortuum violet, burnt carmine, or indianthrene blue as a base color for the very shadowy leaves.

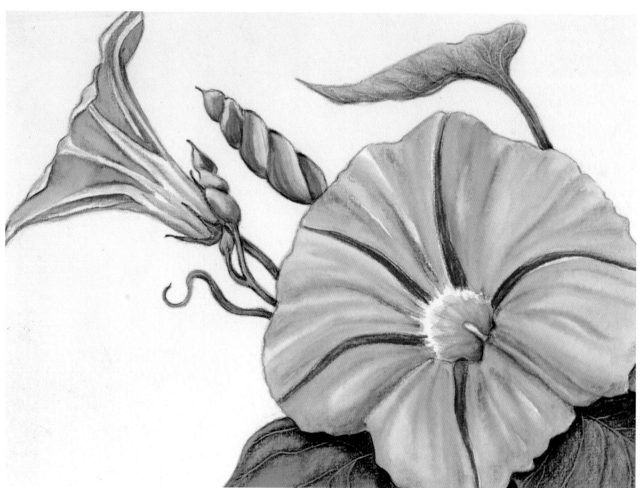

STEP 4 Wet the base color(s) of the leaves with a #6 round brush, and allow to dry. If desired, line impress the veins and follow with a layer of dry watercolor pencil in grass green, earth green yellowish, May green, olive, and/or juniper green. Accent the veins with a Tuscan red or indigo blue Verithin pencil.

Line impress the softly curling stems and tendrils. Follow with a yellow-green (such as May green), layering the receding or shadowy areas with burnt carmine. Leave the stems and tendrils dry for a more matte appearance, or wet them with the fine point of a Colorless Blender Marker for a smoother effect. Use a Tuscan red or indigo blue Verithin pencil to refine the edges. Wet the dark, yellow-orange area in the flower center with a #2 round brush; when dry, peel back the masking fluid from the white pistil, and edge it lightly with a lavender Verithin pencil.

POPPIES

Poppies feature many textures, from the fringe of very dark stamens and buttonlike pistil to the petals, which can be smooth or reminiscent of crepe paper. Each of these textures requires some planning, but they can be painted successfully by following the steps here.

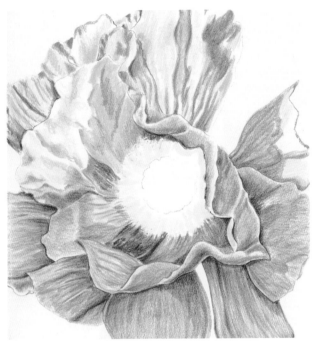

STEP 1 Prepare a line drawing of a poppy using a terra-cotta or lavender pencil on a smooth drawing surface, such as hot-press watercolor paper. Draw in the range of values in each petal, including ivory, cream, cadmium yellow, dark flesh, and cadmium orange in the lighter areas. The darker values should be layered with permanent carmine and madder (the darkest value).

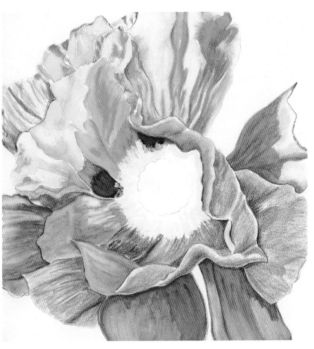

STEP 2 Apply heavy strokes of caput mortuum violet or burnt carmine for the darkest area near the base of the petal. Moving from the light values to the dark values, stroke a slightly wet #6 round brush on each petal. This will leave some of the pigment partially dissolved, lending the petals a crepe-paper effect.

STEP 3 If the petals are more smooth than crinkly, they are often more uniformly colored and have fewer folds. Stroke a slightly wetter brush, moving from the light to dark values. The result will be a more fluid, smooth wash, which helps to represent this type of texture.

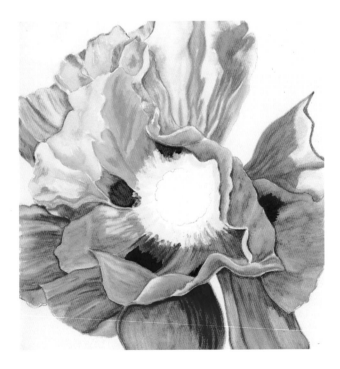

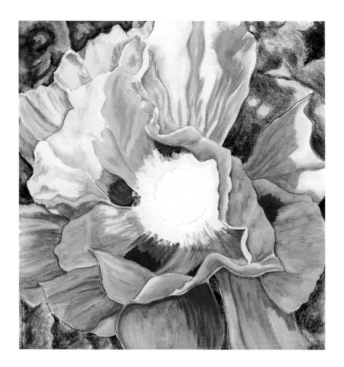

STEP 4 Using a range of hues—such as cadmium yellow lemon, May green, olive green yellowish, and pine green—draw in soft-focused shapes in the background that resemble vegetation. Use a wet #6 round brush to swirl the colors together.

BELOW: *Backlit Poppy,* 2004. Watercolor pencil on Fabriano Artistico hot-press watercolor paper, 8" × 7 1/2". Courtesy of Kristy Kutch.

STEP 5 The many pollen-bearing stamens in the flower's center resemble a chenille-like, dark fringe. By line impressing the stamens—remember not to make them too perfectly aligned—it is possible to render them without drawing each one individually. After making the line impressions, heavily dot walnut brown or sepia and burnt carmine or caput mortuum violet in the few "nooks" between stamens; add a touch of permanent carmine and madder for rosy highlights. For the buttonlike pistil, apply layers of madder on the outer edges and walnut brown in the centers of the sections. To lend a fuzzy appearance, wet the flower center sparingly with the tip of a Colorless Blender Marker. Rewet the bottom petals on the area closest to the center with a damp brush, and grate a little burnt carmine or caput mortuum violet over it to create the effect of pollen. Use a Tuscan red Verithin pencil to refine the edges of the center and petals.

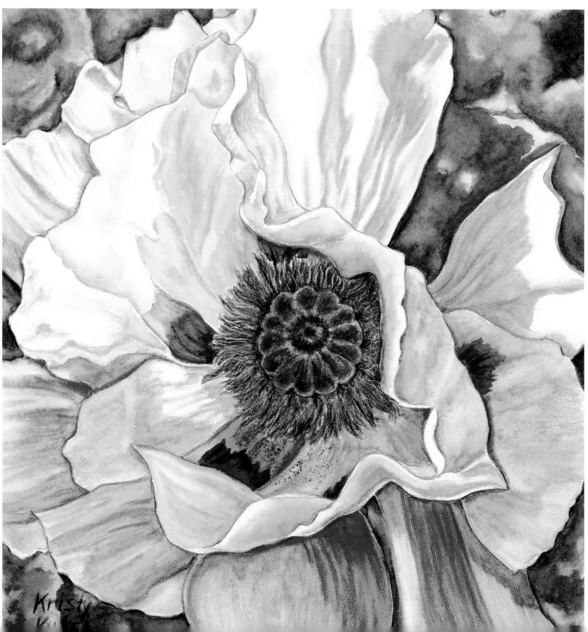

HYDRANGEAS

Patience is important when trying to capture the many blooms of an inflorescence, or composite flower. Hyacinths, forsythias, lilacs, lupines, and hydrangeas have grace, beauty, and terrific appeal, but all the tiny blossoms can be intimidating!

Before beginning a drawing or painting of this flower, study it closely, and examine its individual parts. Note the lovely color range, from very pale smalt blue to phthalo, cobalt, ultramarine, and Prussian blues. The petals often have touches of pink or red-violet, depending on the type of hydrangea and the soil chemistry. Note the structure of one tiny floret, or blossom. When considered one by one, each floret is not difficult to render.

STEP 1 Prepare a line drawing of a hydrangea with blue pencil on hot-press watercolor paper. Apply layers of light cobalt turquoise, light phthalo blue, and middle phthalo blue to the background.

STEP 2 Wet the blue background layers by sweeping the area with the side of a damp #12 round brush. Allow it to dry completely.

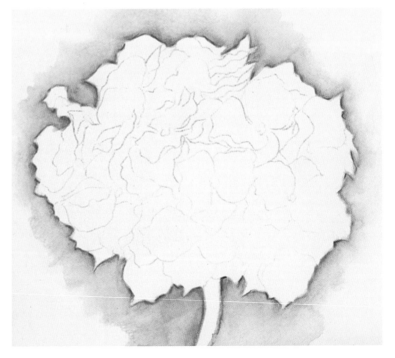

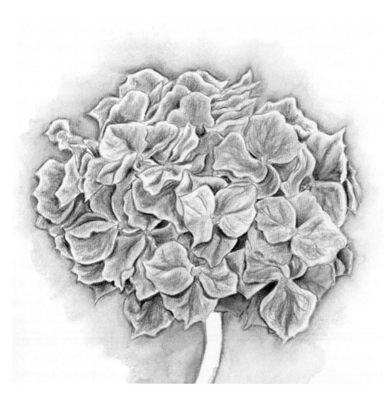

STEP 3 Apply a range of related hues (sky blue, light phthalo, ultramarine, Prussian blue, cobalt blue, and/or light purple) to each tiny floret. Be sure to vary the colors applied to each floret. Apply cadmium yellow to the centers of the florets.

BELOW: *Blue Hydrangea,* 2004. Watercolor pencil on Fabriano Artistico Extra White hot-press watercolor paper, 8" × 7¹/₂". Courtesy of Kristy Kutch.

STEP 4 With a #2 round brush and clean water, wet each floret petal, moving from lightest value to the darkest. To keep each one distinct, skip around the flower to different petals so the wash from one floret doesn't bleed into another. Leave some of the layers partially dissolved. For extra bursts of color, load a #2 round brush with pigment directly from the pencil of the desired color, and touch the tip of the brush into the wet areas.

Apply permanent green olive (or any medium yellow-green) to the stem. Indicate a shadow on the upper stem with juniper green, line impress the veins, and then skim chrome oxide green (a dark green) lightly along the entire stem. Use a Verithin pencil in sky blue, indigo blue, violet, and/or Tuscan red to refine the edges of the flower and stem.

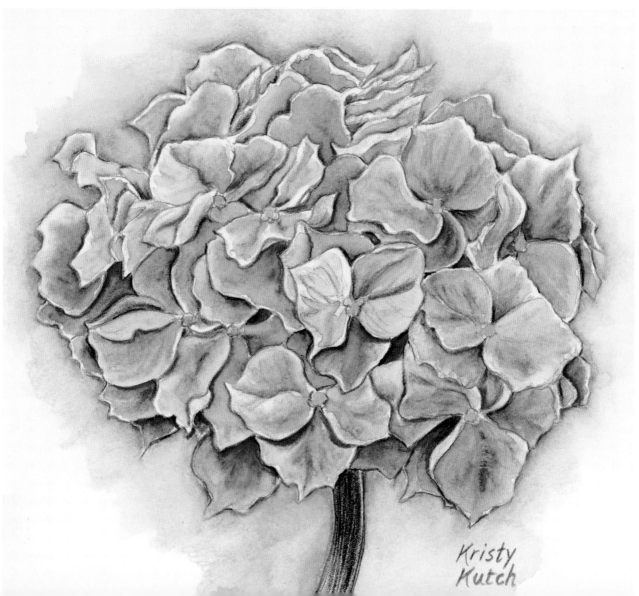

Kristy Kutch

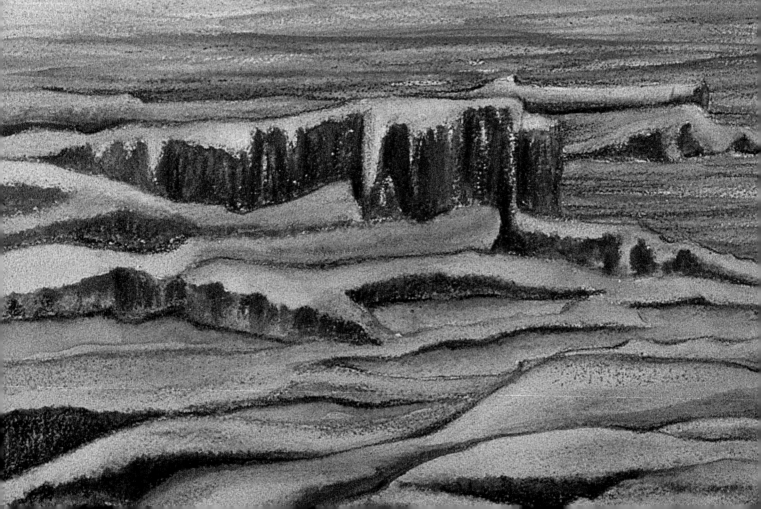

Putting It All Together:

Creating Complete Compositions

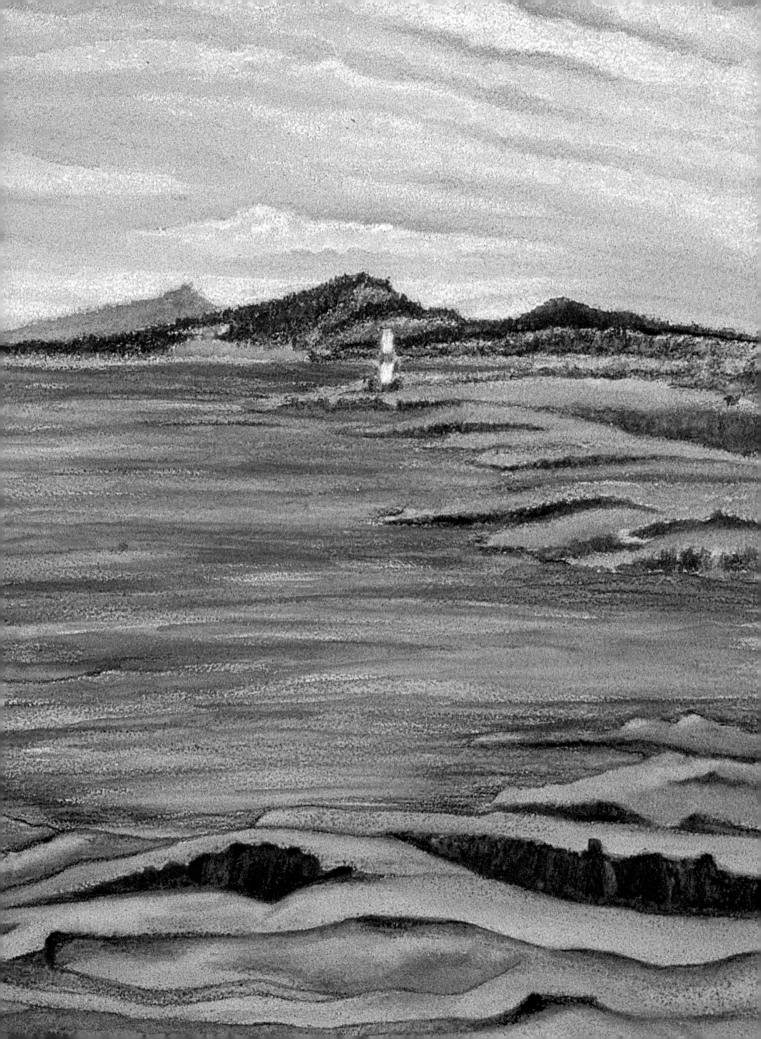

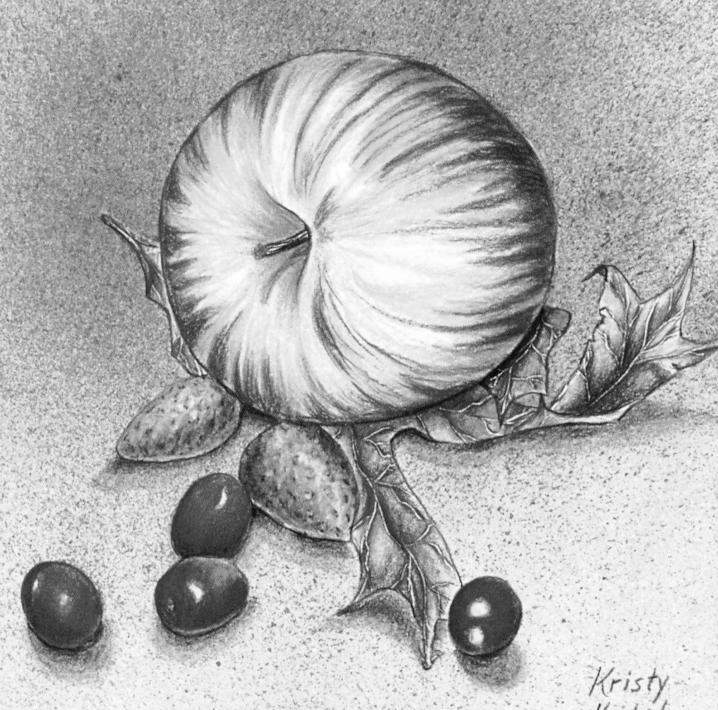

Kristy
Kutch

CHAPTER 7

Beautiful Backgrounds

Capturing just a single subject with traditional or watercolor pencils—whether it's a flower, shell, or piece of fruit—can be a very rewarding artistic experience. But after creating such a work, the artist faces a challenge: what background, if any, would best complete this composition? Planning and anticipating the entire drawing or painting is ideal, but frequently compositions are not created with a background in mind. This chapter explores approaches and strategies for choosing, drawing, and painting backgrounds using wet and dry techniques with traditional and watercolor pencils.

DRY TECHNIQUES

Dry colored pencil backgrounds are easy because there are no surprises: the color goes on and stays exactly where it was applied. Since there is no concern about time (which is sometimes the case with wet techniques where color must be applied quickly while an area is still wet), applying the colors for the background can be done at one's own pace. Dry backgrounds using traditional or watercolor pencil can be soft and subtle or more bold and dramatic. If a more textured background is desired, allow the tooth of the paper to show through the color layers.

THE "NO BACKGROUND" BACKGROUND

Some subjects lend themselves to this approach, which involves allowing the plain surface of the white or colored paper to serve as the background or tightly cropping the image to fill the entire picture plane so that there is little or no background at all.

Golden Delicious, Cranberries, and Almonds, 2004. Colored pencil and watercolor pencil on Borden and Riley regular-finish Bristol board, 14" × 11". Courtesy of Kristy Kutch.

OPPOSITE (DETAIL) AND ABOVE: This still life, composed of just a few elements, called for a "barely there" approach to the background, so that the main focus of the viewer's eye was on the brightly streaked skin of the apple and the glistening cranberries. Two colors were chosen to accomplish this: a cool background of madder and a warm foreground of dark cadmium yellow. Using a toothbrush loaded with pigment from both pencils (at separate times), pigment was spattered on the desired areas to create the subtle airbrushed effect.

Botanical drawings and scientific illustrations are done on a white surface and have no added background elements, such as *Michigan Wildflower* (opposite, top). They look crisp and elegant in their simplicity. Colored pencils are ideal for these subjects because of their precision in applying color.

Another option for a work with no background is to create cool, underlying shadows that include hints of reflected colors to "ground" the subject, such as *Mango and Berries* (below). These shadows are very subtle, requiring just a few strokes. In a composition featuring strawberries, for example, touches of red would be added to the blue shadows. These reflected colors serve to strengthen the overall color unity of the work.

Colored pencil looks striking on colored paper or board, and color builds quickly on these surfaces. (It does, however, take some adjustment to make decisions regarding which colors to choose.) The color of the paper serves as a ready-made background and directs the attention of the viewer to the central features, as exemplified by *Shell with Money Plant* (opposite, bottom). Even sketchy, loose renderings on colored surfaces look complete without backgrounds. Some colored papers have tiny flower petals built into the surface, which are an interesting complement to various subjects.

Severe cropping of the central feature of a composition so there are few or no background elements can create a very arresting work. In an outdoor floral work, such as *High-Noon Hollyhocks* (pg. 104) for example, branches, leaves, blossoms, and stems may fill the entire surface with little sky or additional background features. In a work with an arrangement of fruit, the artist may magnify the most important element so that other features are nearly "crowded out" of the picture.

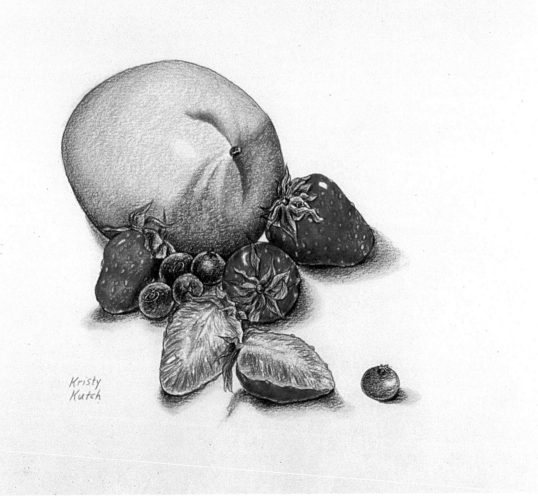

Mango and Berries, 2004. Colored pencil and watercolor pencil on Borden and Riley regular-finish Bristol board, 14" × 11". Courtesy of Kristy Kutch.

Michigan Wildflower,
1997. Colored pencil on
Windberg pastel board,
5" × 7". Courtesy of Kristy
Kutch.

Shell with Money Plant,
1999. Colored pencil
and watercolor pencil on
Fabriano Tiziano pastel
paper, 11" × 7 1/2".
Courtesy of Kristy Kutch.

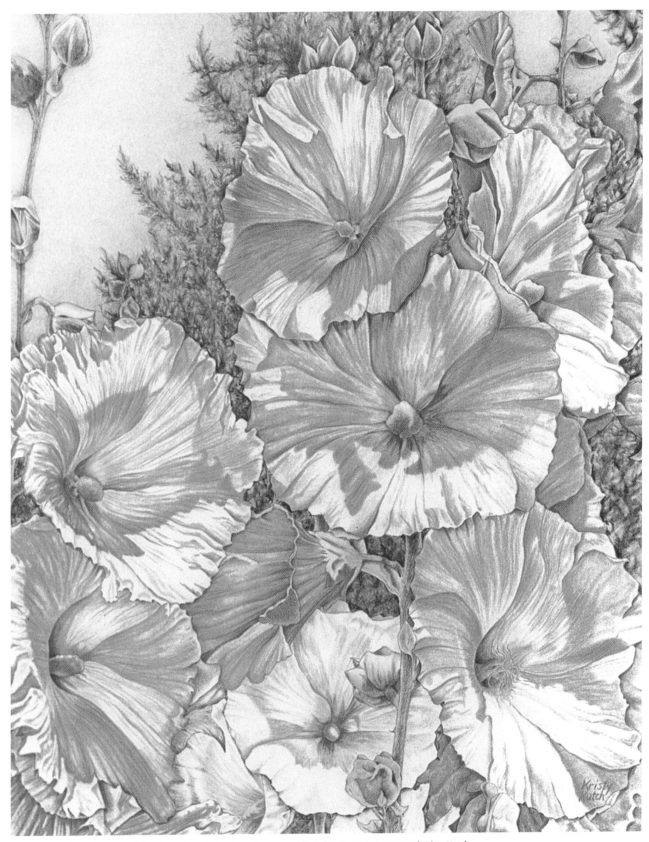

High-Noon Hollyhocks, 2003. Colored pencil on Rising four-ply museum board, 16" × 20". Courtesy of Kristy Kutch.

DRY VIGNETTE

Many portraits or works featuring wildlife have a cloud of color close to the subject that fades into the background. This halo of color is the basis of the vignette background. A soft veil of color hugs the head and shoulders of the portrait subject or the elements in a still life, with the greatest color intensity closest to the subject. *Honeydew and Berries* (right) illustrates the dry vignette for a still life. To create a vignette background, layer the color evenly in circular or linear strokes, making the application lighter as it moves farther from the subject. Oil-based traditional pencils are perfect for this approach, since they can be easily blended with a soft cloth or makeup sponge.

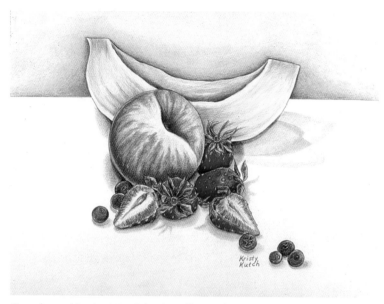

Honeydew and Berries, 2004. Colored pencil on Borden and Riley regular-finish Bristol board, 14" × 11". Courtesy of Kristy Kutch.

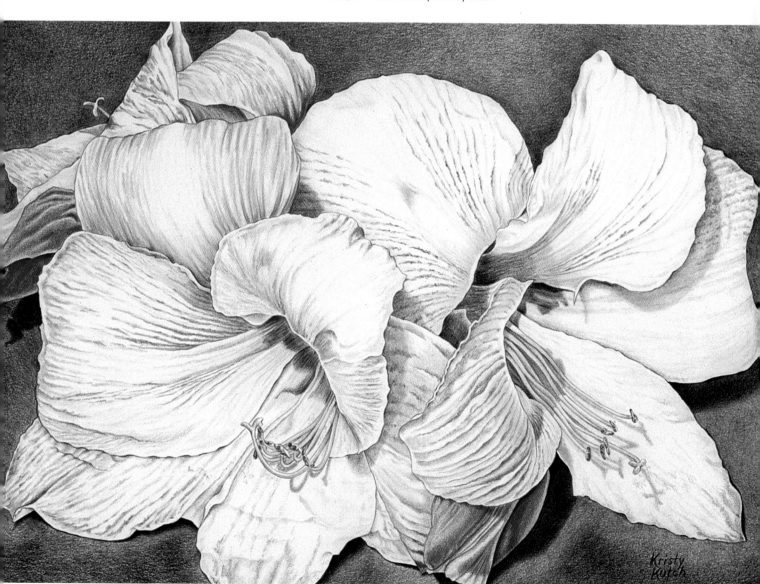

Trinity Amaryllis, 2004. Colored pencil on Rising four-ply museum board, 20" × 15". Courtesy of Kristy Kutch.

SOFT, TEXTURAL BACKGROUNDS

This type of background is simply an expanse of diffuse or saturated color as used in *Trinity Amaryllis* (pg. 105). Using light pressure while applying the background will ensure that the tooth of the paper is evident through the color layers, which is important in creating a sense of a subtle texture. To achieve the best results, cushion the drawing surface (even if it is thick, like four-ply museum board) by placing two or three sections of newspaper underneath it. Using oval strokes and light pressure, apply several layers of color. Using this method of application, individual pencil strokes become less apparent and the multiple layers of color blend smoothly.

A related approach to this kind of background is featuring drapery as a frame for the main elements of the composition, as used in *Nectarine Trio* (below). The drapery will fill the picture plane, focusing the viewer's attention to the objects in the center of the composition.

Linen, for example, can be used as a very attractive, if somewhat neutral, background. It has a visible weave, so it can be drawn easily with crosshatched lines. Velvet, on the other hand, is very luxurious, more dramatic, and has no visible nap or weave. It requires loose, oval or circular, overlapping strokes. The color should be very saturated, which can be accomplished by applying a Colorless Blender Marker to an initial layer of color and following that with another layer of color over the slightly dissolved pigment. It can also be rendered by burnishing with an unpigmented blending pencil.

Shiny fabrics like satin can lend a more formal feeling to a composition. These fabrics should be rendered with high contrast using a very light value or white on the highlights. As a final touch, burnish with white, cream, or an unpigmented blending pencil to enhance the sheen.

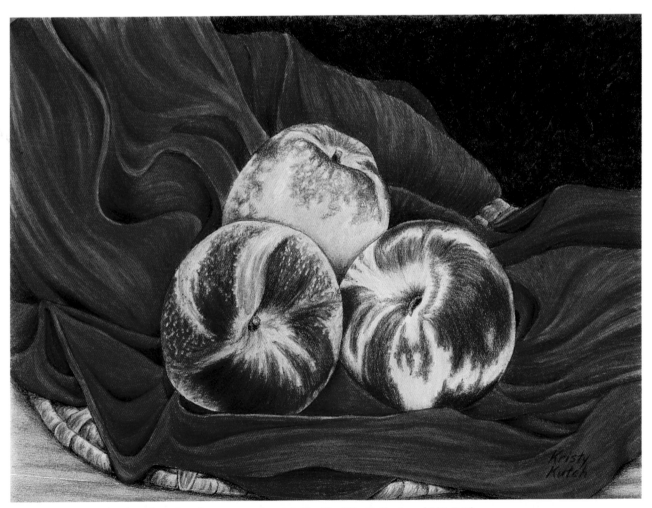

Nectarine Trio, 1996. Colored pencil on Clearprint cotton, translucent drafting film, 10" × 8". Courtesy of Kristy Kutch.

WET BACKGROUNDS

Using wet techniques with watercolor pencil is very effective for creating several types of attractive backgrounds. Veils of color so characteristic of the medium—whether used as a vignette or to cover the entire background—never fail to delight the viewer in their simple beauty. Another very different approach creates an airbrushed effect, producing a unique background.

WET VIGNETTE

To create a vignette using watercolor pencil, use the side of the pencil in the desired color, and apply layers with heavy pressure around the object, graduating to lighter pressure the farther the layers are from the object. Then apply a wet brush to the band of color with the tip of the brush aimed at the more heavily layered color. This creates a greater concentration of color in that area.

This composition with a simple green pear looks complete with the vignette background of Prussian blue. The background was created by applying the pencil strokes close to the edges of the pear, and then wetting the layers with a large brush.

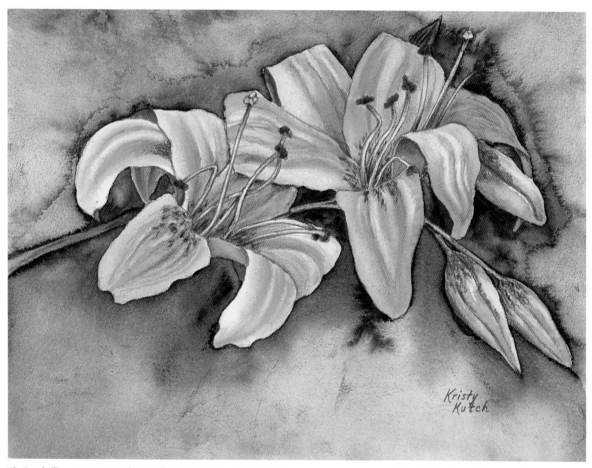

Tie-Dyed Lilies, 1999. Watercolor pencil on Hannemühle Hamburg hot-press watercolor paper, 10" × 8". Collection of Chuck and Penny Cannon.

This wet background was created by applying a heavy layer of violet and then wetting it with a large brush. The soft, tie-dyed effect—with faint watermarks still visible—is a nice contrast with the defined edges of the lilies.

Richly Saturated Watercolor Background

This type of background generally covers the entire surface with deep color and can provide a dramatic contrast to the crisply drawn foreground features. Cool colors—like blues, purples, lavenders, burgundies, and greens—work especially well, because they tend to recede.

STEP 1 Prepare a line drawing of a rose using a light-colored pencil or an HB pencil on textured board.

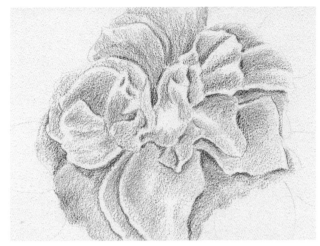

STEP 2 Apply layers of the various hues (from pink to deep rose) on the petals, including pink madder lake, fuchsia, pink carmine, and madder.

STEP 3 Wet a petal using a #6 round brush, and move from the lighter pink areas toward the darker madder areas. Be sure to skip around to nonadjacent petals during this wetting process to avoid the bleeding of color from one petal to another. To create highlights, rinse the brush and squeeze off the moisture so that it is partially dry. Drag it through the area to be lightened, leaving a lighter streak. Apply heavy layers of cadmium yellow and dark chrome yellow to the center, and dissolve the pigment with a Colorless Blender Marker. Draw the leaves with May green, permanent green olive, and pine green.

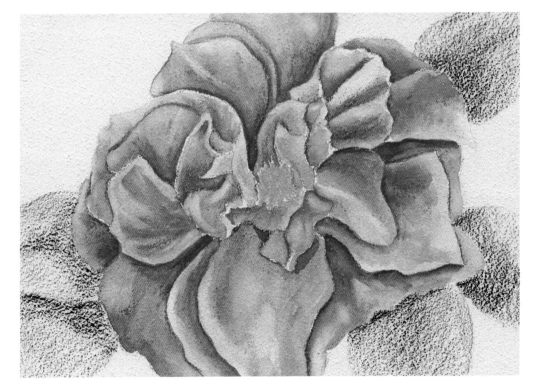

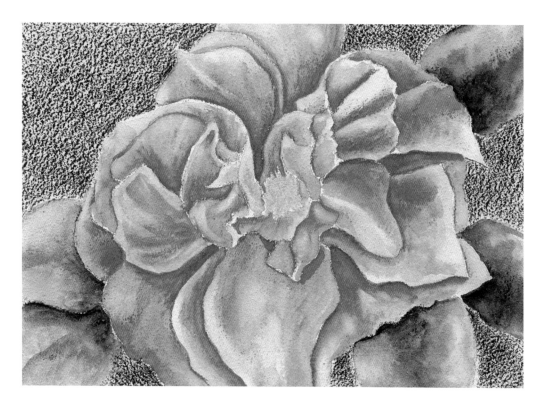

STEP 4 Wet the leaves with a #6 round brush. With heavy pressure, layer the background with Prussian blue, indianthrene blue, and purple.

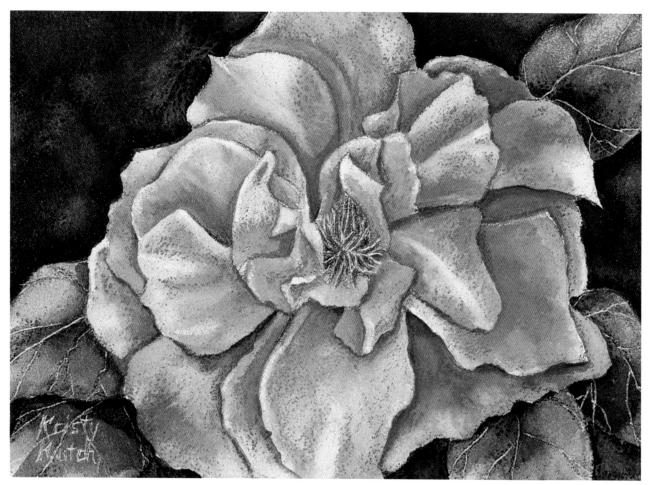

Emmalie's Rose, 2003. Watercolor pencil on Claybord Textured, 7" × 5". Courtesy of Kristy Kutch.

STEP 5 Wet the background with a #6 (or larger) brush using a swirling motion. After this is completely dry, make incisions into the board with a very sharp razor blade or X-Acto knife to indicate fine veins in the leaves. The same razor technique can be used to cut stamens in the yellow center of the rose, which then can be accented with a Tuscan red Verithin pencil and slightly dissolved with the fine point of a Colorless Blender Marker.

Airbrushed Effect Using Spattering

A toothbrush and frisket film are the essential tools to create this background. Be sure to choose a color that provides a dramatic contrast with the foreground subject. Before trying this on a finished work, practice on a piece of scrap paper.

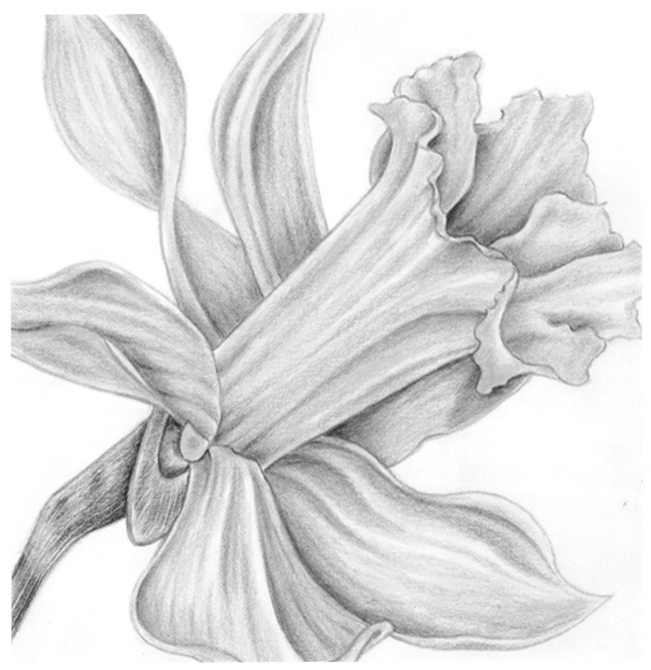

STEP 1 Begin with a finished composition that has a plain background.

STEP 2 Place a sheet of low-tack frisket film *shiny side up* over the drawing. With a fine-tipped, fast-drying permanent marker, outline the edges of the object to create a silhouette on the film. Do not include shadows cast underneath the object when tracing it on the film, as shadows should not be protected from spattering.

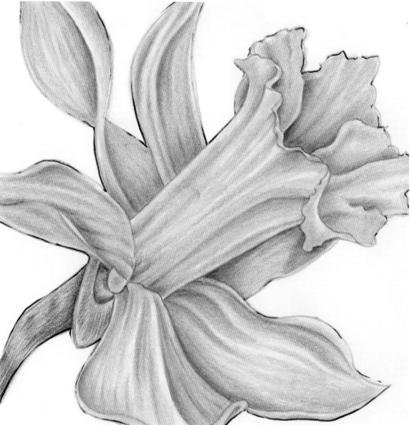

STEP 3 Cut out the pattern, using manicure scissors for precision if necessary. Peel back the film from the paper backing and lightly pat it—be sure not to rub—directly over the drawing to create a shield.

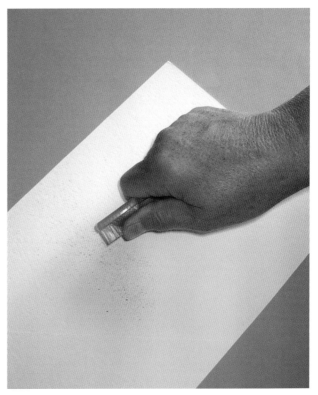

STEP 4 Gather these items: a toothbrush, tissues, water, and watercolor pencils in the desired background colors. Wet the toothbrush and touch it to the tip of the watercolor pencil lead to thoroughly load the bristles with pigment. Dab the brush four or five times with tissues to remove excess pigment.

STEP 5 Gripping the toothbrush between the index finger and thumb, hold it approximately two or three inches above the paper with the bristles down. Using the thumb, stroke the bristles so that pigment sprays off the brush and onto the paper. It may be necessary to reload the brush with new applications of color to achieve the desired results.

STEP 6 Spatter a few layers of cadmium yellow. Allow each spattered layer to dry for at least 15 minutes.

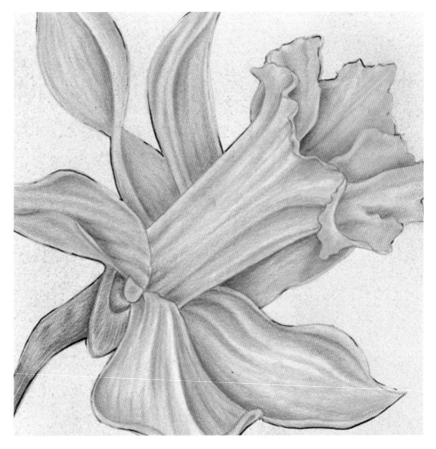

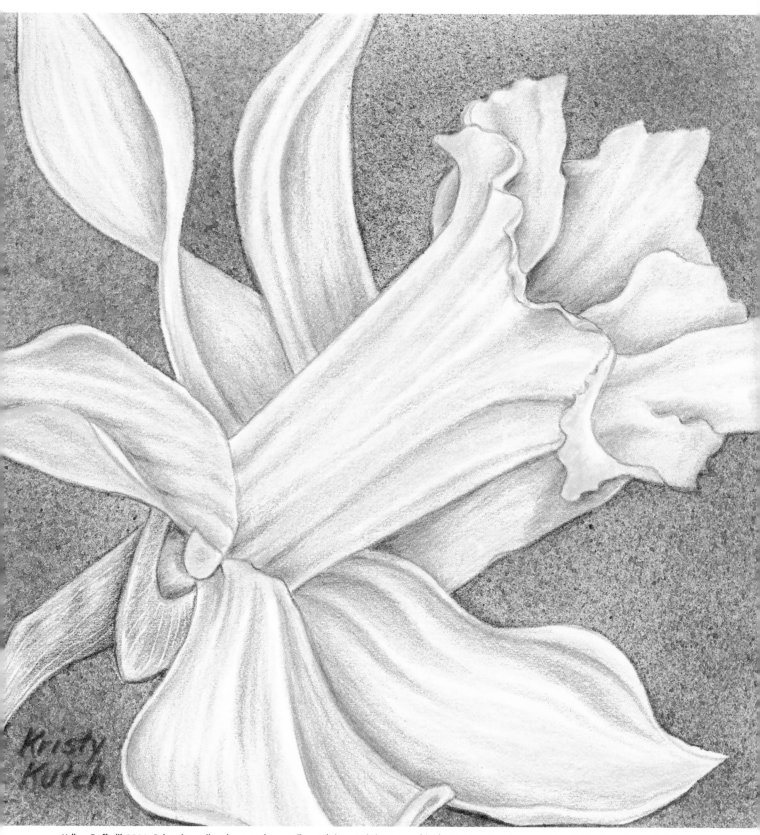

Yellow Daffodil, 2004. Colored pencil and watercolor pencil on Fabriano Artistico Extra White hot-press watercolor paper, 6" × 6". Courtesy of Kristy Kutch.

STEP 7 Spatter the top layer using mauve pigment. (The base layer of yellow, the complement of violet, gives the mauve a warmer, more vibrant effect.) When the background is dry, peel the film back to reveal the drawing underneath. If the film lifted any color, simply reapply as needed. If there are any white areas leftover (this occurs when the film is too large), dot in the colors with a dry pencil to create the airbrushed effect.

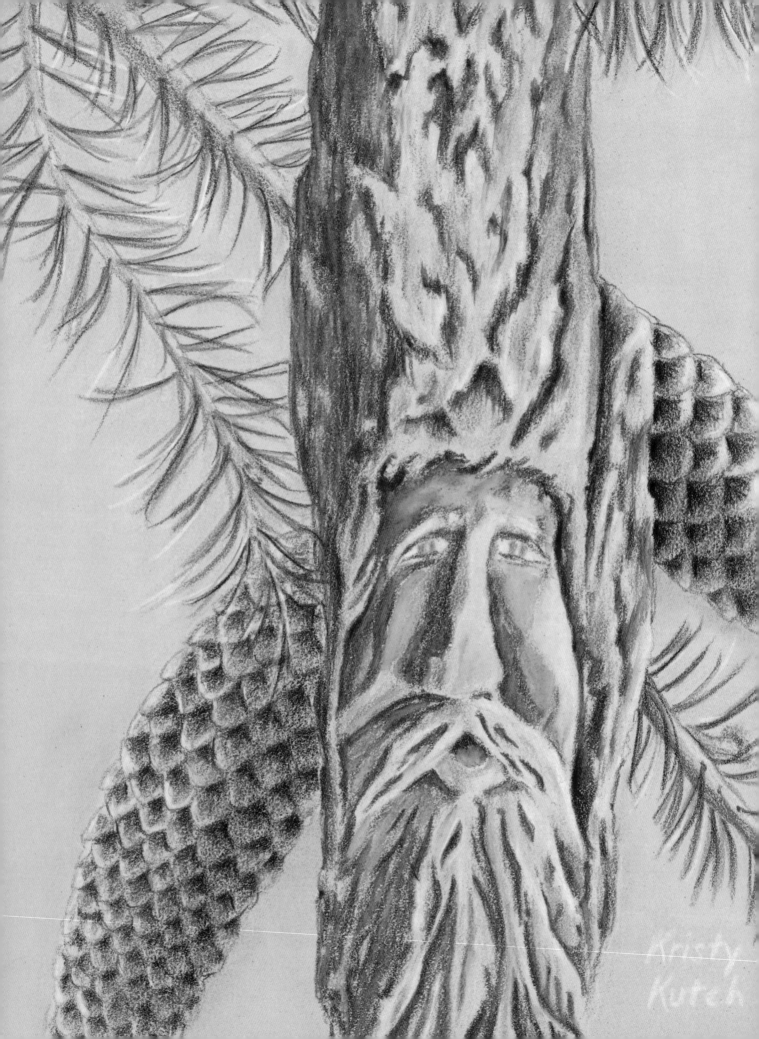

Combining Traditional and Watercolor Pencils in Still Lifes, Landscapes, and Seascapes

The three important genres of still life, landscape, and seascape incorporate a wide range of subject matter. By using traditional and watercolor pencils with wet and dry techniques, however, one has the necessary tools to produce work with confidence in any of these three genres. Building on the information previously discussed, this chapter will bring together the two media and introduce the artist to combining them in the same composition.

While either medium can work well to render any of the elements found in still lifes, landscapes, and seascapes, each one excels at reproducing different features. Applying a wet brush to layers of watercolor pencil creates smooth washes, perfect for skies, bodies of water, and smooth-surfaced objects where the color should be slightly transparent or semiopaque. Layers of watercolor pencil also serve as a good base on which to apply more layers of dry water-color pencil or traditional colored pencil. The base layer fills in the tooth of the paper so surfaces are not "interrupted" by the paper's texture. Dishes and pottery, often found in still lifes, are greatly enhanced by a base layer of color.

Dry traditional and watercolor pencils yield very saturated color and have a somewhat granular lay-down, so they are good for creating more textured effects. Rugged features in landscapes and seascapes are well-suited to either medium, as are flowers and fruit, frequently the central features of still lifes. For objects that are shiny but whose color is dense and opaque, such as various types of fabric, many layers of traditional colored pencil can be applied and then burnished to create a lovely, rich sheen.

Joan's Wood Spirit, 2005. Colored pencil and water-color pencil on Colourfix pastel paper, 8" × 10". Courtesy of Kristy Kutch.

OPPOSITE: Colourfix paper was used for this mixed-media work to enhance the rough textures it features.

STILL LIFES

Still lifes depict inanimate objects—such as flowers, fruit, dishes, vases, fabric, and musical instruments, among other items—which are grouped together in a harmonious arrangement. The first challenge in creating a still life is to create an arrangement that is appealing, which can be difficult with an assortment of disparate objects. Take time to try different combinations of the objects and lighting options, and be sure to draw preliminary sketches to assess how all the elements come together on paper. The second challenge is to render each object realistically. Study the particular characteristics of each object: is it shiny or matte, rough or smooth? Is the color dense or transparent? By spending a few minutes scrutinizing these details, the final result will be much more successful and the experience all the more rewarding.

Using a base layer of watercolor pencil that is slightly dissolved provides a smooth layer perfect for petals, leaves, fruit, or any type of reflective object. Following the base layer with dry watercolor pencil or traditional colored pencil will create rich, saturated color.

While watercolor pencils can be used for burnishing, the results are much better with traditional colored pencils. Use them for very shiny, luminescent surfaces, such as silver cutlery or a pewter urn (both commonly found in traditional still lifes.) And because traditional colored pencils have hard leads that hold a point longer than watercolor pencils, they should be used for fine details such as the delicate patterns of lace or veins in leaves and flowers.

DEMONSTRATION

Still Life

Beachside souvenirs are popular subjects among artists. The combination of a glossy shell, worn driftwood, and gritty sand dollar atop fabric and a woven mat makes a lovely arrangement.

STEP 1 Prepare a line drawing using a violet Verithin pencil with light pressure on hot-press watercolor paper.

STEP 2 On the lower right corner, draw the edge of the cloth and woven mat peeking out from under it. Using masking fluid, mask the edges of the shell, driftwood, sand dollar (as well as the hole on top), and the cloth on the lower right corner.

STEP 3 Using dry watercolor pencil in shades of smalt blue, light ultramarine blue, and indianthrene blue, draw the various values of the cloth, beginning with the light values and ending with the dark values.

STEP 4 With a #12 round brush, wet the blue layers, taking care to push the pigment into the darker areas. Apply masking fluid on the shell's highlights.

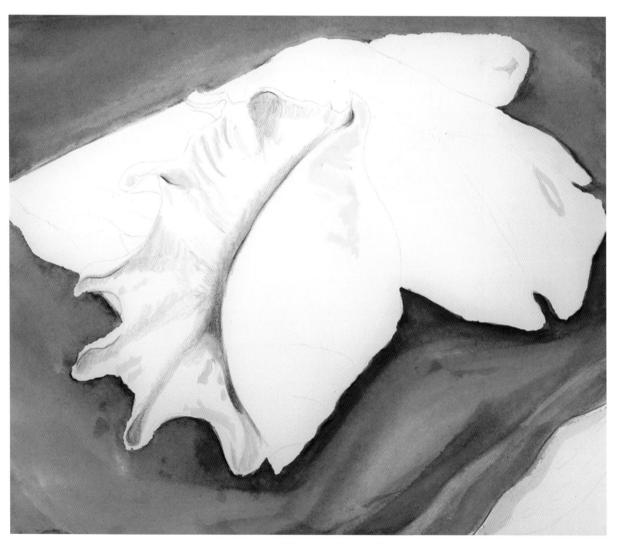

STEP 5 Peel away the masking fluid from the edges of the driftwood and sand dollar. Draw the colors on the inside of the shell with watercolor pencil using light flesh, medium flesh, cinnamon, and Pompeian red. Add strokes of magenta in the shadowy hollow of the shell and touches of light ultramarine blue along the outer, scalloped edge.

STEP 6 With a #12 round brush, wet the inside of the shell. While it is drying, using the same colors, draw the stripes and patches on the right side of the shell.

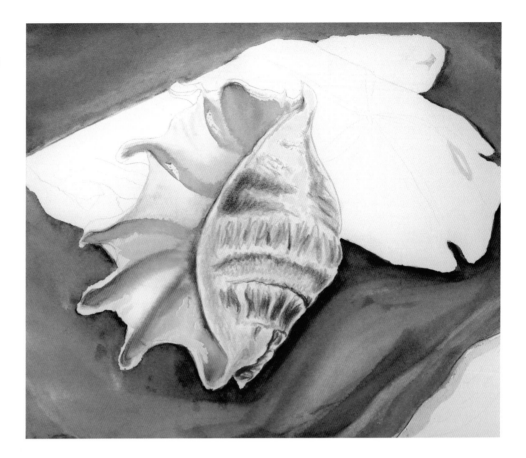

STEP 7 Using a #6 round brush, stroke the stripes on the right side of the shell. Let it dry completely. Peel back the masking fluid to reveal the highlights.

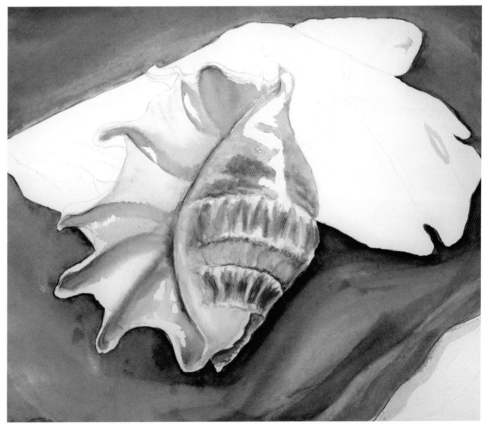

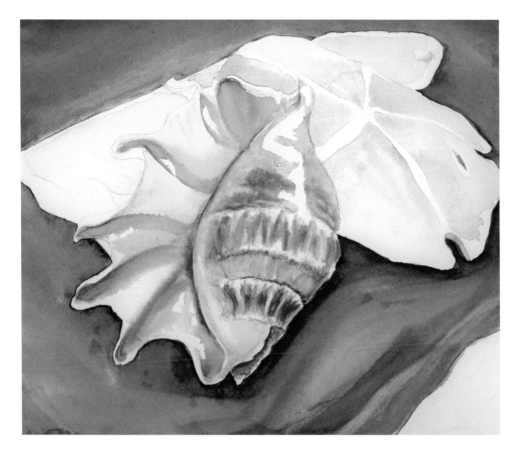

STEP 8 On scrap paper, prepare a homemade palette of light ultramarine blue and Pompeian red. Wet a #6 (or larger) brush with clean water, dab off any excess, and stroke a section of the sand dollar. Dip the same brush into the light ultramarine blue from the homemade palette, and stroke the brush on the wet section of the sand dollar. Repeat the process with Pompeian red. Paint the remaining sections of the sand dollar in the same way, alternating the light ultramarine blue and Pompeian red. Follow the same procedure with the piece of driftwood, brushing it with a wet brush and stroking it with light ultramarine blue. Allow these areas to dry completely. Peel back the masking fluid on top of the sand dollar and on the edge of the cloth.

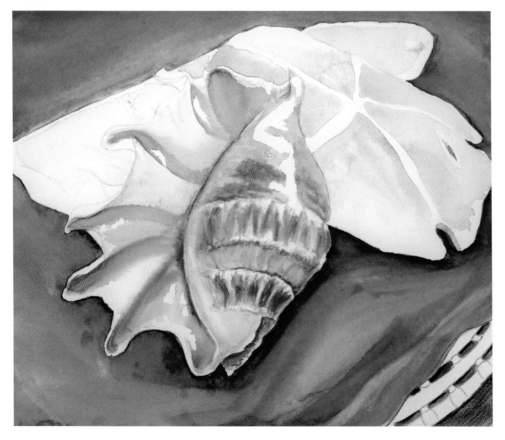

STEP 9 Draw the mat and the area under it using watercolor pencils in magenta and indianthrene blue. Line impress the woven texture of the mat.

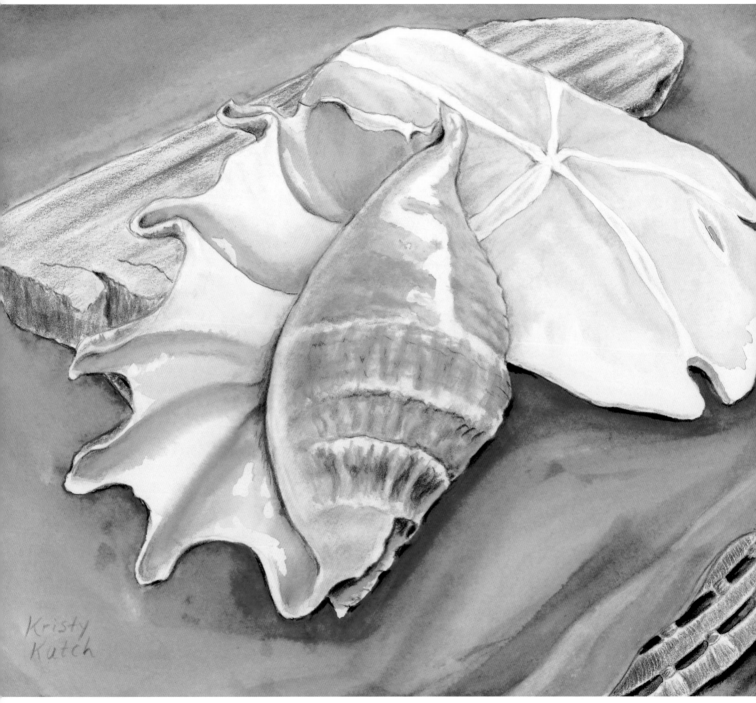

Shoreline Treasures, 2005. Colored pencil and watercolor pencil on Fabriano Artistico Extra White hot-press watercolor paper, 10" × 8". Courtesy of Kristy Kutch.

STEP 10 On the shell, apply a layer of white, ivory, or cream traditional colored pencil to burnish, followed by layers of the following traditional colored pencils: periwinkle blue or blue violet lake, Tuscan red, and sienna brown. Apply layers of blue violet lake, lilac, or a very light layer of imperial violet around the curved edges of the shell. Follow this with another burnishing layer of white or cream. (This creates a pearly sheen on the shell and also blends the underlying layers.) Apply additional shadows on the sand dollar with blue violet lake and a hue of violet using light pressure. Blend these soft shadows with an eye shadow applicator, if desired. Render the driftwood with streaks of traditional colored pencil in light French grey or warm grey, cloud blue, light umber, and periwinkle on the darkest areas. Use an indigo blue or Tuscan red Verithin pencil to refine the edges. With a #6 round brush, wet the underlying areas that show through the mat. Use light umber, Tuscan red, and periwinkle traditional colored pencils for the mat, and accent the details with a Tuscan red or indigo blue Verithin pencil.

LANDSCAPES AND SEASCAPES

Colored pencils are compact, portable, and neat and are therefore an ideal medium for the traveling artist who enjoys drawing and painting landscapes and seascapes. Just a few items are needed: a sketchbook, colored pencils (both traditional and watercolor), and a few supplies (an eraser, reusable putty adhesive, a brush, a Colorless Blender Marker, and a container of water). Of course, the artist working in a home studio from reference photos can also create beautiful landscapes and seascapes.

UNDERSTANDING PERSPECTIVE

Perspective is the method used to represent three-dimensional objects on a two-dimensional surface. It plays an essential role in rendering any scene realistically. In a composition that uses perspective effectively, objects closer to the viewer appear larger, and objects farther away appear smaller.

There are several types of perspective, but the two that are most important to colored pencil art are color perspective and atmospheric perspective. Color perspective entails using warm and cool colors to convey the impression of distance or proximity. Appropriate cool colors (which recede in a composition) in either type of colored pencil include various hues of blue (smalt, periwinkle, and ultramarine); green (green earth, jade, and celadon); burgundy (Tuscan red, burnt carmine, black cherry, and caput mortuum violet); and violet (lilac, lavender, mauve, and black grape). Lightly applied layers of lavender or cool blues set back the more distant landscape features, such as forests and mountains.

As the landscape moves closer to the viewer, warm colors are used to enhance the impression of proximity. Warm colors include (in either traditional or watercolor pencil) cream, yellow, chartreuse, apple green, limepeel, olive, and hues of ochre and gold. Although there may be cool-colored features in the foreground, such as purple flowers or violet shadows, the overall color palette is warm.

Color intensity also adjusts with distance. Generally, distant mountain ridges, for

example, are rendered in softer, lighter values with a hint of cool colors, which are more muted and subtle. As a rule of thumb, the closer the object is to the viewer, the more intense and saturated the hues become.

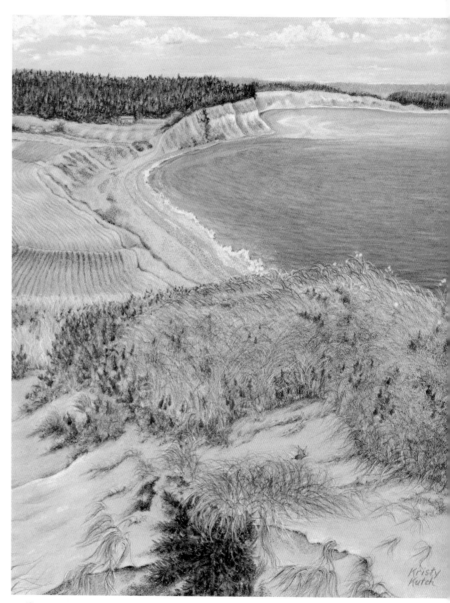

Pacific Panorama, 2004. Colored pencil and watercolor pencil on Colourfix pastel paper, 12" × 15". Courtesy of Kristy Kutch.

This scene from the coast of Washington state was executed using watercolor pencil and traditional colored pencils. Dry watercolor pencil in cool shades of blue and violet define the muted Olympic Mountains in the distance. Violet watercolor pencil was applied and dissolved into a wash to render the shadows on the summit. The bay, in intense shades of Prussian and phthalo blues, was drawn with curved lines to imitate the waves, and was later stroked with a wet brush. The dune grass in the foreground was drawn with hundreds of strokes of traditional and Verithin colored pencils.

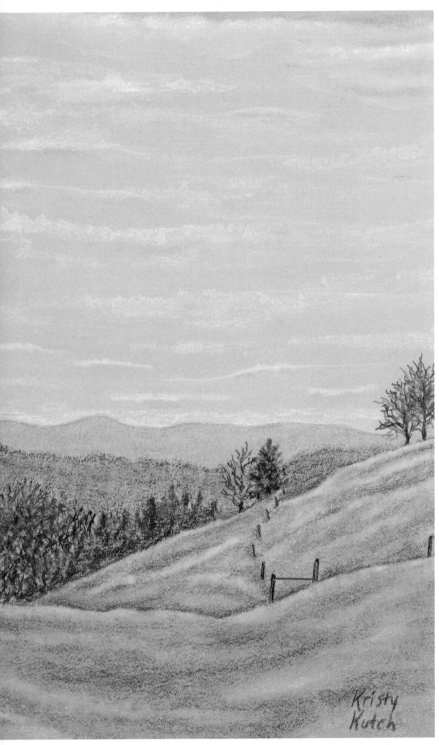

Terry's Backyard, 2005. Colored pencil and watercolor pencil on Colourfix pastel paper, 6" × 9". Courtesy of Kristy Kutch; reference photo courtesy of Terry Henry.

Employing principles of atmospheric perspective was essential to capturing this scene of the mountains of North Carolina, which are known for their hazy, bluish colors. To represent that overall tonality, various hues of blue in both traditional and watercolor pencil were used. Smalt blue or light ultramarine blue watercolor pencils were used on the most distant ridges to emphasize their slightly blurred edges. The ridges and hills closer to the viewer are more focused, with just a touch of cloud blue traditional colored pencil on the hillside.

In works employing atmospheric perspective, features in the distance are muted and hazy, while foreground features are much more distinct. The greater the distance between the viewer and the feature, the more soft-focused the feature should be. The aim is to reproduce on paper how one actually sees, so rendering distant objects in meticulous detail would be inconsistent with that. By contrast, objects closer to the viewer are very focused. Frequently, artists use aspects of both types of perspective when creating a work.

CREATING A REALISTIC LANDSCAPE: FOUR PRINCIPLES

The four guidelines here will prove invaluable to the artist new to landscapes, and for the more experienced artist, they serve as a gentle reminder. Two of the principles are based on the tenets of color and atmospheric perspective.

1 **WORK FROM THE DISTANCE TO THE FORE-GROUND.** This principle is well-known to watercolorists, as the sequence in which various elements are painted is critical to the final result. It is also very important for colored pencil artists when creating a landscape. Render the sky, and the land will more naturally take its place. Overlapping landscape features are most convincingly portrayed when the sequence moves from the background to the foreground.

2 **THE CLOSER THE LANDSCAPE FEATURES ARE TO THE VIEWER, THE MORE DETAILED THEY BECOME.** This is one of the aspects of atmospheric perspective discussed above. Distant mountains, fields, and cloud banks are drawn more loosely, often with gestural strokes using the side of the pencil. The parts of the landscape that are closer to the viewer, however, become more focused, more detailed, and proportionately larger. Pay special attention to the shape and growth patterns of the trees, bushes, flowers, and grasses in the foreground. Keep the pencil points sharp, because they produce sharper details. Verithin pencils, with their needlelike leads, are ideal for these details as they render fine branches, twigs, and grasses with precision.

3 THE CLOSER THE LANDSCAPE FEATURES ARE TO THE VIEWER, THE MORE INTENSELY COLORED THEY BECOME. This is one of the critical aspects of color perspective. More color intensity on foreground features can be accomplished easily by using a damp brush and stroking the watercolor pencil layers on these features (which can include grasses, bushes, flowers, leaves, and rocks) and layering another application of watercolor pencil on top of the wash. The artist can use traditional colored pencil as well for these features by applying layers with heavy pressure. The objects closest to the viewer become even more intense by using a Colorless Blender Marker to dissolve the pigment, then repeating the color over the dissolved strokes.

4 KEEP PENCIL STROKES IN A VERTICAL TREND FOR MEADOWS, FIELDS, AND GRASSES. Short, vertical strokes are ideal for these features and for the shadows that fall on or underneath them by lending a more natural, integrated appearance. If the first color layer is applied with light sweeps using the side of a pencil or woodless pencil rod, be certain to follow that with layer(s) of short, vertical lines. If there are shadows cast on the land, use this type of stroke for these darker areas, too.

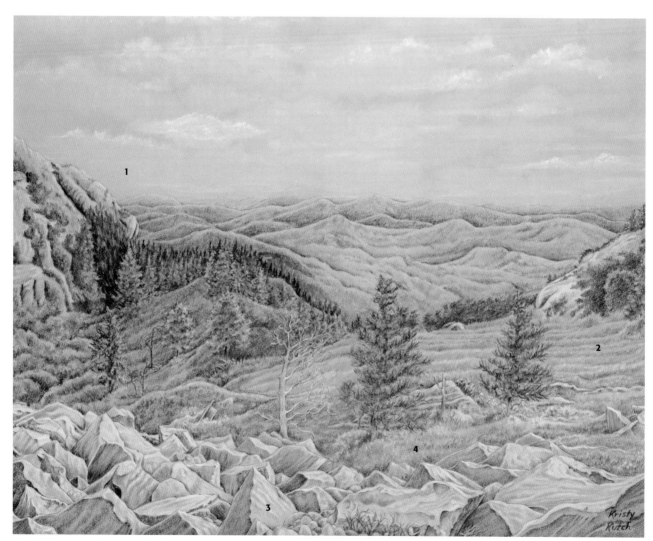

Grandfather Mountain, 2004. Colored pencil and watercolor pencil on Colourfix pastel paper, 20" × 16". Courtesy of Kristy Kutch.

This work is numbered to show the sequence in which the various areas of the landscape were drawn. As with every landscape, it was begun by drawing the features in the far distance first (1). The next area drawn was the rocky, mossy ridge on the right (2), which was rendered with more detail than the distant mountain features. The large boulders in the foreground (3) were drawn using rosy greys, soft greens, and bluish greens. Because they are close to the viewer, these features were executed with more detail and color saturation. The last area drawn was the foreground vegetation (4)—the trees and grasses and the shadows that fall on and under them.

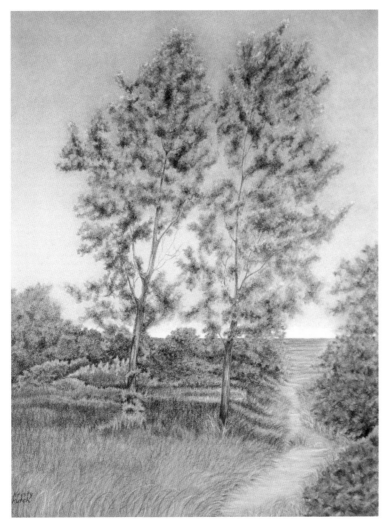

Tom and Betty Poplars, 2003. Colored pencil on Colourfix pastel paper, 18" × 24½".
Collection of Tom and Betty Pellegrini.

It was essential to capture the feeling of the movement of the lightweight poplar leaves, which was accomplished by applying short strokes that were then scumbled. Since poplars have leaves that flutter in the wind and reflect the sun, it was important to create those highlights by using traditional colored pencil in cream, ivory, and white (watercolor pencils would also work for this). Warm greens, like apple green and olive green, were used on the leaves, and deep cool greens, like juniper green and dark green, were used on the more shadowy areas. Burgundies, such as Tuscan red, black cherry, and burnt carmine, were used on the deeply set boughs. Strokes of Verithin pencils—in silver and gold, along with a few other colors—completed the dune grasses in the foreground.

1 2

To draw a boulder covered with moss, draw an outline of a boulder and stroke in a base color of a greyish green, such as earth green, using watercolor pencil (1). Then wet the boulder with a damp #6 brush, and quickly grate watercolor pencils in the desired hues over the boulder, such as grass green, earth green, juniper green, and burnt carmine. Add a shadow in earth green and grass in grass green and earth green, if desired (2). When the grating is finished, lightly blow away the excess pigment.

ELEMENTS OF A LANDSCAPE AND SEASCAPE

The important features of any landscape or seascape are trees; mottled and gritty features, such as mosses, lichens, and sand; skies, clouds, and mist; and water. The following section describes how to execute each convincingly.

TREES

It would be maddening—and nearly impossible—to draw or paint all the leaves on a tree one by one. Thankfully, it is not necessary to do this in order to realistically draw a tree. Before doing so, it is helpful to observe several characteristics: its overall shape or silhouette, how the branches grow from the trunk and how far apart they are from each other, and how the leaves move.

Deciduous trees, such as poplars, aspens, and maples, have leaves that are lightweight and move easily in the wind. Pencil strokes used to render these leaves, using either type of colored pencil, should be drawn loosely. Often there are gaps of open sky visible, so the leaves and boughs should not be drawn too closely together. For trees with leaves that are densely massed, like finely pruned topiary trees, the strokes should be closer together, with very little—if any—background peeking through them.

Color, of course, is important. Use shades of green (such as apple green, limepeel, olive, dark green, or jade green in traditional colored pencil) for deciduous trees and burgundies (such as Tuscan red in traditional colored pencil) for the shadowy areas. Use cream or white in either type of colored pencil for glints of highlights on leaves to indicate where the sunlight strikes them. Study the trunk color and texture (use a tree reference guide, if possible), and note that some tree trunks may be French grey with touches of Tuscan red, rather than shades of brown. If the boughs hang low, be sure to draw their shadows on the trunk. Frottage, as described in Chapter 3, is ideally suited for rendering evergreens such as spruce, fir, pine, or conifer trees.

MOTTLED AND GRITTY FEATURES

There are many speckled objects in nature that can best be described as mottled. Lichens and mosses, for example, add

touches of blue-green, bright green, and sometimes orange to rocks, boulders, trees, and logs. At first, these features may seem impossibly intricate, with small spots of very dense color, but they are relatively easy to render using the grating technique and watercolor pencils.

Gritty features like sand are greatly enhanced by using salt. Using dry watercolor pencils, stroke heavy layers of the desired colors, and wet these layers with a damp brush. While the area is still wet, sprinkle some table or Kosher salt over it. The salt absorbs the wet pigment, leaving a granular texture. Allow the area to dry completely before brushing away the salt granules.

SKIES, CLOUDS, AND MIST

Before drawing and painting these elements, it is important to study them. Observe the different types of clouds (such as wispy cirrus clouds and billowy cumulus clouds) and how they move in the sky. Depending on how the light falls on them, highlights will differ in shape and brightness. These highlights generally occur along the tops of the cloud ridges with darker values in the "underbelly" of the cloud. (Light reflecting in unusual ways or early evening sun can reverse this, however.) Reflected colors of pink, peach, and lavender may also appear in the sky and in the clouds themselves, especially at sunrise and sunset. Dramatic storm clouds are heavy with moisture and they appear so with their overall dark tones. Fair-weather clouds are generally light in color with small bursts of dark color for the most dramatic shadows. Watercolor pencils in smalt blue, light ultramarine blue, or light cobalt turquoise are effective midrange values for clouds, and ultramarine and cobalt blue are perfect for rendering the darker shadows.

Skies drawn and painted with watercolor pencil on colored paper take shape quickly. (Traditional colored pencils can be employed as well for equally satisfactory results.) Colored paper with a watercolor paper base allows for a much longer drying time and thus more time to manipulate the wet colors. Once the painting is dry, the paper will accept more layers of color, if desired.

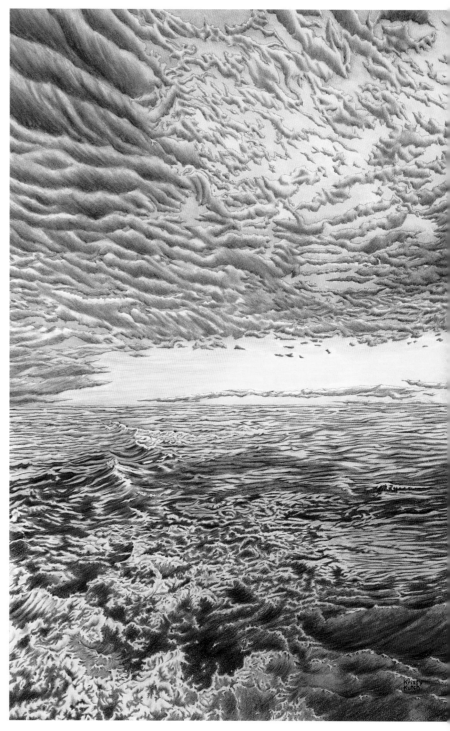

Wake, 1995. Colored pencil and watercolor pencil on Lana hot-press watercolor paper, 18" × 27". **Courtesy of Kristy Kutch.**

This vivid work was inspired by a brilliant, late summer sunset on Lake Michigan. Watercolor pencil was used for the many clouds and patches of sky, but to keep these areas well-defined, they were stroked with a Colorless Blender Marker. The waves and ripples in the foreground were drawn with traditional colored pencils, and then wetted with a Colorless Blender Marker to dissolve the pigment. To create the spray of water in the left foreground, a toothbrush loaded with white pigment was spattered across the area.

To practice drawing clouds, use a colored paper that accepts water media. After drawing the general shape of the cloud with white watercolor pencil, add blues and greys to the underside and in the shadows (1). With a light touch and a #6 round brush, wet the cloud; be aware that it takes surprisingly little water to dissolve the pencil layer. Swirl the brush in a circular direction, in keeping with the rounded cloud forms. (If the cloud is a wispy cirrus cloud, imitate that form with linear brush strokes that trail off when pulling the brush away from the paper.) Load the brush with pigment to create more shadows (such as light cobalt turquoise and light ultramarine blue), and touch the loaded brush into the desired areas of the cloud for a wet-into-wet effect (2). For added emphasis, stroke the brightest whites with more white pencil (3).

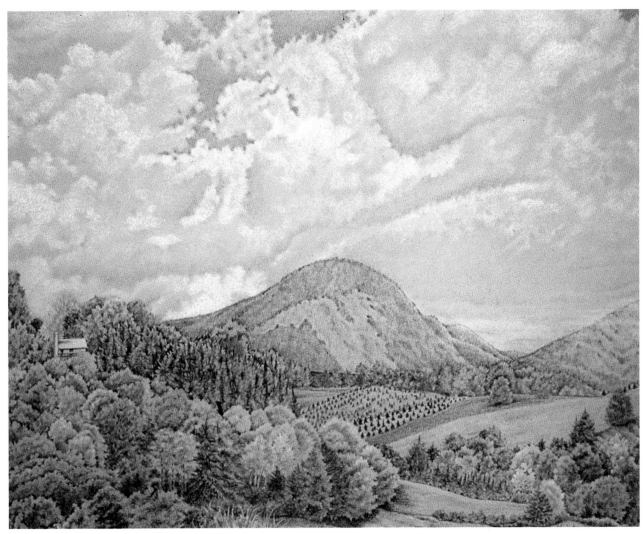

Blue Ridge Dreams, 2002. Colored pencil on Colourfix pastel paper, 20" × 15". Courtesy of Kristy Kutch.

The sky in this mountain scene was drawn using traditional colored pencils and by applying heavy pressure. The full-bodied clouds were drawn in cloud blue, periwinkle blue, and white.

To render mist and fog, Washington artist Edwina Kleeman suggests grating a traditional colored pencil over dry, heavily textured paper (which will hold the pigment shavings easily). This should be done with a white pencil as the very last step. To make sure the pigment adheres to the surface, gently dab at the area with a cotton ball or swab. Repeat the grating process, if desired. Place the work on a flat surface, spray it with fixative to permanently set the pigment in place, and allow it to dry before moving it.

WATER

Water fascinates many artists working in a variety of media perhaps because of the many moods it can create. Crashing waves or the ocean in the middle of a storm are favored by artists who have a penchant for drama, while the peaceful serenity of the still water of a lake or pond suits quieter sensibilities.

Smaller bodies of water are often calm and very smooth. For this reason, it's best to use hot-press watercolor paper. To draw ponds, pools, and other still bodies of water, use the side of the pencil (rather than the point) in various hues of blue and touches of green watercolor pencil, and dissolve with a large brush. The larger the brush and the more sweeping its stroke, the smoother the overall effect will be.

A lake or bay may have slightly choppy ridges or swells. A more textured watercolor paper, such as cold-press, should be used for this because the toothy flecks of paper will peek through the color and appear like glints of light on the waves. Draw the most distant waves as shorter dashes and dark lines close together, but not too perfectly spaced or straight. As the water approaches the viewer, draw the ridges of the waves with longer strokes that are softly curved. The swells should appear larger and the wave intervals should be farther apart. Swells closer to the viewer should have greater definition. Once the water has been drawn with dry watercolor pencils, wet and lightly dab off a one-inch-wide flat brush. Carefully wet the wave ridges with the brush. The bristles should point straight down on the paper; do not use the side of

the brush. For more active waves, do not completely wet each wave as the dryness of the undissolved pencil and the white flecks of the paper create an impression of greater choppiness. If there is a sky in the composition, be sure to add some contrast at the horizon with a tiny band of white between the water and the sky.

Rippled or slightly choppy water is easily created by drawing the ripples with watercolor pencils in ultramarine blue, Prussian blue, and light cobalt turquoise (top). The troughs of the waves near the horizon should be shorter and closer to each other, and as they approach the viewer they should be progressively longer. With the side of a one-inch-wide flat brush, stroke the waves until they are partially wetted, leaving some tooth of the paper showing (center). Once the rippled water has dried, the sky is stroked with clean water and wet-into-wet streaks of light cobalt turquoise and ultramarine blue are dragged into it with a #12 round brush from a homemade palette (bottom). These sky colors should softly flow together, which can be helped by gently tilting the paper back and forth.

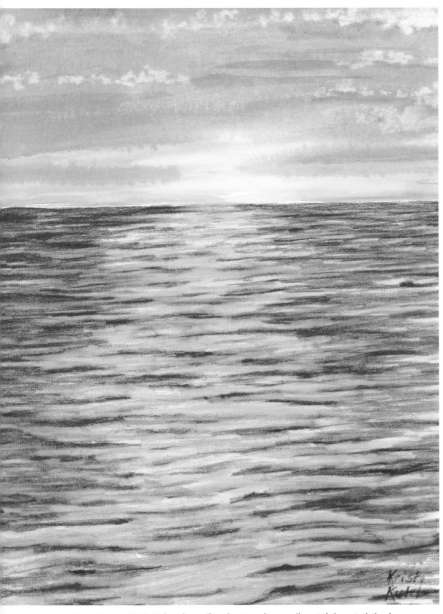

Curling whitecaps and foamy water can be a little intimidating, but using the proper paper (such as cold-press or other heavily textured watercolor paper) and practicing the technique described in the caption below will ensure that these features are rendered convincingly.

Remember that a curling wave is an object, even though it changes its shape in a split second. Because of this, it should be drawn sketchily in a light blue pencil with uneven, ragged edges. Be sure to include plenty of random irregularities and lacy holes in the wave. This type of wave casts a dark shadow immediately under its curling lip. By rendering this concave underbelly of the wave with a very dark value, the lip of the wave and the whitecap itself will appear even brighter.

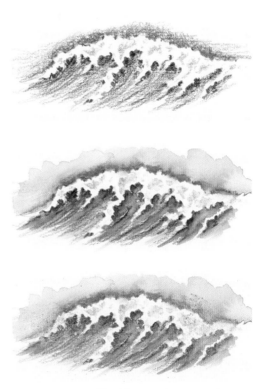

Nevis Sunset, 2005. Colored pencil and watercolor pencil on Fabriano Artistico hot-press watercolor paper, 7$\frac{1}{2}$" × 10". Courtesy of Kristy Kutch.

Caribbean sunsets are magnificent, and this scene from the island of Nevis is no exception. The sky was drawn first with streaks of dark chrome yellow, cadmium yellows, and cadmium orange in watercolor pencils, and then wetted and allowed to dry. The rest of the sky was later brushed with pigment from a homemade palette in middle phthalo blue, ultramarine blue, and bluish turquoise and dabbed with tissue to wick out the puffy white clouds. Using gentle, curving strokes with dry watercolor pencils in the same combination of yellows and orange that captured the brilliant sky, the sun-kissed, rippled waters appear to glow; the darker waters were also drawn with the same blues as the sky, as well as indianthrene blue. These color layers were dissolved with a Colorless Blender Marker, and after drying overnight, the entire sea was brushed with cadmium yellow from a homemade palette.

To create a wave with whitecaps, draw one using watercolor pencils in ultramarine blue, Prussian blue, and juniper green, saving the white of the paper for the foam. The area just under the curl is emphasized with heavy layers of Prussian blue to create the very darkest value (top). With a #6 round brush, the colors are dissolved into a rich wash, leaving some of the pigment partially dissolved to create the effect of frothy water (center). Using a wet toothbrush loaded with pigment from light yellow ochre and light cobalt turquoise pencils, create the airborne spray of water (bottom).

Landscape

This mountain scene was created using wet and dry techniques with both watercolor and traditional colored pencils. The challenge with this composition was to render the very different features, from the wispy clouds to the rugged boulders in the foreground.

STEP 1 Before drawing, take the reference photo and draw a grid of one-inch squares over it. This grid will act as a guide when creating the line drawing and ensure that it is proportional. If desired, the grid can be drawn lightly on the paper using an HB pencil.

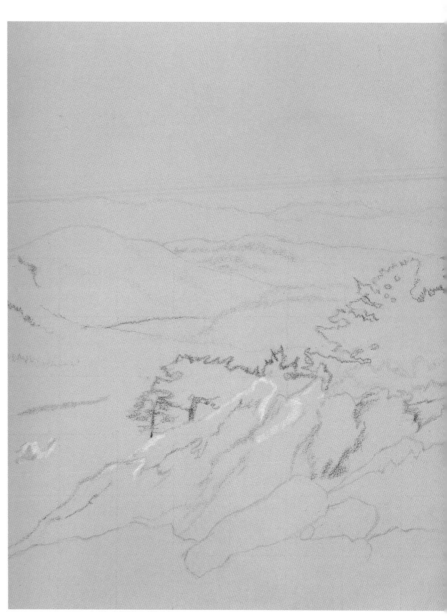

STEP 2 Select a colored paper that accepts water media. With the reference photo, use traditional colored pencils to draw the outlines of the landscape features, square by square. Use cream pencil to indicate the ridge closest to the viewer. Erase the faint grid marks so that only the line drawing remains.

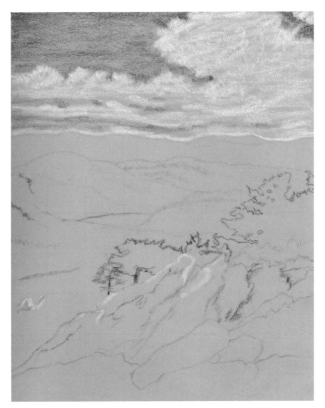

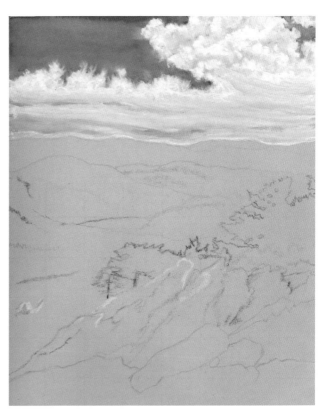

STEP 3 With dry watercolor pencils in smalt blue, middle phthalo blue, and a little Prussian blue, draw in the blues of the sky, starting with the lighter values and ending with the darkest values. Draw the billowy cloud with a heavy layer of white watercolor pencil.

STEP 4 With a #6 round brush, wet the sky. Start with the blue areas and progress to the clouds. Tip the paper slightly so that the wet clouds flow into the wet blue sky as little white wisps. With light cobalt turquoise, light ultramarine blue, and ultramarine blue watercolor pencils, load the tip of the wet brush, and add some billowy shadows on the wet clouds. Follow the same procedure with the white pencil, loading its pigment onto the brush and adding extra white to the brightest spot on the clouds. Allow the sky to dry completely.

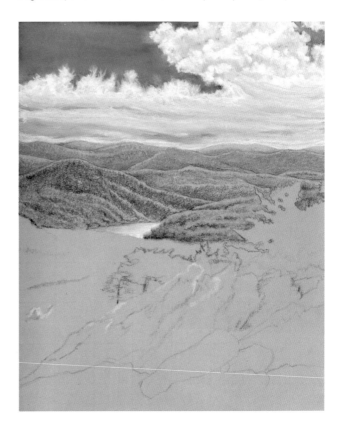

STEP 5 Using dry watercolor pencils in light ultramarine blue and earth green, draw the distant mountain ridges with vertical strokes. For the hills and ridges closer to the viewer, gradually use less of the cool blue. Apply watercolor pencils in pine green, juniper green, May green, leaf green, and cream. Draw the distant lake with light cobalt turquoise and white, and then wet it with a #2 round brush.

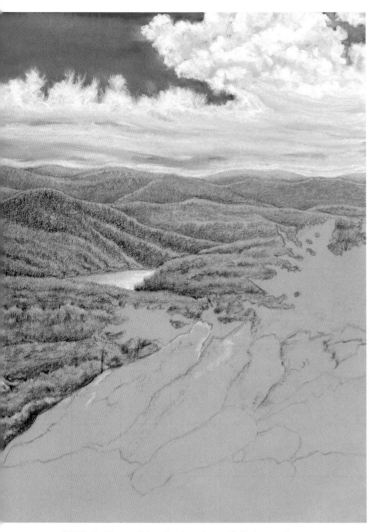

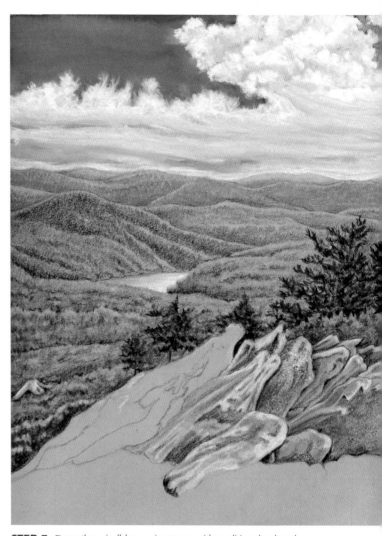

STEP 6 Use traditional colored pencils in hues of warm green, cream, and yellow on the trees and bushes, and render them with some detail.

STEP 7 Draw the windblown pine trees with traditional colored pencils in dark green, and add a few touches of lemon yellow where the sunlight strikes them. Use apple green for the bushes, with touches of olive and hues of burgundy (such as Tuscan red) to give them dimension. With watercolor pencils, draw the boulders with white, ivory, earth green, May green, or any light blue. Wet a boulder and then lightly grate watercolor pencils in ivory and/or a hue of yellow-green (such as May green) onto it. Wet one boulder at a time, and skip around to nonadjacent boulders to prevent the color from bleeding from one to another.

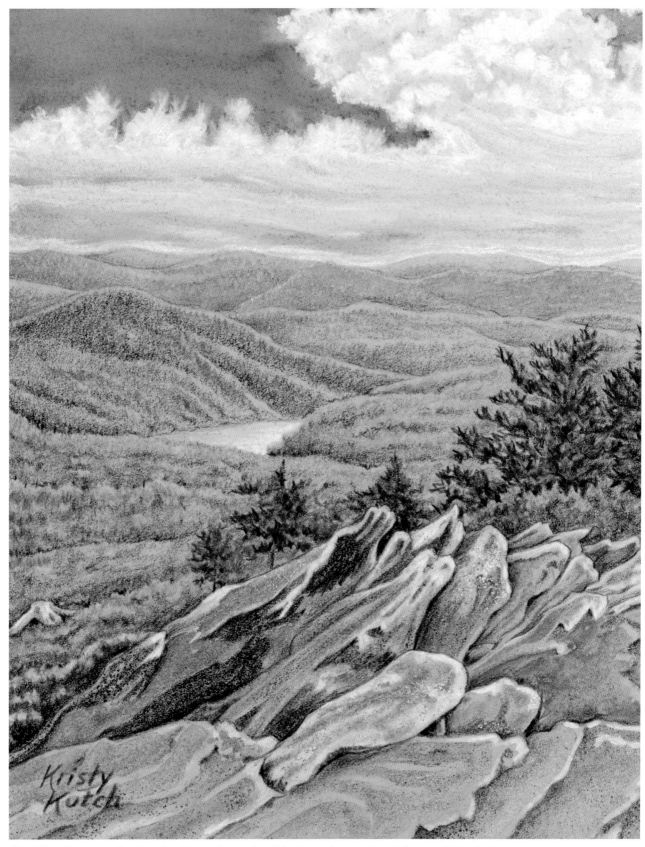

Blue Ridge Valley, 2004. Colored pencil and watercolor pencil on Colourfix pastel paper, 8" × 10". Courtesy of Kristy Kutch.

STEP 8 Finish the boulders using the grating technique with juniper on the darkest shadows. Using an indigo blue Verithin pencil, refine the edges.

Seascape

This serene seascape includes rippled waves, which roll onto shore as foamy whitecaps. Creating the different types of waves as they approach the viewer takes some practice, so use a piece of scrap paper if necessary to feel more confident before moving on to create the finished work.

STEP 1 Sketch the horizon line and shoreline using a light-colored, traditional colored pencil on a rosy grey pastel paper that accepts water media.

STEP 3 Using a one-inch-wide flat brush (or any large watercolor brush), wet the sky, leaving a crisp, dry edge at the horizon. Allow this to dry.

STEP 2 With watercolor pencils, sketch in the range of blues of the sky with (from top to bottom) cobalt blue, smalt blue, middle phthalo blue, light phthalo blue, and a band of white closest to the horizon.

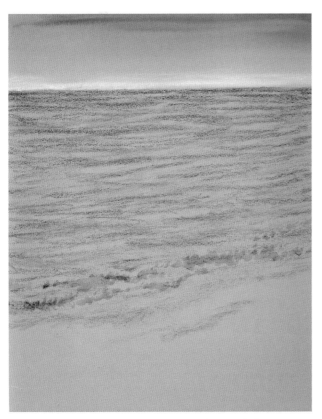

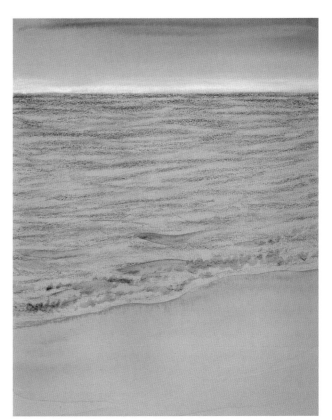

STEP 4 With a range of watercolor pencil blues (including Prussian blue, light ultramarine blue, smalt blue, middle phthalo blue, and light phthalo blue), draw the colors of the water, using the darker values of blue for the small ripples. Use masking fluid to save the areas that will be curling whitecaps. (Do not be concerned if the masking fluid becomes tinted by watercolor pencil pigment; it will be peeled off later from the paper.) In the very shallow water and along the water's edge, streak in a touch of green gold watercolor pencil with the blues.

STEP 5 Although it is usually recommended to work from the distance to the foreground, the shallow sandbar and the beach should be wetted first because the water will eventually overlap and wash over it. With a #12 round brush, wet the green gold areas in the shallow water and along the shoreline. Take a caput mortuum pencil, touch it to the tip of the round brush to load it with pigment, and streak it through the sand. Allow this to dry completely.

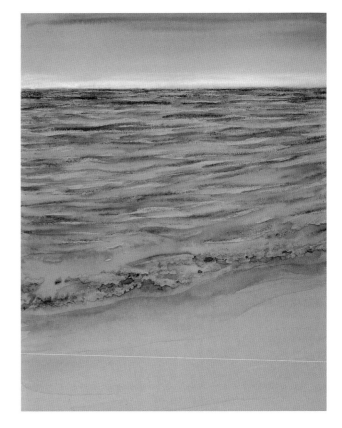

STEP 6 With a small brush (such as a #2 round), begin at the horizon and start wetting the water and the wave furrows. Do not be concerned if some small areas do not get dissolved as that will add to the highlights on the waves. Gradually move to a larger brush and wet the larger furrows closer to the viewer. Tilt the damp paper, and let the blue wash flow over the wet, sandy areas. Load a wet #6 round brush with Prussian blue from a home-made palette, and stroke it underneath the curl of each wave that is masked.

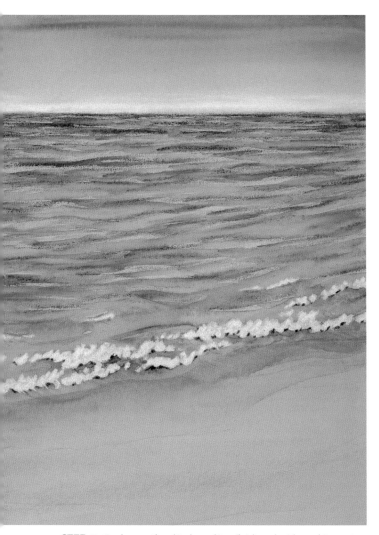

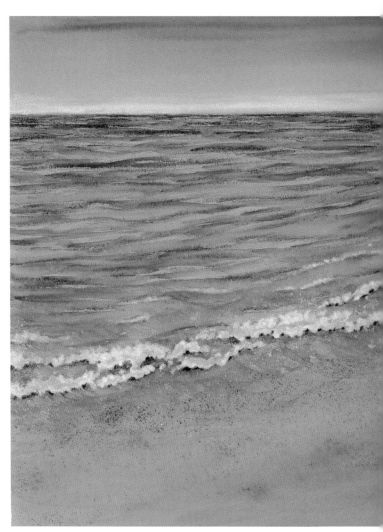

STEP 7 Peel away the dried masking fluid, and with a white water-color pencil, draw in the white wave crests. Add a touch of light cobalt turquoise in the foam of the waves as well as streaks of it through the shallow waters. Using a very sharp Prussian blue pencil, emphasize the deep blue shadow just under the curl of the wave crests. Add a few more dry streaks of green gold in the shallow water. Using the side of a violet pencil, and applying light pressure, draw a shadowy area in the foreground.

STEP 8 Wet a section of a foamy wave with a #6 round brush, swirl the pigment, and touch in a little light ultramarine blue or light cobalt turquoise. Tilt the paper to encourage the wet pigment to flow into wispy patterns. Continue with other waves in the same manner. With a very tiny brush (such as a #2 round), wet the Prussian blue shadows just underneath the curl of each wave. Wet the shoreline and the beach in the foreground with a #12 round brush, and quickly grate caput mortuum, green gold, and a light touch of violet, concentrating the grated pigment along the water's edge. After this has dried, dip a toothbrush into clean water, dab off any excess, and lightly spatter the clean water over and slightly above the waves; quickly grate white colored pencil into these spattered wet spots so that it will stick to the paper and resemble foamy spray. Let this dry.

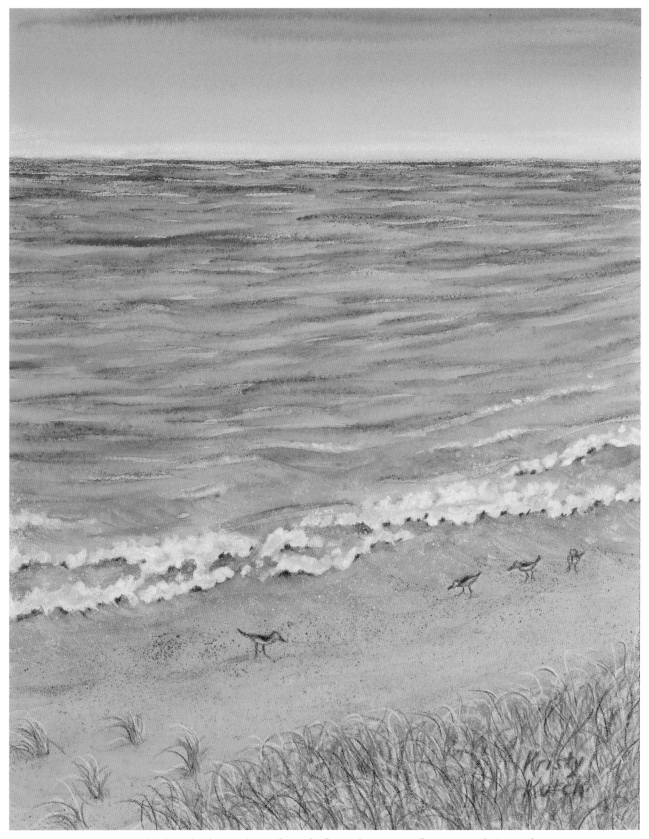

Grand Haven, Michigan, 2005. Colored pencil and watercolor pencil on Colourfix pastel paper, 8" × 11³/₄". Courtesy of Kristy Kutch.

STEP 9 Spatter more clean water from a toothbrush onto the waves and shore, this time following with some grated light cobalt turquoise. Using Verithin pencils and traditional colored pencils, add strokes of yellow ochre, apple green or limepeel, olive, Tuscan red, lilac, cream, and white to render the dune grass. Draw the sandpipers using a dark brown Verithin pencil. Using traditional colored pencils, accent the shadows in the sand with lilac or periwinkle.

APPENDIX

The color charts reproduced here represent the major colored pencil manufacturers that offer pencils in open stock refills. They are: Cretacolor (watercolor pencils only), Derwent, Faber-Castell, Lyra, and Sanford.

Color names for the same hue may differ from one manufacturer to another, and these charts will serve as a convenient reference guide when trying to determine equivalent hues from different brands.

CRETACOLOR: AQUAMONOLITHS AND AQUARELLITHS (BOTH WATERSOLUBLE)

Permanent White, #101

Sunproof Yellow Citron, #103

Flash Yellow, #104

Naples Yellow, #105

Straw Yellow, #106

Cadmium Citron, #107

Chromium Yellow, #108

Permanent Dark Yellow, #109

Orange, #111

Vermillion Light, #112

Vermillion Dark, #114

Permanent Red Light, #113

Permanent Red Dark, #115

Carmine Extra Fine, #116

Madder Carmine, #117

Mars Violet Light, #125

Magenta, #128

Tan Dark, #130

Tan Light, #131

English Rose, #132

Cyclamen, #134

Old Rose Light, #135

Old Rose Dark, #136

Violet, #138

Mars Violet Dark, #140

Pastel Blue, #150

Glacier Blue, #151

Delft Blue, #153

Cobalt Blue, #154

Ultramarine, #155

Blue Violet, #156

Mountain Blue, #157

Light Blue, #158

Medium Blue, #159

Prussian Blue, #161

Indigo, #162

Bremen Blue, #163

Smyrna Blue, #164

Turquoise Dark, #176

Emerald, #177

Leaf Green, #178

Fir Green, #179

Light Green, #180

Moss Green Light, #181

Moss Green Dark, #182

French Green, #183

Grass Green, #184

Lime Green, #185

Pea Green, #187

Olive Green Light, #188

Green Earth Light, #189

Green Earth Dark, #190

Olive Green Dark, #191

Umber Green Light, #192

Ivory, #201

Ochre Light, #202

Ochre Dark, #203

Sienna Natural, #204

English Red, #209

Red Brown, #211

Indian Red, #212

Pompeian Red, #213

Chestnut Brown, #215

Olive Brown, #216

Sepia Light, #218

Van Dycke Brown, #220

Umber, #221

Light Grey, #232

Dark Grey, #235

Blue Grey, #237

Ivory Black, #250

Graphite Aquarell, #260

*Rutile Yellow, #S000		*Phthalocyanine Blue, #S100		*Davy's Grey, #S200	
Azo Lemon, #S005		Phthalo. Blue Lt., #S105		Pale Yellow Oxide, #S205	
*Azo Yellow, #S010		*Iron Blue, #S110		Bright Yellow Oxide, #S210	
*Diazo Yellow, #S015		*Blue Black, #S115		*Yellow Oxide, #S215	
*Anthraquinone Orange, #S020		Ultramarine Light, #S120		Orange Oxide, #S220	
*Azo Orange, #S025		Manganese Blue, #S125		*Pink Oxide, #S225	
Anthraquinone Scarlet, #S030		*Phthalo.Turquoise, #S130		*Red Oxide Transparent,#S230	
*Anthraquinone Red, #S035		*Cobalt Turquoise, #135		Red Oxide, #235	
Anthraquinone Pink, #S040		*Phthalo. Green, #140		Anthraquinone Brown, #S240	
Azo Red, #S045		Honister Grey, #145		*Violet Oxide, #S245	
*Anthraquinone Crimson, #S050		*Phthalo. Green Blue, #S150		*Taupe Oxide, #S250	
*Quinacridone Magenta, #S055		*Phthalo. Green Yellow, #S155		*Umber, #S255	
*Manganese Violet, #S060		*Cadmium Green, #S160		*Holland Brown, #S260	
*Dioxazine Purple, #S065		*Cobalt Green, #S165		*Sepia Oxide, #S265	
*Ultramarine Violet, #S070		Prussian Green, #S170		*Burnt Oxide, #S270	
*Dioxazine Violet, #S075		Sap Green, #S175		Dark Grey, #S275	
Ultramarine Purple, #S080		*Olive Phthalo., #S180		*Carbon Black, #S280	
*French Ultramarine, #S085		Ultramarine Green, #S185		*Payne's Grey. #S285	
*Cobalt Blue, #S090		*Rutile Green, #S190		Light Grey, #S290	
*Indanthrene Blue, #S095		Oxide Green, #S195		*Rutile White, #S295	

*Studio Coloured Pencils and *Watercolour Pencils*

*Zinc Yellow, #01		*Dark Violet, #25		*Sap Green, #49	
*Lemon Cadmium, #02		*Light Violet, #26		*Cedar Green, #50	
*Gold, #03		*Blue Violet Lake, #27		*Olive Green, #51	
*Primrose Yellow, #04		*Delft Blue, #28		*Bronze, #52	
*Straw Yellow, #05		*Ultramarine, #29		*Sepia, #53	
*Deep Cadmium, #06		*Smalt Blue, #30		*Burnt Umber, #54	
*Naples Yellow, #07		*Cobalt Blue, #31		*Vandyke Brown, #55	
*Middle Chrome, #08		*Spectrum Blue, #32		*Raw Umber, #56	
*Deep Chrome, #09		*Light Blue, #33		*Brown Ochre, #57	
*Orange Chrome, #10		*Sky Blue, #34		*Raw Sienna, #58	
*Spectrum Orange, #11		*Prussian Blue, #35		*Golden Brown, #59	
*Scarlet Lake, #12		*Indigo, #36		*Burnt Yellow Ochre, #60	
*Pale Vermilion, #13		*Oriental Blue, #37		*Copper Beech, #61	
*Deep Vermilion, #14		*Kingfisher Blue, #38		*Burnt Sienna, #62	
*Geranium Lake, #15		*Turquoise Blue, #39		*Venetian Red, #63	
*Flesh Pink, #16		*Turquoise Green, #40		*Terracotta, #64	
*Pink Madder Lake, #17		*Jade Green, #41		*Burnt Carmine, #65	
*Rose Pink, #18		*Juniper Green, #42		*Chocolate, #66	
*Madder Carmine, #19		*Bottle Green, #43		*Ivory Black, #67	
*Crimson Lake, #20		*Water Green, #44		*Blue Grey, #68	
*Rose Madder Lake, #21		*Mineral Green, #45		*Gunmetal, #69	
*Magenta, #22		*Emerald Green, #46		*French Grey, #70	
*Imperial Purple, #23		*Grass Green, #47		*Silver Grey, #71	
*Red Violet Lake, #24		*May Green, #48		*Chinese White, #72	

FABER-CASTELL: POLYCHROMOS AND *ALBRECHT DÜRER WATERCOLOR PENCILS

*White, #101

*Ivory, #103

*Cream, #102

*Light Yellow Glaze, #104

*Cadmium Yellow Lemon, #205

*Light Cadmium Yellow, #105

*Light Chrome Yellow, #106

*Cadmium Yellow, #107

*Dark Cadmium Yellow, #108

*Dark Chrome Yellow, #109

*Cadmium Orange, #111

*Orange Glaze, #113

*Dark Cadmium Orange, #115

*Light Cadmium Red, #117

*Scarlet Red, #118

*Pale Geranium Lake, #121

*Deep Scarlet Red, #219

*Permanent Carmine, #126

*Deep Red, #223

*Middle Cadmium Red, #217

*Dark Red, #225

*Madder, #142

*Alizarin Crimson, #226

*Pink Carmine, #127

*Rose Carmine, #124

*Light Purple Pink, #128

*Fuchsia, #123

*Magenta, #133

*Light Magenta, #119

*Pink Madder Lake, #129

*Middle Purple Pink, #125

*Crimson, #134

*Manganese Violet, #160

*Violet, #138

*Purple Violet, #136

*Blue Violet, #137

*Mauve, #249

*Delft Blue, #141

*Dark Indigo, #157

*Indianthrene Blue, #247

*Helioblue Reddish, #151

*Cobalt Blue, #143

*Ultramarine, #120

*Light Ultramarine, #140

*Smalt Blue, #146

*Cobalt Blue Greenish, #144

*Phthalo Blue, #110

*Middle Phthalo Blue, #152

*Light Phthalo Blue, #145

*Bluish Turquoise, #149

*Prussian Blue, #246

*Helio Turquoise, #155

*Cobalt Turquoise, #153

*Light Cobalt Turquoise, #154

*Cobalt Green, #156

*Deep Cobalt Green, #158

*Hooker's Green, #159

*Dark Phthalo Green, #264

*Chrome Oxide Grn. Fiery, #276

*Phthalo Green, #161

*Emerald Green, #163

*Light Phthalo Green, #162

*Light Green, #171

*Grass Green, #166

*Leaf Green, #112

*Permanent Green, #266

*Permanent Green Olive, #167

*Pine Green, #267

*Chrome Oxide Green, #278

*Juniper Green, #165

*Olive Green Yellowish, #173

*Green Gold, #268

*May Green, #170

*Earth Green Yellowish, #168

*Chrome Green Opaque, #174

*Earth Green, #172

*Caput Mortuum, #169

*Caput Mortuum Violet, #263

*Burnt Carmine, #193

*Red-Violet, #194

*Light Red-Violet, #135

*Dark Flesh, #130

*Medium Flesh, #131

*Light Flesh, #132

*Cinnamon, #189

*Pompeian Red, #191

*Indian Red, #192

*Venetian Red, #190

*Sanguine, #188

*Burnt Ochre, #187

*Terracotta, #186

*Light Yellow Ochre, #183

*Naples Yellow, #185

*Dark Naples Yellow, #184

*Brown Ochre, #182

*Raw Umber, #180

*Bistre, #179

*Van Dyck Brown, #176

*Nougat, #178

*Burnt Umber, #280

*Burnt Siena, #283

*Walnut Brown, #177

*Dark Sepia, #175

*Warm Grey VI, #275

*Warm Grey V, #274

*Warm Grey IV, #273

*Warm Grey III, #272

*Warm Grey II, #271

*Warm Grey I, #270

*Cold Grey I, #230

*Cold Grey II, #231

*Cold Grey III, #232

*Cold Grey IV, #233

*Cold Grey V, #234

*Cold Grey VI, #235

*Payne's Grey, #181

*Black, #199

*Silver, #251

*Gold, #250

*Copper, #252

*+White, #01		*Cream, #02	
*+Zinc Yellow, #04		*Lemon Cadmium, #05	
*Light Chrome, #06		*+Lemon, #07	
*Canary Yellow, #08		*Orange Yellow, #09	
*+Light Orange, #13		*Dark Orange, #15	
*Vermilion, #17		*+Scarlet Lake, #18	
*Pale Geranium Lake, #21		*Rose Carmine, #24	
*Dark Carmine, #26		*+Light Carmine, #27	
*Rose Madder Lake, #28		*+Pink Madder Lake, #29	
*Dark Flesh, #30		*Medium Flesh, #31	
*+Light Flesh, #32		*Wine Red, #33	
*Magenta, #34		*Red Violet, #35	
*+Dark Violet, #36		*Blue Violet, #37	
*Violet, #38		*+Light Violet, #39	
*Delft Blue, #41		*Deep Cobalt, #43	
*Light Cobalt, #44		*+Sky Blue, #46	
*+Light Blue, #47		*True Blue, #48	
*Oriental Blue, #49		*Paris Blue, #50	
*+Prussian Blue, #51		*Peacock Blue, #53	
*+Aquamarine, #54		*Night Green, #55	
*Sea Green, #58		*+Hooker's Green, #59	
*Viridian, #61		*True Green, #62	
*Emerald Green, #63		*Juniper Green, #65	
*Sap Green, #67		*Moss Green, #68	
*+Apple Green, #70		*Light Green, #71	
*Grey Green, #72		*Olive Green, #73	
*Cedar Green, #74		*Dark Sepia, #75	
*+Van Dyck Brown, #76		*Raw Umber, #80	
*Brown Ochre, #82		*Gold Ochre, #83	
*Ochre, #84		*Light Ochre, #85	
*Burnt Ochre, #87		*Cinnamon, #89	
*+Venetian Red, #90		*Pompeian Red, #91	
*Indian Red, #92		*Burnt Carmine, #93	
*Purple, #94		*Light Grey, #95	
*Silver Grey, #96		*+Medium Grey, #97	
*Dark Grey, #98		*+Black, #99	
Metallic Brown, #231 Purecolour only		Metallic Yellow, #232, Purecolour only	
Metallic Lilac, #234, Purecolour only		Metallic Blue, #235, Purecolour only	
Metallic Pink, #236, Purecolour only		Metallic Turquoise, #237, Purecolour only	
Champagne, #238, Purecolour only		Copper, #240, Purecolour only	
Gold, #250, Purecolour only		Silver, #251, Purecolour only	

Sand, #940		Chartreuse, #989		Scarlet Lake, #923	
Neon Yellow, #1035		*+True Green, #910		*Blush Pink, #928	
*Cream, #914		Peacock Green, #907		*+Pink, #929	
*Sunburst Yellow, #917		*+Grass Green, #909		*+Crimson Red, #924	
Yellow Ochre, #942		+Apple Green, #912		+Scarlet, #922 (Art Stix only)	
Lemon, #915		Neon Green, #1039		Hot Pink, #993	
Beige, #997		Light Green, #920		*+Mulberry, #995	
*+Canary Yellow, #916		Marine Green, #988		Pink Rose, #1018	
Jasmine, #1012		Limepeel, #1005		*Carmine Red, #926	
*+Goldenrod, #1034		Celadon Green, #1020		Process Red, #994	
Deco Yellow, #1011		*Olive Green, #911		Neon Pink, #1038	
Yellow Chartreuse, #1004		*Spring Green, #913		Neon Red, #1037	
Metallic Gold, #950		Jade Green, #1021		Deco Pink, #1014	
Bronze, #1028		*Parrot Green, #1006		Clay Rose, #1017	
Sepia, #948		*+Dark Green, #908		Magenta, #930	
*+Sienna Brown, #945		*+Orange, #918		Crimson Lake, #925	
Burnt Ochre, #943		Pale Vermillion, #921		Raspberry, #1030	
*+Dark Brown, #946		Salmon, #1001		*Poppy Red, #922	
*Dark Umber, #947		+Spanish Orange, #1003		Mahogany Red, #1029	
Light Umber, #941		+Peach, #939		Henna, #1031	
*Terra Cotta, #944		Yellowed Orange, #1002		Steel, #1041	
*+Black, #935		*Light Peach, #927		Slate Grey, #936	
*+White, #938		Mineral Orange, #1033		Metallic Silver, #949	
Deco Blue, #1015		Pumpkin Orange, #1032		Warm Grey 10%, #1050	
Electric Blue, #1040		Deco Orange, #1010		Warm Grey 20%, #1051	
Blue Violet Lake, #1079		Neon Orange, #1036		Warm Grey 30%, #1052	
*+True Blue, #903		Deco Peach, #1013		Warm Grey 50%, #1054	
Aquamarine, #905		Rosy Beige, #1019		Warm Grey 70%, #1056	
*+Indigo Blue, #901		Dark Purple, #931		Warm Grey 90%, #1058	
*Ultramarine, #902		Greyed Lavender, #1026		French Grey 10%, #1068	
*Copenhagen, #906		*Lilac, #956		*French Grey 20%, #1069	
*Non-Photo Blue, #919		Black Grape, #996		French Grey 30%, #1070	
*+Violet Blue, #933		+Parma Violet, #1008		French Grey 50%, #1022	
Mediterranean Blue, #1022		*+Violet, #932		French Grey 70%, #1074	
Deco Aqua, #1016		Lavender, #934		French Grey 90%, #1076	
Cloud Blue, #1023		Imperial Violet, #1007		Cool Grey 10%, #1059	
Periwinkle, #1025		Black Cherry, #1078		Cool Grey 20%, #1060	
*Peacock Blue, #1027		Dahlia Purple, #1009		Cool Grey 30%, #1061	
Blue Slate, #1024		+Tuscan Red, #937		*Cool Grey 50%, #1062	
Light Aqua, #992		+Colorless Blender, #1077		Cool Grey 70%, #1065	
Cerulean #904 (+Lt. Blue Art Stix)				Cool Grey 90%, #1067	

BIBLIOGRAPHY

Borgeson, Bet. *The Colored Pencil (Revised Edition)*. New York: Watson-Guptill Publications, 1995.

———. *Colored Pencil: Fast Techniques*. New York: Watson-Guptill Publications, 1988.

———. *Colored Pencil for the Serious Beginner*. New York: Watson-Guptill Publications, 1998.

Denvir, Bernard. *The Thames and Hudson Encyclopaedia of Impressionism*. New York: Thames and Hudson, Ltd., 1990.

Edwards, Betty. *The New Drawing on the Right of the Brain*. New York: Jeremy P. Tarcher/Putnam, 1999.

Reid, Grant W. *Landscape Graphics: From Concept Sketch to Presentation Rendering*. New York: Watson-Guptill Publications, 1987.

Sidaway, Ian. *Color Mixing Bible*. New York: Watson-Guptill Publications, 2002.

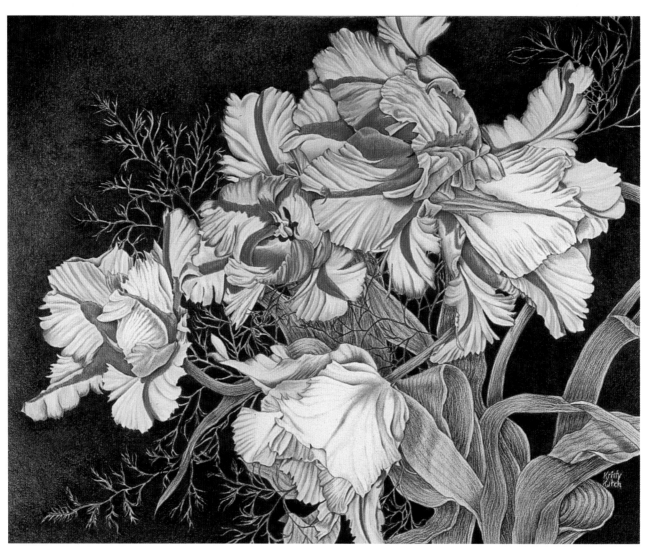

Parrot Tulips, 2001. Colored pencil on Rising four-ply museum board, 20" × 16". Courtesy of Kristy Kutch.

INDEX